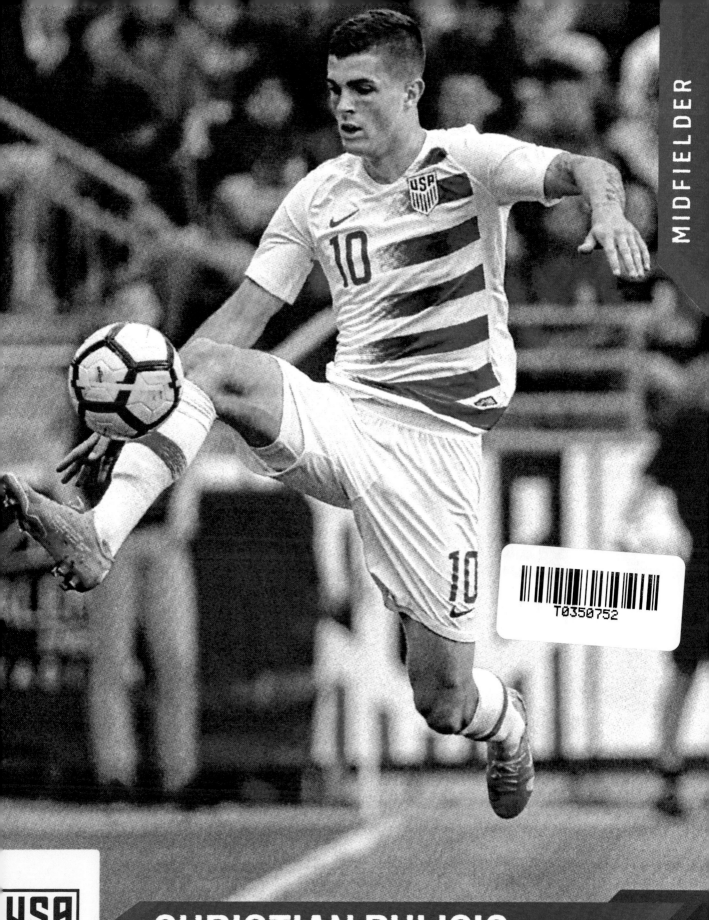

MIDFIELDER

T0350752

CHRISTIAN PULISIC
2018 U.S. MEN'S NATIONAL TEAM

PULISIC

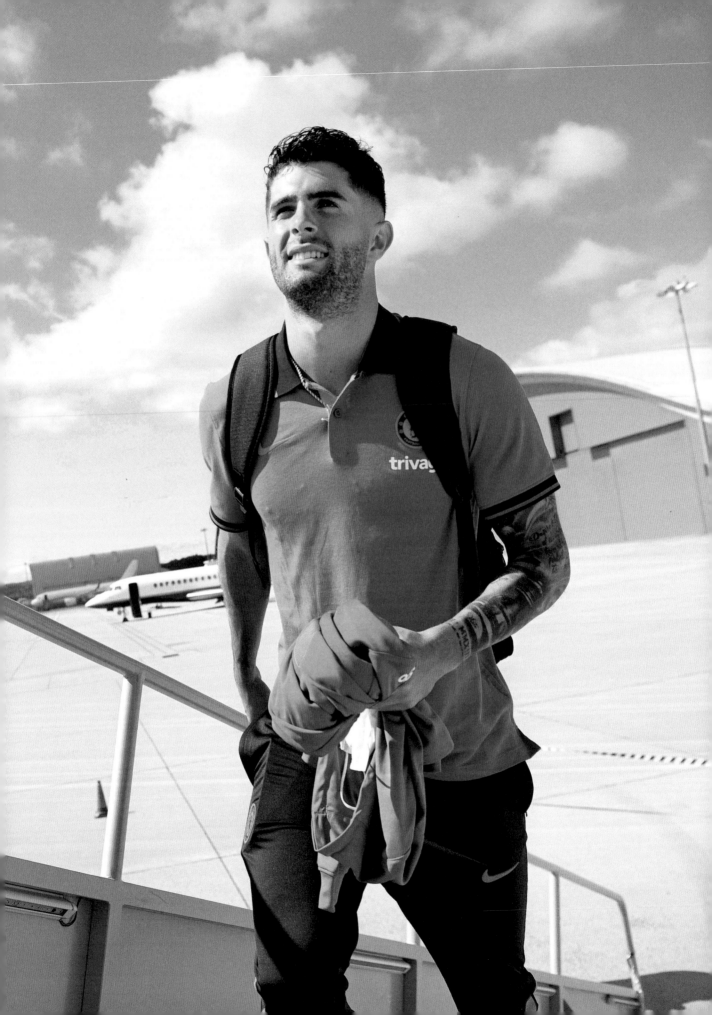

PULISIC
MY JOURNEY SO FAR

CHRISTIAN PULISIC

CONVERSATIONS WITH DANIEL MELAMUD

RIZZOLI
NEW YORK

New York · Paris · London · Milan

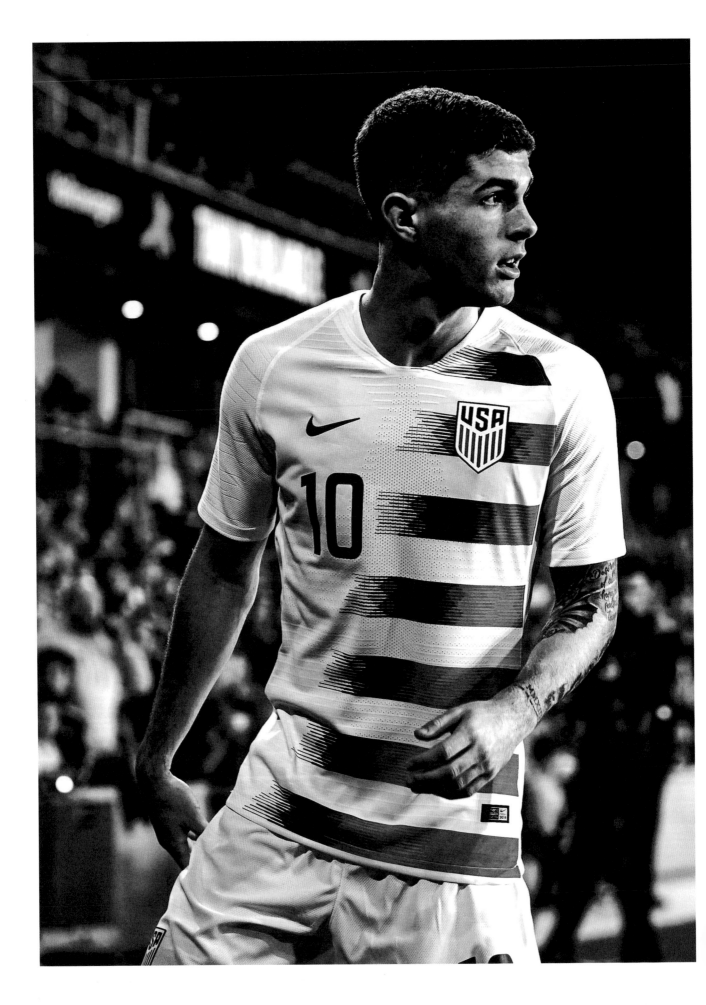

CONTENTS

FORWARD 13
A foreword by Daniel Melamud

HOME SWEET HOME 15

CAPTAIN AMERICA 49

THE YELLOW WALL 75

LONDON IS BLUE 95

SHOTS 136
Commentary by Arlo White

ACKNOWLEDGMENTS 239

PHOTOGRAPHY CREDITS 240

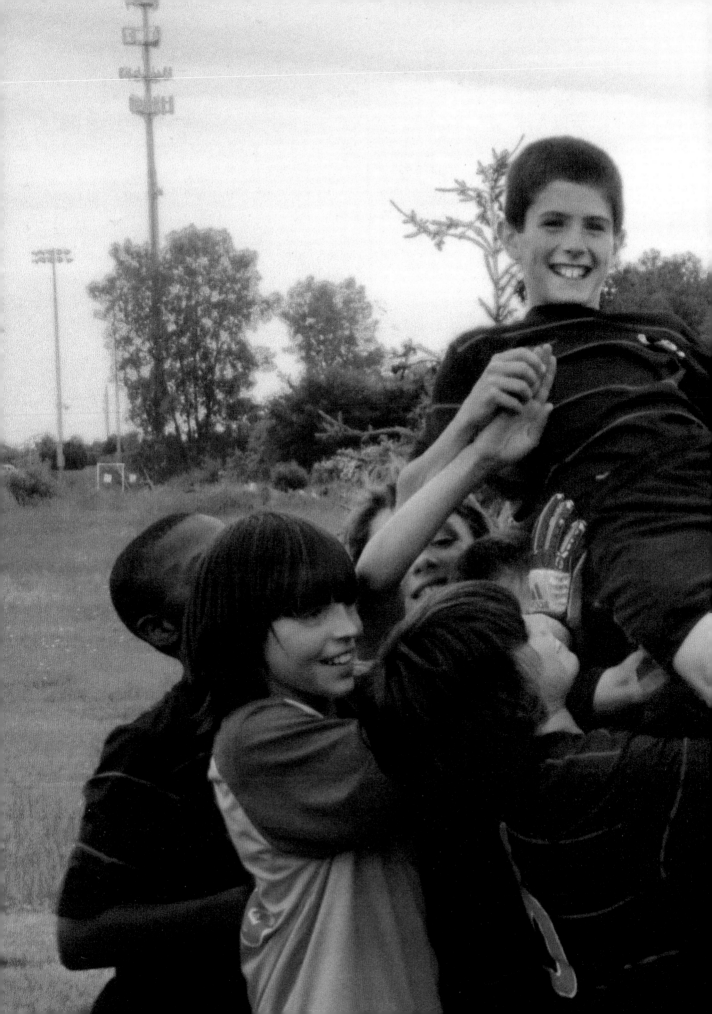

07/2011

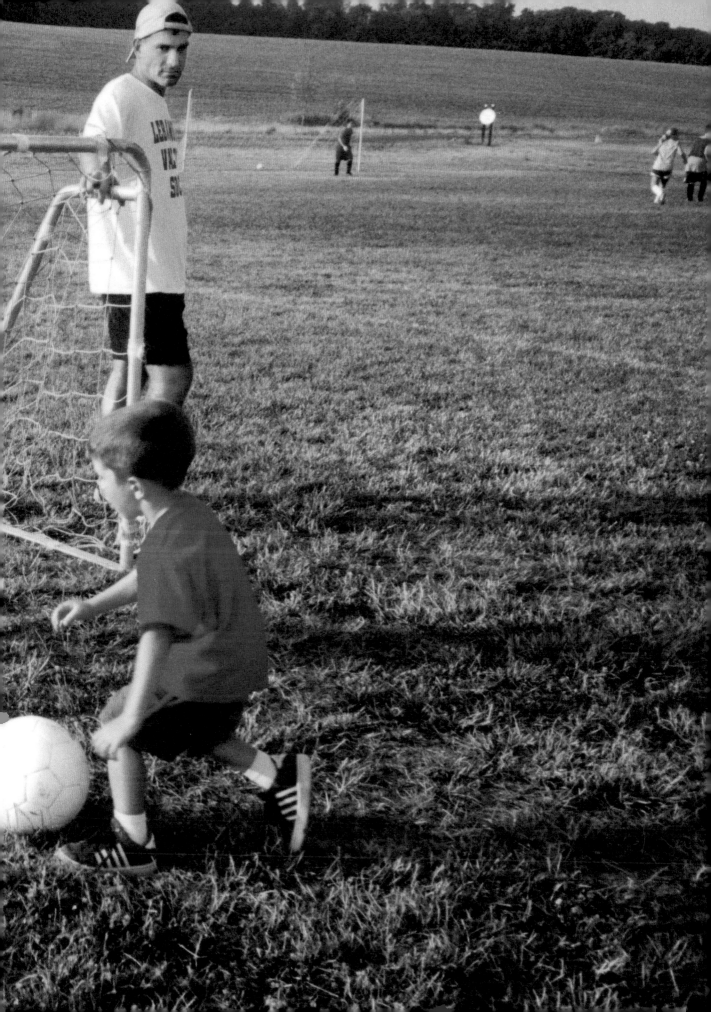

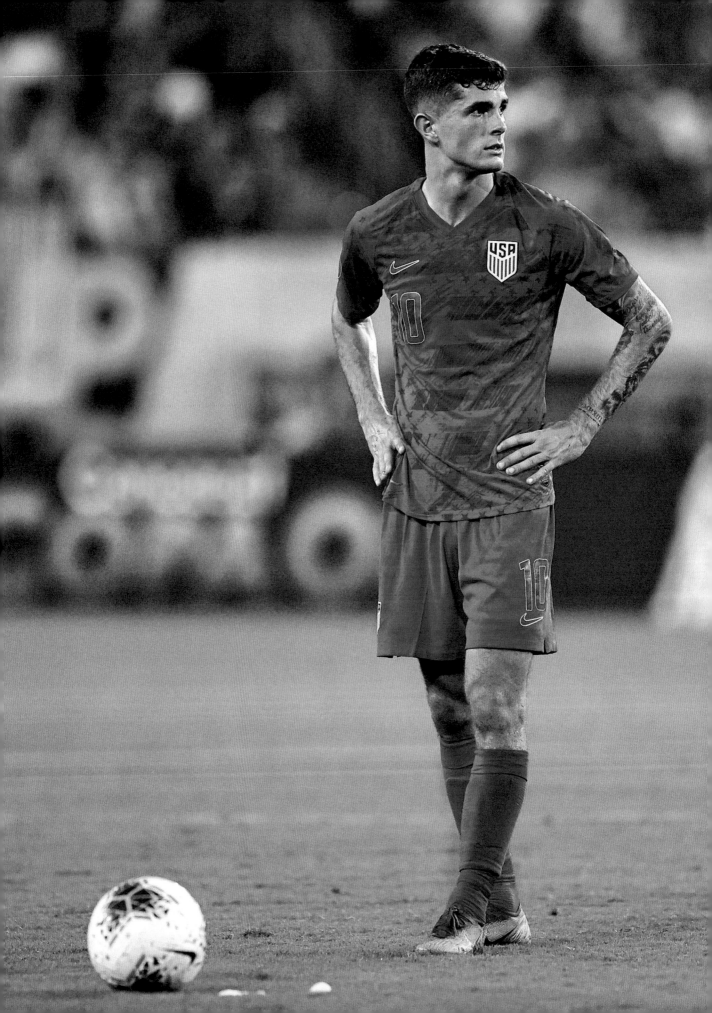

FORWARD

A foreword by Daniel Melamud

Christian Pulisic is the best player in the history of US soccer. He still holds the record for the highest transfer fee for a US national when he moved from Borussia Dortmund to Chelsea for $73.1 million in 2019. (The second-highest American transfer is $23.1 million for Sergiño Dest from Ajax to Barcelona in 2020.) Christian has made it, and at the time of his much-publicized move to west London he was only twenty.

This book is about his journey, which is ultimately a story about the relentless determination to succeed. Christian discovered his passion for soccer at a very early age and has never looked back. While he's obviously an extraordinary natural talent, he has constantly had to prove himself on the world stage—making him the perfect flag bearer for US soccer. He didn't have a path to follow so he had to forge his own. Soccer has been a late developer stateside. We looked abroad for elite players to show us the way. The very best were invited: George Best, Pelé, David Beckham, Thierry Henry. Foreign stars slowly helped change the narrative. Christian turned on the TV to watch the leagues in Europe and was inspired by the brilliance of Figo, Ronaldinho, Wayne Rooney. He practiced their moves in his yard, refusing to go inside until he'd figured them out. His parents, Kelley and Mark, met playing soccer at university and both went on to coach the game, so they quickly recognized the ability and dedication of their son. Mark encouraged Christian, naturally a right-footer, to practice with his left foot. To the frustration of defenders marking him today, Christian would practice every drill with both feet until he was as good at it with his left as his right. This commitment to perfecting his technique helped him become one of the most entertaining attacking players in world football with the skill to change the course of any game.

The first time I met Christian he was observing drills on a soccer field at his childhood club, PA Classics, nestled in Pennsylvania farmland. Rain was pouring down, and youth players wearing soaked Pulisic jerseys trained in front of their role model. The event marked the opening of new facilities Christian had donated to the club. Just two days before, he was in Utah with the national team for a friendly against Costa Rica. The game marked the end of a long season in which he had won the Champions League with his club and raised the inaugural Concacaf Nations League trophy captaining the US. During the coverage of the match in Utah, a commentator pointed out that Christian would be on a beach somewhere relaxing away from it all in a couple of days. Well, that beach was a wet soccer field, and he was surrounded by hundreds of young soccer fans and a swarm of media. He seemed at ease and genuinely happy to be there. The US now has its very own soccer star. And his name is Christian Pulisic.

Ready to take a free kick during the Concacaf Gold Cup semifinal between the US and Jamaica, Nissan Stadium, Nashville, Tennessee, July 3, 2019.

HOME SWEET HOME

The following conversation took place on September 24, 2021, in the garden of Christian's home in London. There was a goal set up and a football ready for play.

Christian, it's good to see you again. The last time we met, back at PA Classics Soccer Park—your childhood stomping grounds—you were going through media like defenders . . . well, you didn't run away from them . . . they just kept coming and you negotiated every interview with apparent ease. Are you now used to all the attention?

I'm definitely used to it in a sense that I'm ready for it and I'm always up for it, but I'll never be fully used to it, I guess, if that makes any sense?

It makes total sense.

I can go into an interview mode at times and be ready to do it, but it will always seem kind of crazy to me that people want to talk to me.

Have you had any media training?

No, I just learned through time. Working with my agent, they've given me tips here and there on how to deal with certain topics and different things, but I mostly just learned through experience.

So, back to the beginning. As a kid in Hershey, Pennsylvania, when Halloween came around you wanted to dress as a soccer player. Did you always love soccer?

Yeah, I always did, ever since I can remember.

My dad played, my mom played, it was the only sport that we were always playing with my whole family . . . it was always what I wanted to do when I grew up.

Your freestyling skills are extraordinary. Do you remember how old you were when you first practiced kick-ups?

Ever since I can remember, I was juggling. I'd try

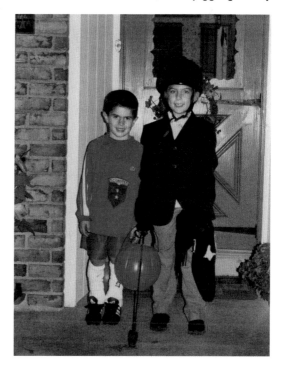

Opposite: Me with a ball and a photobomber pulling a duck face, Annville, Pennsylvania, spring 2001.
Above: Ready to go trick-or-treating with my sister, Devyn, Hershey, Pennsylvania, October 31, 2003.
Following pages: All about me when I was seven in third grade, September 6, 2006.

All About Me

Favorite Color blue

Favorite Pizza Topping peparoni

Favorite TV Show Drak and Josh

Favorite Animal Snake

Favorite School Subject Math

Favorite Sport Soccer

Favorite Ice Cream Flavor Chocdate

Favorite Candy Reses

Favorite Food pasta

My Best Friend's Name brandon

Favorite Book The incredibles

When I grow up I want to be _a pro soccer player_

The thing I like to do most is _play soccer_

The best thing about me is _I love soccer_

PACIFIC

F

Mark Pulisic

Harrisburg Heat

HT: 5'9" WT: 180 Born: September 20, 1968
Citizenship: USA NPSL Experience: 1 year

1991-92 Regular Season Scoring Stats

TEAM	GP	2PG	A	PTS	SH	PIH
Harrisburg	40	35	11	81	88	12

All-Rookie 2nd team Harrisburg Heat 1991-92; four years at George Mason University, all Conference All-State. Favorite athlete is Chris Mullin.

OFFICIALLY LICENSED
NPSL

HARRISBURG

74

DONRUSS

21-22

Road to
FIFA WORLD CUP
Qatar 2022

CHRISTIAN PULISIC

UNITED STATES

M

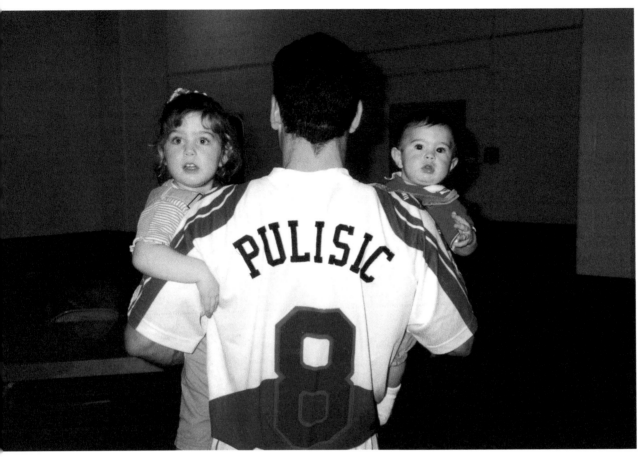

to set a new record, I'd be in my backyard . . . I remember when I was younger I got up to like 500 then 600, and after that I just stopped counting.

Whoa. Younger? How young were you when you were juggling past 500?

I must have been eight or nine at the time. I always loved just messing around with the ball.

So you grew up playing soccer with your family. What's your relationship like with your mom [Kelley], dad [Mark], sister [Devyn], and brother [Chase]. Have they always been supportive?

They've always been very supportive. I'm very close with my parents in different ways. My dad really helped shape me into the player I am. I've learned a lot from him; he was my coach for a long time. I have a good relationship with him. You know, he was harder with me growing up, but now he just wants me to enjoy it more and lets me go. And then my mom, she just always supported me and loved me no matter what. She doesn't really care too much about what happens with soccer or

whatever, so she's the best in that way. Then obviously my siblings are very supportive of me. My brother is my biggest fan. My sister is probably the only one who isn't really that into it, but she loves what I do and we have a great relationship too, so it all works out.

What traits would you say you have from your mom and dad?

That's a good question. I think from my dad I can be quite stubborn and competitive. When it comes to my dad needing to get a job done, that competitive drive and perseverance in the way my dad does things—I've definitely got some of that. My mom is just a very kind, selfless person. I feel like that's what I always try to learn from her; she never does anything for herself, she always looks out for us and is always very nice. I try to be like that, the best I can.

Were all your presents for birthdays and holidays soccer-related?

Maybe some of the time, yeah. Might have been

Preceding pages: Trading cards of my dad from 1993 and me from 2021. I got the curls but not the mullet.
Above: Devyn, my dad, and me just after his last game for the Harrisburg Heat, Harrisburg, Pennsylvania, April 1999.

a new pair of boots or a new ball or something . . . there were definitely soccer gifts. I loved wearing different jerseys, and sometimes my mom would make them—she'd paint team names and logos onto the shirts.

Official jerseys are expensive.

Yeah, and my parents were on teachers' salaries.

Where would you play? In your garden or local park?

My childhood house, actually the side of our house, had a big grass area and we always had a mini goal there. I would just shoot on my dad or my mom would be there crossing to me and I would shoot. The whole family was out there. I played a lot of soccer with them out there, that's where I played the most.

Stanley Matthews set up a row of kitchen chairs in his garden, and he would practice dribbling around them. But that was in the 1920s. Did you ever use cones?

We definitely had some equipment around the house. My dad would set out cones and other stuff like that, but a lot of the time I was just kicking the ball against a wall; it wasn't like we were always using equipment.

As a kid, what training skills did you work on most or enjoy most?

I'd say working on my first touch would be the main thing. Your first touch is really important.

Whether it's just kicking balls up in the air and receiving them. Making sure I did it with both feet was always important. My dad made sure that I was using both feet equally when I was training and to have a good lead foot as well. Some of the stuff that I enjoyed the most was just getting to go and play with my friends whenever I could and play five-a-side or small games. I loved to just play and score. Scoring goals was my favorite thing to do growing up.

Did you play with friends from school? Or were they neighborhood friends?

In America I didn't play much soccer with friends from school because no one really played; none of my friends played soccer, which was tough, but I remember more so when I was in England for a year, after school I would play for hours and hours with school friends and neighbors. I had some soccer friends when my dad was coaching the Harrisburg City Islanders in Pennsylvania close to where I grew up, and I'd always go to the games. During halftime and after the game, a whole bunch of kids would go back there and just play. Yeah, those are some really good memories from back then.

So you were born right-footed but you've always practiced playing with your left foot. Do you get a bigger kick out of scoring with your left? More enjoyment, that is . . .

I don't really mind, to be honest! It's helpful to be able to use both for sure.

Do you generate the same amount of power from both?

My right foot will always be just a little bit stronger, but I think I have a lot of power with my left as well.

Above: Goalkeeping in the yard on Christmas Day, Hershey, Pennsylvania, December 25, 2003.
Right: With Devyn in our front yard, Hershey, Pennsylvania, summer 2001.
Following pages: Mom coaching the Little Gunners. I'm in blue at the far left talking to a teammate instead of listening, spring 2003.
Page 24: Lebanon Valley College Soccer camp team photo, Annville, Pennsylvania, summer 2003.
Page 25: Lower Dauphin Soccer Association team photo, Hershey, Pennsylvania, November 6, 2004.

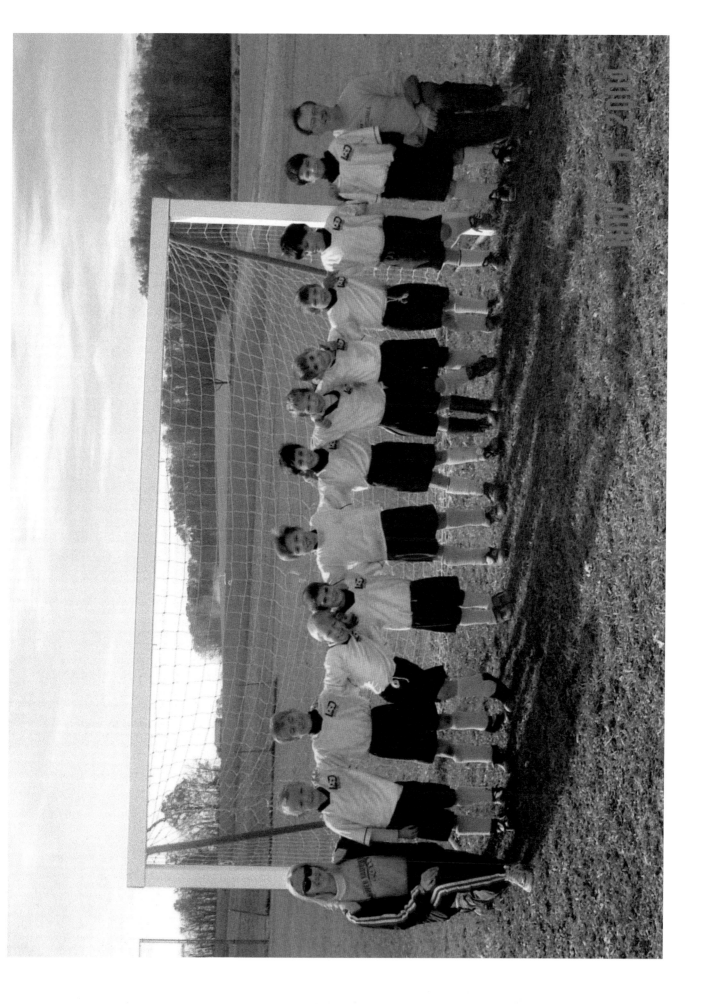

You also played basketball growing up—the fact you can dunk is pretty amazing—was there ever a moment when you thought you might want to pursue a sport other than soccer?
No, I always loved playing other sports, especially basketball and golf, but I think I always kind of knew that I was coming back to soccer. That was my main sport and the one I was best at, but I definitely enjoyed other sports and I think I learned a lot from them as well.
Learned a lot in terms of . . .
I think in terms of my athleticism,

learning different skills. Hand-eye coordination. You know, whether it's jumping ability or speed or quickness or whatever, I always felt like playing those other sports gave me a little bit of an edge.
Yep, there are specific movements you focus on in each sport, and if you bring them to another one it's adding something . . .
Exactly.
You've mentioned that your favorite teams growing up were the New York Jets, the Philadelphia 76ers, and the New York Rangers. Did you support a soccer team?
Well, I definitely supported all my dad's teams. He coached at the City Islanders, he coached at Harrisburg, the Detroit Ignition, he coached at a few different places, so I was always a big fan of those local teams wherever we were living. But as far as European teams, I mean I did like Manchester United for a bit, which is funny because I obviously don't like them anymore [laughter].
Obviously [laughter].
And I liked Real Madrid growing up as well. Those were the two teams that we watched the most, I would say.
So United—did you like them because of a specific player, or was it just because of the way the team played?
I did really like Wayne Rooney. I think he was probably the main reason I was a Man U fan, but I also liked the team in general.
You can see that Wayne Rooney just loves football and you can see that in you, too, that you're soccer through and through. So Luís Figo has always been one of your favorite soccer players. Your first

jersey was Figo's Real Madrid shirt. What is it about the way he played that you were drawn to?
It's kind of how I wanted to play. He was fast. He played a lot on the wing. He was an exciting player. He did a lot of tricks. He was just fun to watch. I wanted to resemble him and how he played, that's the main reason.
Would you try out moves you'd seen Figo do on TV or moves of other players like Ronaldinho and Zinedine Zidane?
Yeah, all the time. Watching on TV . . . I remember sometimes at halftime I'd want to go out and play with my dad. We'd go outside, and I'd try doing a move that I saw. I always loved watching and then trying things and then kind of translating that into my games.
Was there a move in particular you remember trying out for the first time, like a bicycle kick . . .
There was one move that Lionel Messi was doing—it was sort of like a double body feint where he would switch the ball from one foot to the other and I remember I would stay in my garden and do it over and over, practicing it both ways. I remember bringing it to training and I was like, I want to try this today, and I pulled it off perfectly . . .
Nice!
It was nice—it was a beautiful feeling, and I still use it sometimes to this day.
How old were you when you learned it?
Maybe twelve or thirteen, something like that.
Your parents both studied physical education and played soccer for George Mason University. And, when you were almost seven, you moved with your family to England for a year because your mom

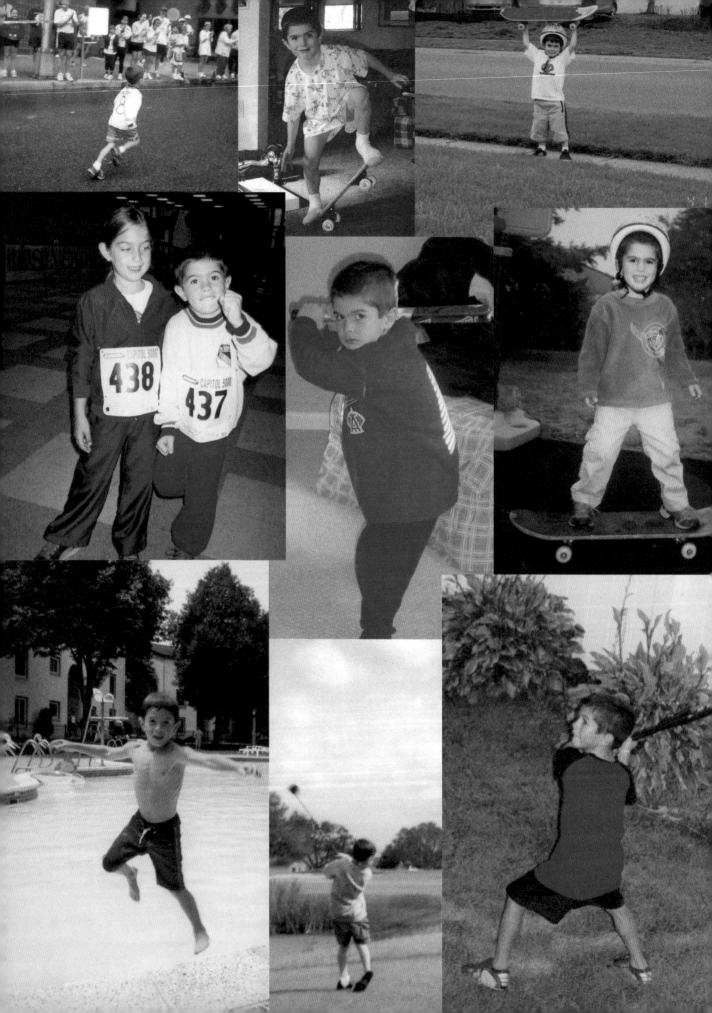

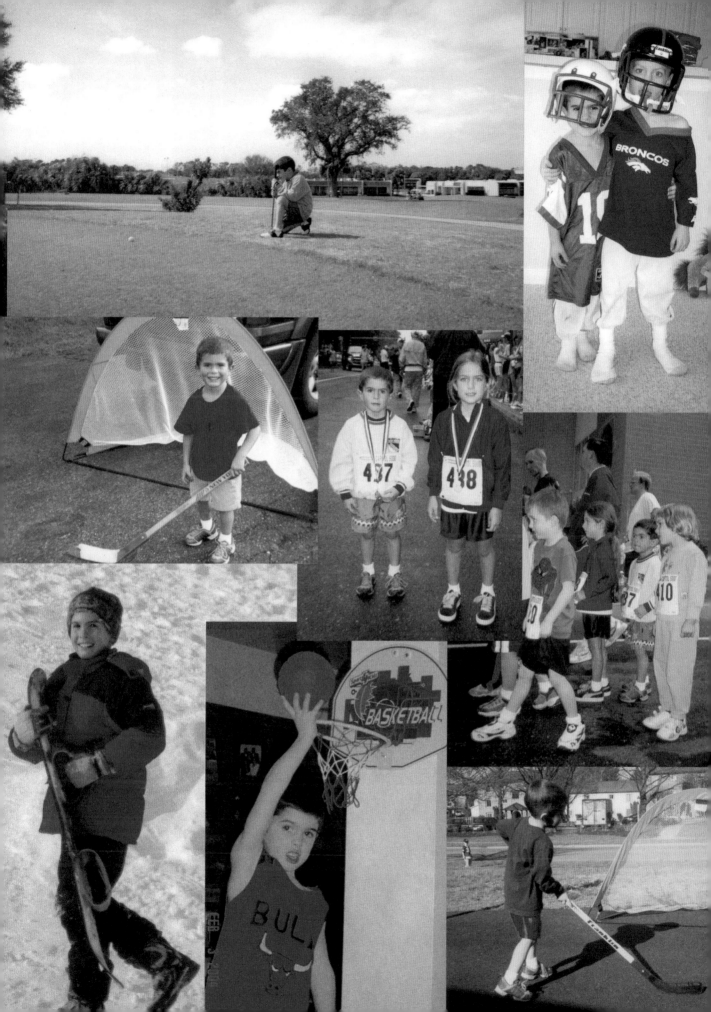

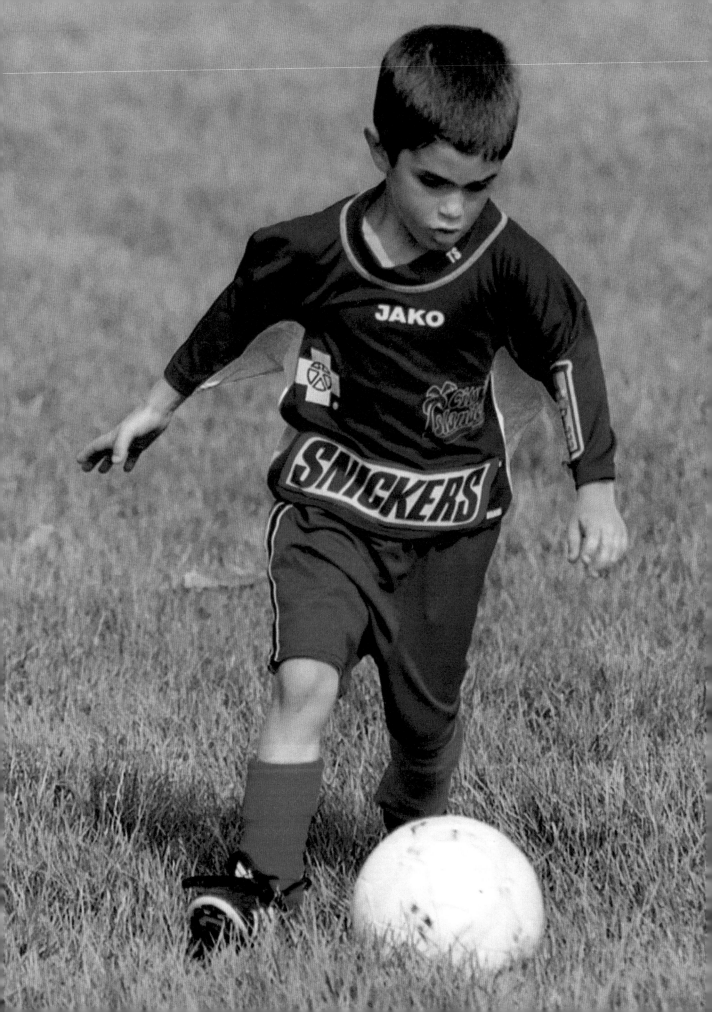

was awarded a Fulbright Teaching Exchange with the Marlborough School in Tackley close to Oxford. While you were there you played for Brackley Town. Did you play on other teams before Brackley?

I played on youth teams back in the States before then.

In Hershey?

Yeah, in Pennsylvania for PA Junior Classics, Lower Dauphin [Soccer Association and Kiddie Kickers], Little Gunners . . . I remember playing a lot of three-versus-three tournaments and youth stuff.

What do you remember most from the time you were in the UK?

After the school day was over, we'd go out and play in this little park right outside the school and just do that for hours and hours. I remember playing for Brackley Town in different tournaments. I even went for a few training stints around England when I was there; I remember taking the train with my dad to go train with Tottenham Hotspur's youth team once a week for a few weeks. I went and trained there and yeah I was really nervous, but I wanted to do it. I was

always excited, I wanted to play and to test myself at a high level. It was really cool.

Let's just skip Tottenham shall we? [Laughter] What position or positions did you play at Brackley?

I can't remember how many people would have been on the field at once, whether it was seven versus seven . . . I was always an attacking player, often a number 10.

Do you remember your first goal?

No, not at all. I remember my first goal in the Premier League, but that was later . . .

I remember my first header on goal . . . it rattled the crossbar, and I just stood there looking at the goal frame moving back and forth and thinking how cool that was, that I'd made that happen. Do you remember from your childhood moments when you scored or did something that really stands out?

Hmm.

You did a lot of exceptional things, that's why they don't come to mind. They stand out for me because they were rare, rare things.

I'm thinking back to my youth days. I remember

Preceding pages: Playing baseball, hockey, golf, basketball, (American) football, skateboarding, snowboarding, swimming, and running. I definitely wasn't always playing soccer.
Opposite: Practicing with the Little Gunners, Hershey, Pennsylvania, spring 2003.
Above: Trying a bicycle kick in a local park, Canton, Michigan, summer 2008.

there was one season playing for PA Classics but this was when I was a bit older, probably thirteen or fourteen, when I must have scored six or seven free kicks; I was on fire, any time there was a free kick, everyone knew I was going to take it and I might score.

Do you remember your kit for Brackley Town?
I think it was red and white stripes. Do you know what it was like, or are you just asking me?

No, no clue!
I thought you were testing me. I'm like, I know we were red and white if I'm not mistaken. But I might be mistaken.

Do you remember your boots?
I remember I had a pair of Puma boots when I was younger in the States, and they were this ultra-light pair of boots that I really wanted and finally got and was super excited about them. I got them right after I got back to the US from England, so I must have been seven or eight.

You played with Nike Mercurial Vapors for ten years, and now you wear Puma Ultras. What's it like being sponsored? Do they automatically ship you boots every month or so? Or do you email them asking for a few new pairs?
I think a lot of players are different in how often they wear their boots. I'm someone who constantly wears new boots. Whenever a new type of boot comes out, for instance with the Ultra, they'll come out with new colors, they'll send you a few pairs, and whenever they start to get a bit worn down for whatever reason, you can contact them and they'll send you new ones.

So you just contact them asking for new pairs?
Yeah, I mean whenever they come out with new pairs they'll send you them without you asking obviously, but if you need new ones you can contact them and they'll send you whatever. It's really nice, it's helpful to have that at your calling.

Do you have any desire or plans to work on a shoe design of your own?
Puma has given me freedom to put some different stuff on my boot, and they've made some designs with my name and stuff like that, which is always really cool. I really enjoy the boots I wear right now so I wouldn't want to design it from brand-new, but different designs or colors are cool to customize. I like that.

Have you customized the ones you wear now?
Well, they just have my initials and the American flag on it, little pictures that I like.

Sweet. Back to Brackley Town—what did you most like about playing for them?
I loved playing at a higher level, so that was fun. I just loved the game in general. I loved scoring goals. I loved dribbling by people. I loved just having the ball at my feet. I loved challenging myself and competing with better players.

So the level in England was higher than back in the US?
It was definitely higher than what I'd experienced up until that point. The kids were technically more advanced. And I'm not sure when exactly I started playing up . . .

By "up" you mean playing against older players?
Yeah, I started playing against bigger and stronger kids as well, which is always a good test. I played against kids who were a year older and then for a while two years older. I remember it was tough for me at first, but I was always very competitive. I wanted to win every game and I wanted to win every tournament, so it was always very important to me.

Do you remember your coach?

Laying around at a photoshoot with Puma, London, England, November 4, 2021.

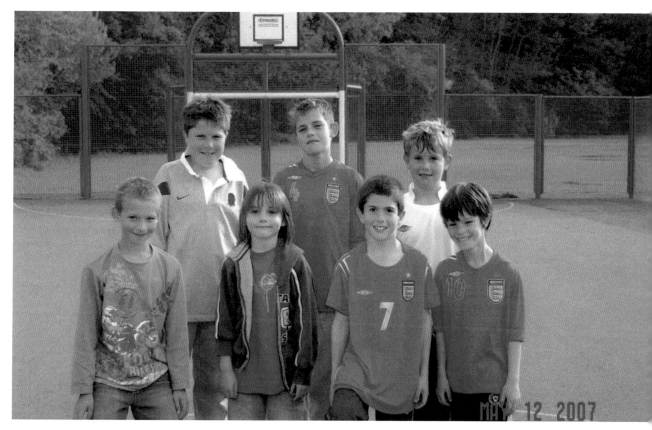

Yes, Robin Walker. I remember his son was on the team. Harvey is his son's name. Robin came once to Germany and saw a game of mine for Dortmund, which was really cool. He's a nice guy.

Did you play away towns or was it all local?
We traveled a bit. I remember traveling to a few different tournaments with them.

Did you like being on the bus with the team?
I always enjoyed that. Growing up I thought it was really fun, chilling with some of your friends on the way to a game; they were some fun times for sure.

How was school in England?
I was always just looking forward to the end of the day when I could go out and kick the ball around, but that wasn't just England. I never really liked school in general but I was always a good student, I worked hard in school, I had to get good grades—that was important to me as well.

Because of your parents? Or was it personally important for you to do well in school?
It's just that whatever I do, I need to be the best at it; I need to be good at it—that's just how I am. That's the way my mind works.

Which subjects did you like the most at school?
I always found languages fascinating so I enjoyed Spanish a lot, and I was quite good at math growing up—it was the one subject I didn't mind. But other than that, I had some cool teachers but those were the two classes I liked the most.

School lunch or packed lunch?
Packed lunch always, in a brown paper bag. A lot of peanut butter and jellies. I always had a lot of applesauce I remember. Applesauce was big in the house. Yogurts and stuff like that.

Did you ever play for your school team or did you just play on club teams?
I never played for my school team. I remember in middle school and high school in Pennsylvania I always wanted to, I always thought it would be cool to play for the school team. Everyone was constantly asking me, "Why don't you play for the school?" but I had different things going on. It wasn't really a high level anyways, but it would have been fun to do.

Did you watch any professional football matches when you were in England?

At the playground in the village park where we'd play soccer after school, Tackley, England, May 12, 2007.

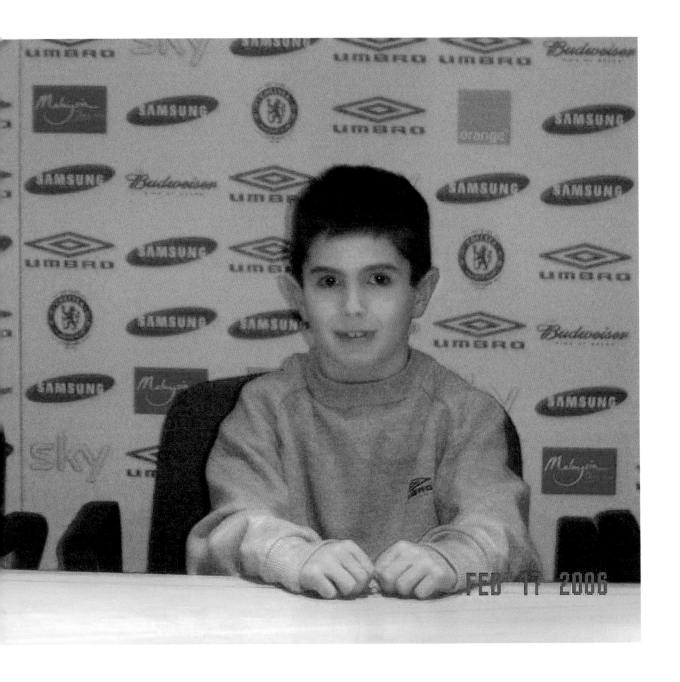

Above: My first visit to Chelsea's media room, Stamford Bridge, London, England, February 17, 2006.
Opposite: Standing in front of Frank Lampard and the Chelsea 2004 and 2005 Premier League winning team, Stamford Bridge, February 17, 2006.

Yeah, I went with my dad to see a few games. I saw Chelsea play, we also went to a Manchester United match, those were the two main ones I remember. I just thought how incredible it was to play in a stadium in front of a big crowd of people. It was really fascinating and I thought, Wow, it would be so cool to do this one day.

You visited Chelsea's training ground during that year back in 2006. What was that like? Did you get to meet any players?

No, I didn't meet any players or management, I just saw the grounds.

What did you think of the facilities? Did you visit Cobham and Stamford Bridge?

I saw both Cobham and Stamford Bridge and obviously they were really nice; to see at that age a stadium like that and the support and everything. Cobham was the best training facility I'd seen—they really took care of it.

Later that year—you were seven at the time—you went on a family holiday to Spain, like a lot of English families, but you went to Barcelona and saw a game at Camp Nou. What do you remember from that experience?

I don't remember the game itself, but I remember walking through the museum outside the Barcelona stadium and seeing all the trophies and walking through Barcelona with my family—it was amazing—I remember I had my Barca jersey on. Barcelona as a city, and being outside the stadium, was really cool.

Who were you most excited to see?

Ronaldinho.

He's a favorite of mine too. Figo had left for Inter Milan by that point.

Ronaldinho was the man.

Ronaldinho was amazing. And he played with such joy.

Yeah, some of the skills he did were incredible—he was the one I was looking forward to seeing.

When you returned to the US from England your dad got a position as head coach of the indoor team Detroit Ignition, so you lived in Detroit and you played for Michigan Rush—you were still seven years old. What was it like transferring from Brackley Town to Michigan Rush?

It was tough. Every time we moved, we had to go to a new school and make new friends. From a soccer side it was OK. I remember going into Michigan Rush, I was a little bit nervous. I didn't really know what to expect, but I ended up really enjoying the team that year. It was a pretty smooth transition so I enjoyed it.

What was Michigan Rush? Was it a U.S. Soccer Development Academy club?

I don't know exactly what it was considered, but it was a local travel team. We played against other towns within the area. We wouldn't travel crazy far, but we would travel around a bit.

Did you get to join in on the training sessions with the Detroit Ignition players?

I definitely got to go to some of the training sessions and watch with my dad. Obviously, I was super young and they were pros but I would kick around with them after training.

Would they teach you tricks?

Yeah, it was really cool. They had some Brazilians on their team and they would show me tricks and different things. I always thought that was pretty sweet.

How was the level of play at Michigan Rush compared to that in England?

I think in Michigan I started playing up a couple of years so the level was good.

What was Detroit like? And how was school?

It was good. I went to Workman Elementary [School]. I remember it was a brand-new school. Going there was tough at first, being new to the area and trying to meet people, but the school was really fun. I made some very cool friends and ended up loving Michigan. I didn't want to leave once again, but we did so it's funny how it works out.

Following page: After returning to the US in the summer of 2006, we went back to England for two weeks a year later and traveled to Belgium with Brackley Town to play in a tournament. This is the away-team bench, but we're wearing Brackley Town's home colors—red and white stripes, Limburg, Belgium, May 5, 2007.
Page 37: Michigan Rush team photo, Northville, Michigan, spring 2008.

You like Quinn XCII, who's from Detroit, and the comedian Lincoln aka Shy Awkward Guy, who's also based in Detroit; do you now have a soft spot for everything Detroit?

I'll always like Michigan and Detroit. I mean it's part of my story, it was home for a bit, so I still have a few friends who I try to keep in touch with from there. I'd love to go back one day but it's hard to find the time to do that.

In 2009, you moved back to your hometown of Hershey and started playing for PA Classics. You'd played on the Junior Classics team before leaving for England. The pitches at PA Classics and the surrounding area feel similar to some parts of the UK countryside.

I've always loved that area. Lancaster and that part of Pennsylvania is known for driving through cornfields and farms. You're not going to find that in some of the bigger clubs—the Phillies, the New Yorks. That is pretty special to PA Classics. People know it as farmland. That's Lancaster.

How often would you be at the club?

Pretty much every day after school. I'd drive with my dad. He was coaching there, and I would play there. We would be there for hours most days after school.

How many years did you play for them?

After Michigan I moved to Pennsylvania at age ten and played for PA Classics until I was fourteen or fifteen, and that's when I moved down to Florida permanently to play with the youth national team. So a good few years.

Did you have many coaches during your time there?

My dad was a coach for a bit when I first went back. Steve Klein was my coach for awhile. I remember a guy named Aleks Radovic was a coach of mine when I was younger who I liked a lot. Steve Klein basically runs the club at PA Classics still, and he's a good friend of ours.

What position did you play? Attacking midfielder?

Yeah, I started to play a lot as a winger as well, on the left wing, and filled in on all the attacking roles really.

What teams would you play against?

In that academy league there were teams all the way from New York to Virginia down in Richmond. And then if you made it into the playoffs, you could play teams from all over the country at some point. You'd meet up somewhere and play them.

Were there any heated rivalries?

I remember playing against FC Delco, which was a rival of PA Classics back in the day. FC Delco was one team we'd always have good battles with. That was a PA rivalry.

While you were playing for PA Classics, thanks to coaching contacts of your dad, you went back to Barcelona but this time it wasn't just to see a game; you trained at their academy—La Masia. What was that like?

That was amazing. It's funny looking back. . . . I remember being so nervous to go there. I was worried that maybe I wasn't good enough. I don't know, it was Barcelona, a huge club, but I went in and tried to enjoy it as best as I could. I loved it in the end, so it was just an amazing experience that I took with me. The facilities were incredible and the level was really high and I loved it.

Scoring for PA Classics, Manheim, Pennsylvania, spring 2010.

You were eleven at the time. Were you training with kids your age?

Yeah, I think I trained with kids my age and with an age group above.

Did you get to meet any Barca players?

Not first team players, no.

Did you learn new drills there?

There was a lot of training in very small areas, which was kind of a surprise to me. All the fields they had were very small, in tight spaces.

To try to cultivate and promote close touch?

Yeah.

Did anything the coaches say stand out? Actually, did you understand anything? Wasn't the coaching all in Spanish?

Yeah, my Spanish wasn't very good at the time, so I didn't understand much.

Barcelona invited you back two more times. Were you excited to go?

Yeah, I was always excited. I was also a bit nervous, I remember, but I loved it and had really amazing experiences there. I feel like I learned a lot in those short weeks.

How long were you there for on those trips?

They were a week each.

It was your first taste of playing in a non-English speaking environment. Sí?

Sí.

In 2010 you also went back to Chelsea's training

grounds at Cobham. But this time you got to train there for a week.

Yeah, I trained at Cobham with the youth Chelsea teams. I don't really know how it was all arranged, but it is cool to see looking back at that now.

How did the trial go and what did it involve? Did you feel like you'd fit right in?

I remember playing in a friendly tournament. I felt like I could hang at that level with those kids. I was very confident and I was a good young player. I thought I did really well, to be honest, when playing at these academies.

Yeah, I've seen videos of you bamboozling defenders twice your size, so I'm sure you were great. It seems like a move to Chelsea was always in the cards then?

I think I always wanted to play in England one day. Once I got the offer from Chelsea, it was just like I really wanted to do it. It was meant to be, I guess.

So back to your hometown and PA Classics. How did it feel to open your training grounds at PA Classics Soccer Park in 2021?

Going back was special. I was really happy I could give back. Inspiring one kid is amazing and

to be able to inspire all those kids and see my name on their jerseys—it really just makes me happy and is pretty incredible.

A bunch of those kids wearing your jersey grilled you for a good ten minutes . . .

Yes! It was a fun day for sure.

Top: Training at Barcelona's La Masia academy, Barcelona, Spain, October 21, 2009.
Right: Playing at Chelsea's training ground, Cobham, England, May 8, 2010.
Following pages: A week of training at Cobham in May 2010, when I met my future teammate Mason Mount for the first time. He had longer hair back then.

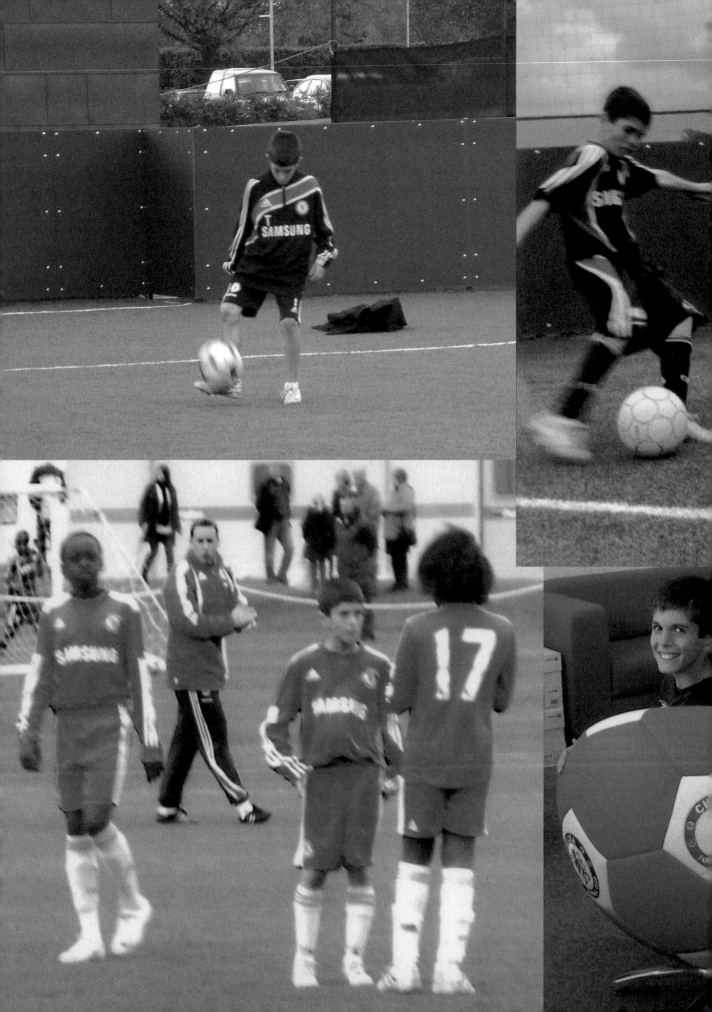

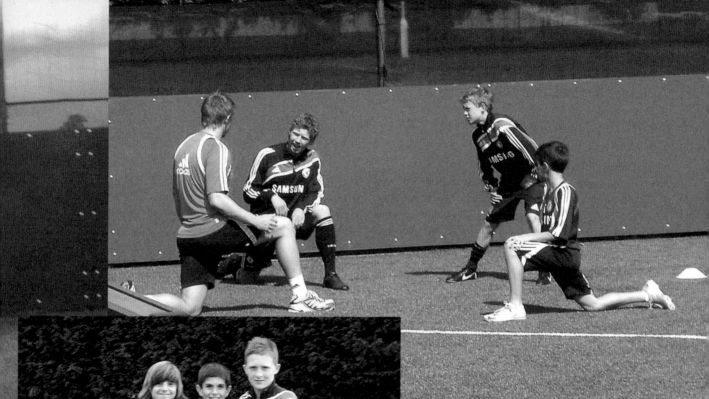

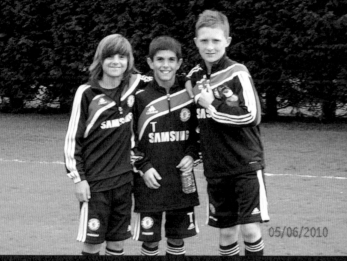

05/06/2010

WELCOME TO WOR

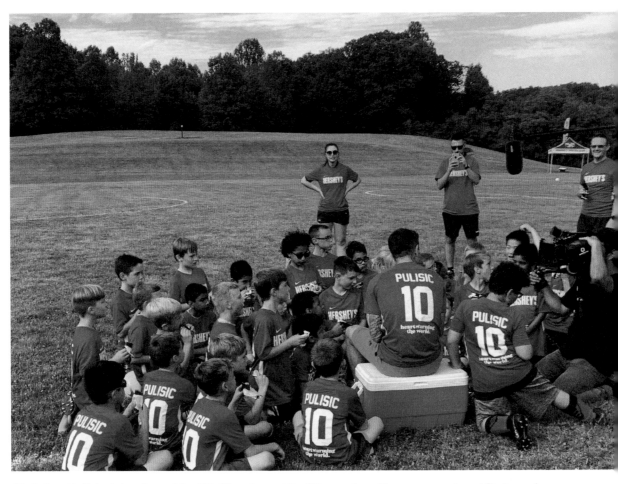

Christian Pulisic interviewed by PA Classics youth players, July 11, 2021.

Why have you picked the numbers you've had on your jerseys?

That's a great question. Actually, does anyone know the number that I wore at Classics?

22! 10!

No, I said at Classics, when I was younger, when I was your age. Whoever gets it, gets a ball.

19, 28, 2!, 49, 12, 27, 13!, 9!, 3!

No one's got it right.

47!, 24!, 23!, 4!

No more guessing!!

7, 8!

OK, he got it! How did you get it?

I guessed.

Lucky guess. I wore 8—that was my dad's number, and I wore it at Classics for a long time. I switched to 10 because 10's always been my favorite number.

I like 22 as well and it was my number at Dortmund, but 10's my favorite so I switched.

What has been the biggest challenge you've had to face?

Probably going to Germany at fifteen years old, leaving America, leaving my family and friends and going over to a new country and trying to make it over there was really tough for me. I didn't speak the language at all, there were a lot of tough things, but I had to stick it out because I really wanted to make it.

How is your diet now compared to when you were younger?

Right now is my off-season, so probably similar to when I was younger. But I have a chef actually over in London who comes to cook for me every day; I try to eat very healthy and make sure I put the right things in my body. It is important. As you get older you start to realize.

Make sure you eat broccoli.

Another Q&A with youth soccer players at a Hershey-organized event in Shank Park, Hummelstown, Pennsylvania, May 24, 2019.

Do you like cheeseburgers?
I love cheeseburgers, I had one last night.
Where do you live?
Most of the year I live in London, which is where Chelsea is. That's where we play. So I live there most of the time. But I'm from around here; my family lives around here. It's my hometown.
Is it hard to be on two teams based in two different countries?
Yeah, it's a lot of travel sometimes. Most of the year I'm based in London, but right after the Champions League final in Porto I had to travel to Denver the next day, so it can be a lot of travel.
What do you do to help train?
During the season I train for the team every single day, and when it's the off-season I normally have some trainers and coaches to come and work with me personally. So yeah, I'm always trying to get better really.
What was it like for your parents when you went to Germany?
You'll have to ask them. They're here somewhere. I'm sure it was tough. My dad came with me the first couple of years, which was nice, but yeah it was tough. It was tough to leave the family.
Do you prefer playing in the center of the field or on the wing?
I like both. I'd probably say the center a bit more. And when on the wing more so on the left side than on the right.

Who are your best friends at Chelsea?
Do you guys know N'Golo Kanté?
Yeah, yeah!
He's my best friend. Also, Christensen and a lot of the younger English guys.

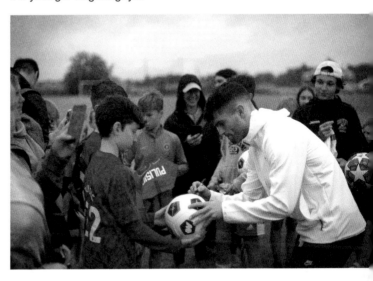

Billy Gilmour?
Yeah, Billy!
What do you plan on doing after soccer?
[Christian hands the boy a football.] Hopefully I still have a long time to go until then, but probably stay in the game. I love working with kids, especially in soccer, so maybe something to do with that.
That makes sense.
Do you ever have free time?
Well, yeah, actually right now is my free time, now that the season is over at Chelsea and I had my last national team game the other day. I have just a couple of weeks off before I have to go back and start preseason again in London, so right now is my time off.
When you were younger, did you ever think you would be as high a level as you are now?
It was always my dream to play professional soccer in Europe. I had never thought it would happen like it did, I would say, but I wanted it to. I worked really hard because that was my

Top: Signing balls and jerseys at the opening of new training facilities at PA Classics Soccer Park, Manheim, Pennsylvania, July 11, 2021.
Bottom: With PA Junior Classics teammates when I was six years old, Manheim, Pennsylvania, July 10, 2005.

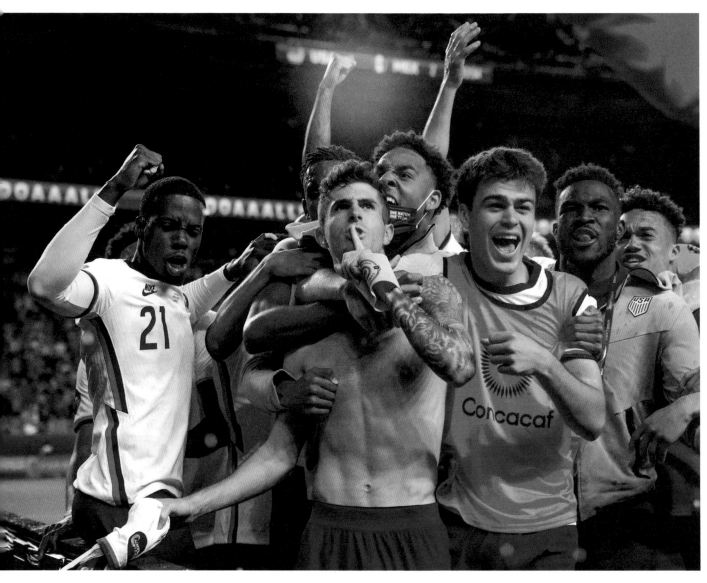

dream. So yeah, it's pretty cool that it came true.
How many hours in total do you think you travel?
That's a great question. I don't even know. When I fly over to London the average flight is like maybe eight hours, so going back and forth you can imagine that's a lot of hours.
Is it basically like going to Las Vegas then?
I'd like to go to Vegas.
How did you get into soccer? Who inspired you?
Definitely my parents. Both my parents played the game. They met in college. They both played soccer there. They were the ones who showed me the game from a very young age, but then there have been a lot of people who I have looked up to and players who I love to watch.
Do you like playing more for Chelsea or for the national team?
I love playing for both, to be honest. Chelsea's fun for sure, and then playing for your country is also pretty special.
I know I've missed a lot of penalties, I was wondering how many penalties you've missed?
I've missed a few in my day. Don't worry, it happens to the best of us. When you go up and take a penalty you have to be confident. Sometimes you miss, I've missed countless times . . . in my youth days I remember I would miss and I'd be so upset, but there's always the next one.

Right after taking the penalty against Mexico during extra time in the Concacaf Nations League final, Empower Field at Mile High, Denver, Colorado, June 6, 2021.

How old do you think you'll be when you stop playing?

I'm twenty-two now and I think a lot of players continue playing until they're . . .

Forty?

Getting up toward forty; thirty-six, thirty-seven, getting up there.

What team is the hardest to play against?

There are some really good teams in England. Liverpool is always tough. Man City is really good. There are a lot of tough teams to play against.

When you took the penalty against Mexico, did you know you were going to go top right?

I wanted to go top corner. I don't know why. I was just feeling confident. I actually walked over to my teammate beforehand and told him to pick a side. And he said, "Go right." And I said, "Alright."

Who did you ask?

It's a secret. And, yeah, I just went for it.

When you go up against Man City and Kevin De Bruyne, what's your mentality?

We know Man City is a tough team to play against. You know that you're not going to have the ball a lot because they love to be on the ball. They pass a lot. And it's a lot of defending. So for me, personally, it's preparing for those moments when we do get the ball and transition and being ready all the time. They're not perfect as well. They make mistakes. You have to capitalize on that.

When you're playing in a game like in the final against Mexico where people are throwing things on the pitch, how do you stay calm?

You don't really. The atmosphere is crazy in those games. I've experienced those types of games before. You're right, it's about just keeping cool and keeping your head because when you've got beer and cups flying at you, it can be a lot. So it's about just trying to stay cool in those moments.

What are your favorite sports other than soccer?

I would say basketball or golf, probably.

What was going through your mind after you won the Champions League final?

It was one of the proudest days of my life. It was just incredible. I had my family there with me. I was thinking about my youth days and all the hard work that I had to put in to get there. And it was a really proud moment for me.

What's it like to overcome injuries?

That's a great question. It's part of the game. You've got to make sure that you stay strong mentally because you can get really down. Me personally, I get really down because all I want to do is play. But when an injury is holding you back, it's hard. It's just about recovering well and focusing on that next game.

How many games have you won?

This season, a lot. We won a lot of games. It was a good year.

How does it feel winning against Man City, who have such good players and a very good coach?

It feels amazing. They're obviously a really strong team, so to be able to beat them a couple of times this season is a great feeling.

[Kelley Pulisic walks over to hand her son Christian his Champions League and Nations League medals.] Here's the Champions League medal, here's the Nations League. Two pretty amazing things.

Are they real?

Oh, they're real.

Are you giving those away too?

These stay with me.

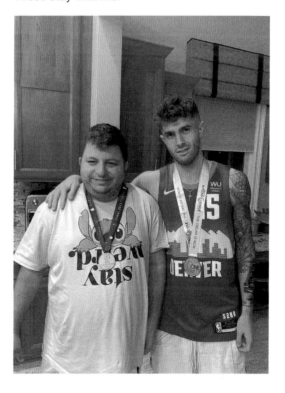

Above: With my brother, Chase, in my parents' kitchen wearing the Nations League and Champions League winner's medals, Lebanon, Pennsylvania, June 10, 2021.

Following pages: Dribbling with the ball during the Concacaf Nations League final, Empower Field at Mile High, Denver, Colorado, June 6, 2021.

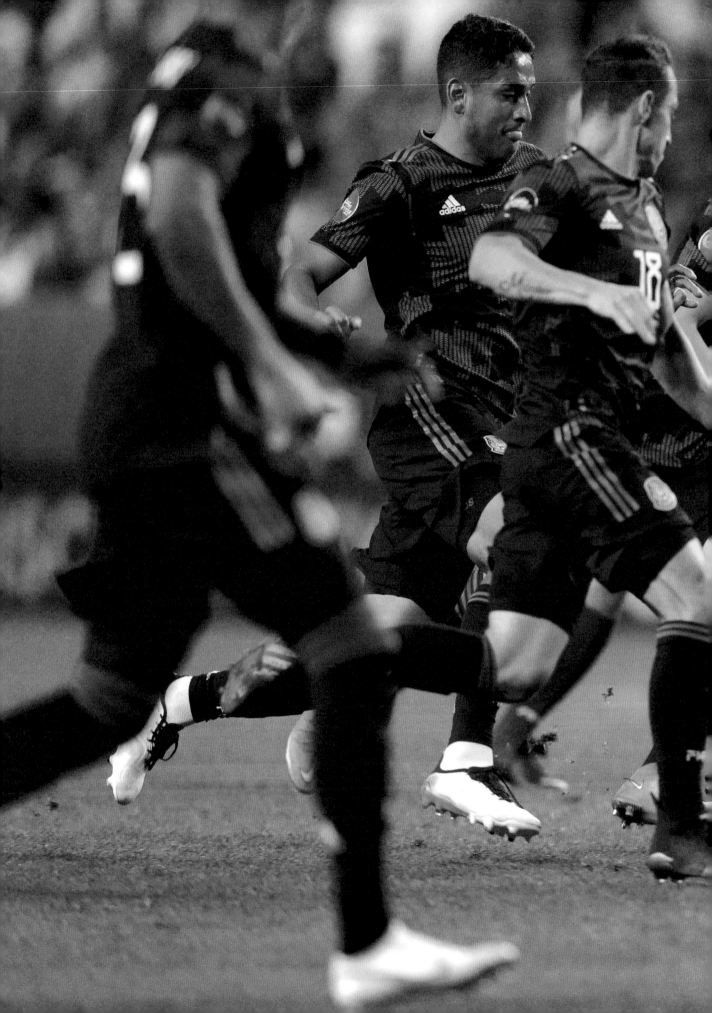

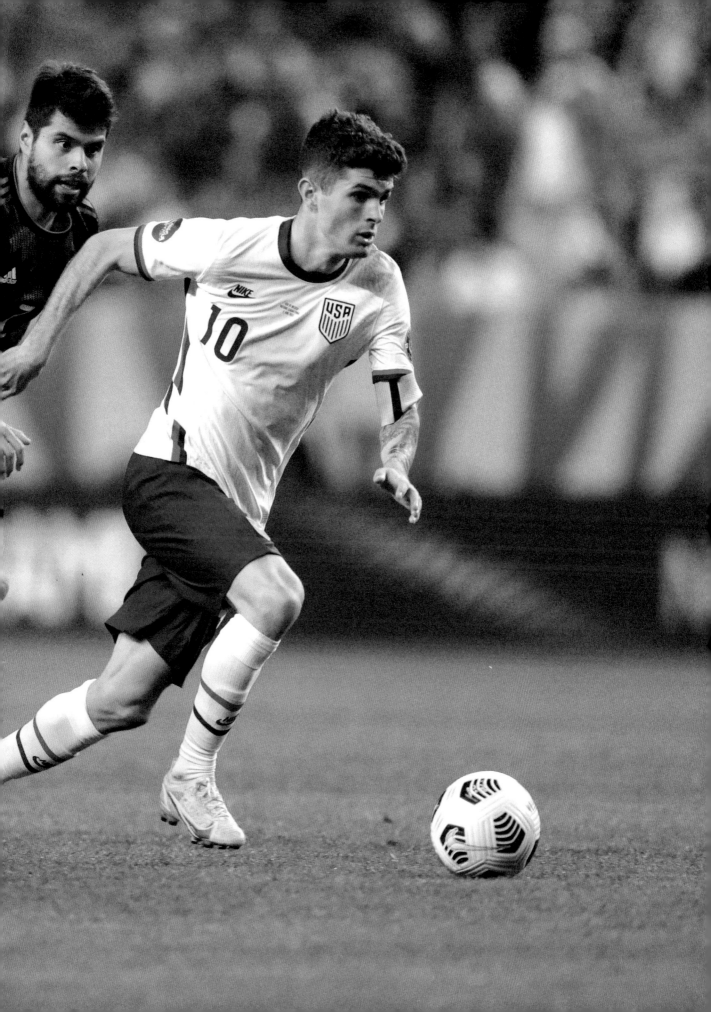

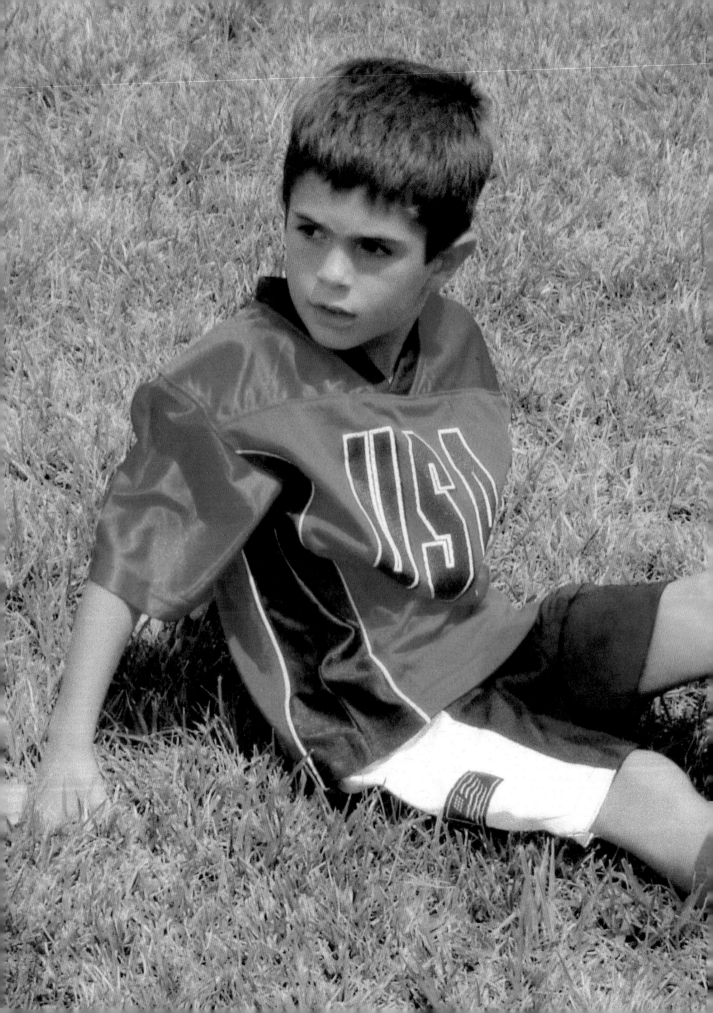

CAPTAIN AMERICA

Our conversation continued on February 8, 2022, over Zoom, while Christian was in Abu Dhabi training with Chelsea less than a week after scoring against Honduras in the third of three World Cup qualifiers with the US national team.

Good to see you!
Hello! Good to see you!
What's it like going from freezing Minnesota to the heat of Abu Dhabi?
Yeah, it's a bit crazy. I like the temperature here. It's 70 degrees Fahrenheit. Which is like what, 25?
Oh, nice. So do you think in Fahrenheit or Celsius now?
I'm still more used to Fahrenheit, to be honest. They use Celsius over here.
What's the ideal temperature to play soccer in?
I'd say the temperature here. I like warm weather.
So you were just with the US team. What's it like when you get to see each other? Is it all business or do you goof around too?
I'm really close with my national team teammates, so we definitely have a good time. But we have to focus when the games come up, and we haven't been able to go out and do so much with Covid and everything. It's kind of strict.
Do you stay in touch with any members of the national team during the year when you're not playing together?

Yeah, we're all really close. I think I stay in touch with a good amount of them. We keep track of what each other is doing and we'll watch each other play and communicate. I think a lot of us like to stay in touch.
The US team is on a twenty-two-game unbeaten home streak. Do players use that kind of stat as extra motivation?
I don't think we really think about that at all, to be honest. We just take it game by game. And we're really just trying to win every game. That's our mentality.
At the beginning of every game you sing the national anthem. Who's the best singer on the US team?
That's a good question. I don't think we have a lot of good singers on this team [laughter]. There's no one that stands out as the best.
And as the worst?
Not really, to be honest. We're all pretty bad.
Well, you've had quite a bit of practice. You got your first call-up for the national team, at Under-15 level, when you were thirteen. How did you hear about it? Do you remember what you were doing at the time?
I don't remember getting the call-up, but I remember going to camp, and I was really nervous. These kids were bigger, stronger, and it's the national team. I was always nervous to go to camps, but I learned a lot. It was a cool experience.

Opposite: Taking a breather, Hershey, Pennsylvania, July 8, 2004.
Following pages: Age fifteen lining up with the US Under-17 team and Croatia Under-17s, Gorizia, Italy, fall 2013.

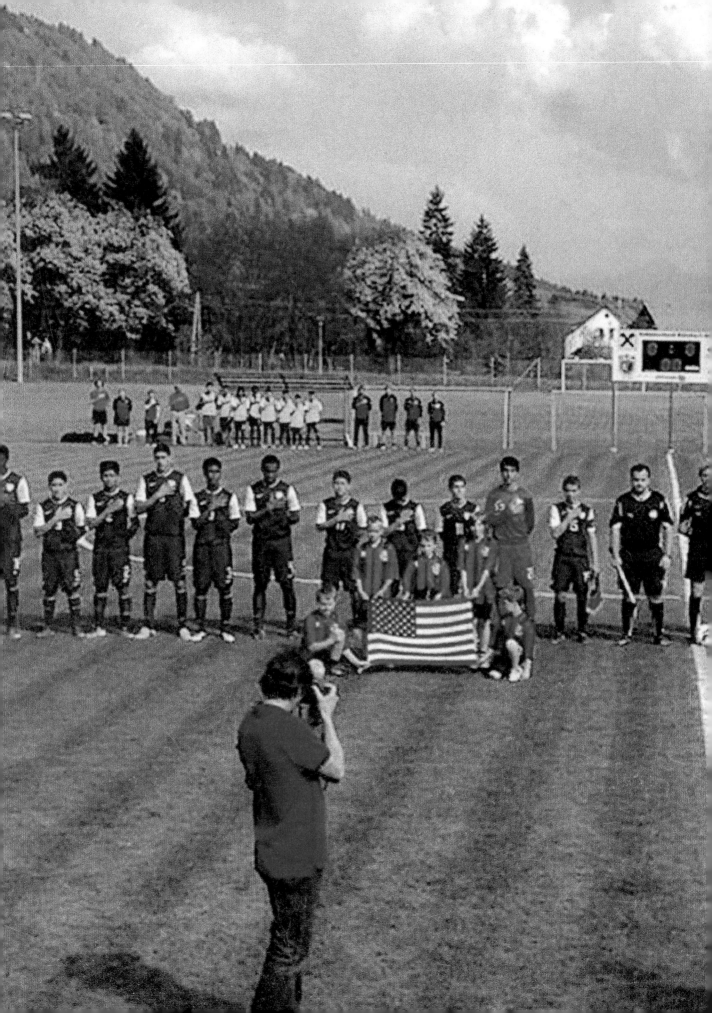

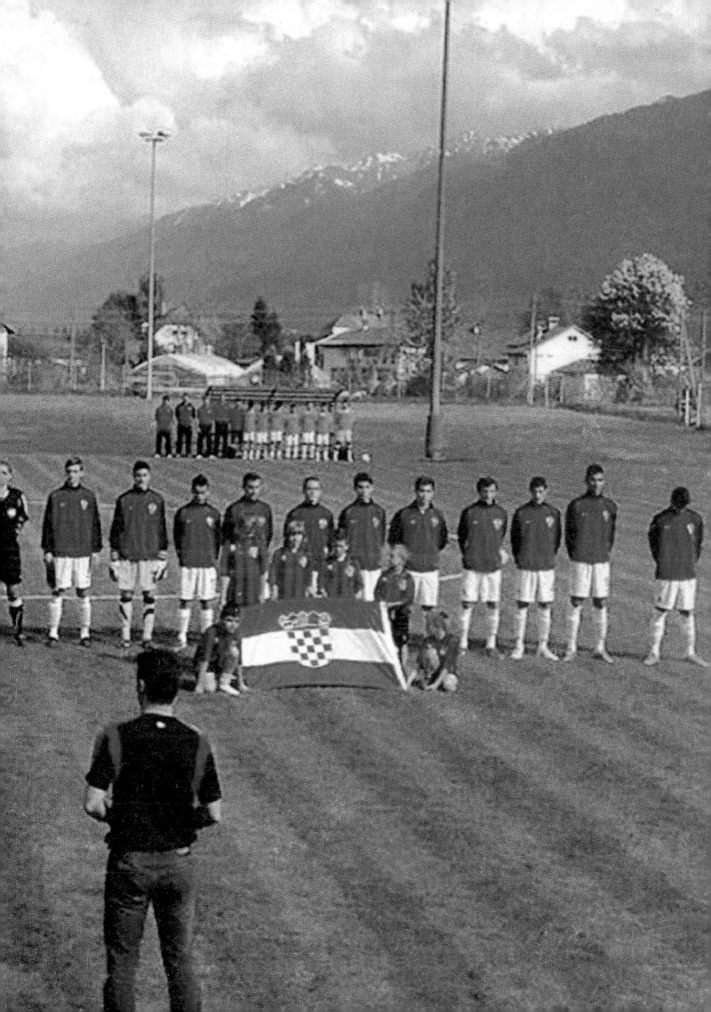

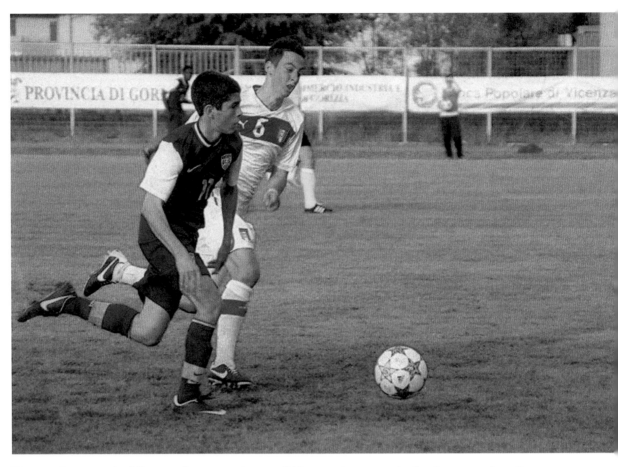

Was getting onto the US team the moment you realized you were really going to make it as a professional soccer player, or did you always have that belief?

I wouldn't say that that was the time; it was a bit later when I felt that I can make it pro, I can make it, I can really do big things. I always said I wanted to be a pro. I wanted to play soccer. But it came, I think, a little bit later in 2013 or so, when I really thought, Now is when I need to start my professional career and I know I can do this.

Was training with the national team at a higher level than you'd experienced before?

It was definitely the highest level that I had experienced at that time. There were really good players for sure.

Do you still have your first US jersey?

Not from the youth camps. We didn't keep our jerseys, but I have the shirts from some of my debuts with the full national team, my mom has them at least.

Did you get some sort of welcome package?

They must have sent us a bunch of stuff from Nike. We always get clothes when we first go to a camp; everyone has to wear the same outfits so, yeah, we always got some cool gear. They would send you boots as well, and they were always fun to receive.

During the match for the 2021 Super Cup you were wearing stars-and-stripes shin pads. How long have you worn them?

I started wearing them toward the end of last season.

How often do you change your shin pads?

It's actually the one thing I pretty much never change. I'm not big on which ones I wear, so I just wear them and the kit men keep them. I wear pretty much the same ones every game. But I'm not superstitious or something like that. I wear new stuff too.

What country did you play against in your first game for the US Under-15s?

Playing for the US Under-17 team against Italy in the Trofeo Nereo Rocco tournament, Gorizia, Italy, fall 2013.

With the youth teams, when we went to those youth national team camps we wouldn't usually play against other countries, it would be teams from around California and the area where we were training, often older teams.

Would you play against clubs from other countries?

Sometimes, yeah, like clubs from Mexico.

And did you play in attacking positions?

Yeah, either as an attacking midfielder or a winger.

What did it feel like playing for your country? Were you nervous?

I was definitely more nervous than playing at club level, like at PA Classics where I was very comfortable. I wanted to have a good showing, you know. It was really important to me. I wanted to be on the national team and I wanted to do well. So yeah, definitely nervous.

While training and playing for the US team you were still with PA Classics. Did you spend all of your time focusing on soccer, or would you occasionally go out with friends from school?

I would say that I was a pretty normal kid. I would hang out with my friends after school and we would play all different kinds of sports. My life was not only soccer all of the time, to be honest. I did a lot of other things that I wanted to do, like what my friends were doing, playing different games, obviously going to school, and yeah

there were a lot of things that I enjoyed doing.

Nice, so it felt balanced, you didn't feel like you were sacrificing anything?

At that age I was never putting so much pressure on myself to play; it wasn't all the time soccer.

Did you have any jobs growing up?

You see that was the one thing I was kind of ashamed of. I never really did. I mean, I moved away from home when I was fourteen and I was doing soccer full-time. I never had an actual job like a lot of kids used to.

Well, you were pretty busy. Not a lot of kids have something going on that requires so much time.

Yeah.

And yes, you were only fourteen when you moved to Florida to live at the US Under-17 National Team Residency Program in Bradenton. Did you go alone or with your family?

Alone with the team.

What was the accommodation like? Did you have roommates?

Yeah, we had a couple of roommates. I was at IMG Academy in Bradenton, and we all went down there. We had our own dorms and our little section for our team. It was very cool. We went to school there and trained every morning. It was fun.

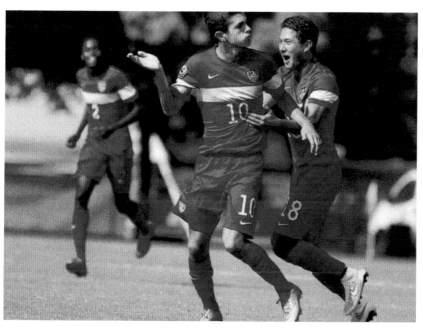

Top: On our way to South Beach to play Canada with US Under-17 teammate Logan Panchot, Bradenton, Florida, spring 2014.
Bottom: Celebrating scoring with U-17 teammates Matthew Olosunde (left) and Josh Perez (right), Lakewood Ranch, Sarasota, Florida, fall 2014.

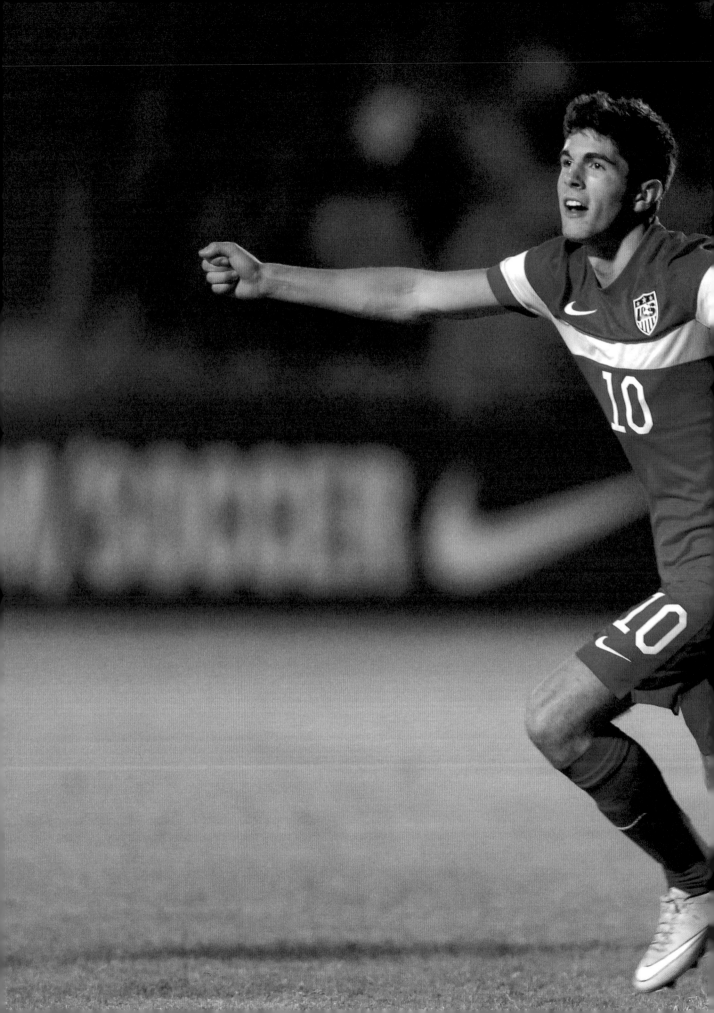

Did you know any of the players before arriving?
I'd been in the youth national teams with a lot of those guys, so I knew most of them actually.
Are you still in touch with anyone from that time?
My cousin Will [Pulisic] was on the team; he was the goalkeeper and he's now a goalkeeper at the MLS [Major League Soccer] club Austin FC. He was one of my roommates. I actually have two friends staying with me right now, Terrell Lowe and Raheem Taylor-Parkes, who were living there at the residency in Florida. I'm in touch with a lot of them.
Nice. Did many of them continue playing soccer?
A good amount of them continued in soccer and play in USL [United Soccer League], MLS, in Europe even. Terrell and Raheem played Division I at UVA [University of Virginia]. Some of them have moved on and done other things.
I met Nick Taitague, who was really nice, in Lancaster, PA. When he was in Germany playing for Schalke and you were at Dortmund, did you ever meet up?
All the time. Yeah, we were best friends.
I chatted with Andre Kin too—also incredibly easy to talk to.
Yep, he's a good friend of mine. We played at PA Classics.
You seem to surround yourself with really authentic and kind people.
Yeah. I have a small circle I would say, but they're good friends.
What was the training schedule in Bradenton?
We'd train every morning. It started at 9 or 10, and then after that we would go to school for the rest of the day and at night we would chill.
At fifteen you captained the US Under-17 team. And that year, in 2013, there was one game in particular that announced you to the world stage. The US played Brazil in the final of the Nike International U-17 Showcase. The US won 4–1 and you were the MVP. What do you remember about that match?
That was the match when I really felt like I could play at the highest level, that I could do this. I wanted to become a professional, I wanted to eventually move to Europe, that was my whole plan. So that day was a massive day that

changed my life. I actually have that date tattooed on my arm, the day we won the final.
In roman numerals?
Yeah. 12/13/2013.
After that game your family got a lot of calls from clubs around the world. What was that time like?
My parents, my agency who I signed with at about that time, and I were looking at my options and seeing where in Europe I felt was best and what exactly was the right time to go. When the offer from Dortmund came in I felt like the timing was right, the whole situation there was right, everything seemed like it was falling into place.
You took a free kick against Tottenham's U-18 side on December 20, 2013, for the US. It was at least thirty yards from goal and you curl it up over the wall into the top left-hand corner. It's as good a free kick as anyone can do, and you were fifteen. How often would you practice taking long-range free kicks?
A good amount for sure. Pretty much always the day before games I would practice free kicks.
And you'd do that from the age of eight or nine?
I'd say a little bit older than that is when I started to work on free kicks specifically.
How often would the US youth side play youth club teams from England?
Not too often. When we were in Bradenton we'd usually play against local teams that were older.

Preceding pages: Celebrating scoring against England (William Patching #18 behind me) during the Nike International Friendlies at the Premier Sports Campus, Lakewood Ranch, Sarasota, Florida, November 28, 2014.
Above: With my cousin Will Pulisic at the IMG Academy, Bradenton, Florida, spring 2014.

We only played against a couple of English teams. I remember that Tottenham match was a tournament game.

What lessons did you learn from the US youth team experience?

I learned a lot. I mean I was playing with some of the best players of my age in the country. From being one of the better players on my local team and then coming in and playing with really great players. There were times when I had to adapt and figure out how to play with other players who were very strong at the time. It was a really good experience, especially living down in Florida with them and getting to play with them on a daily basis.

Where were you and how did you find out you were getting your first cap for the US men's team? What were you doing? Who told you? What was it like? What happened?

The first time I got called up, it was after playing some games for the Dortmund first team, and Jürgen Klinsmann [the US team coach at the time] contacted me. I think it was by email first, and then he called me and told me that they were calling me into camp for one of the World Cup qualifiers. I didn't know if I was going to play or anything; I was just really excited to go and train.

Do you remember your very first training session with the men's team?

Yeah, my first trainings with the men's national team were in Columbus [Ohio]. It was really cool. I was the youngest by far. I was a bit nervous, but it was surreal to be playing with some of my heroes and the guys on the team. It was just a really amazing experience for me.

Was there anyone in particular who you were really excited to train with?

I was a big fan of Clint Dempsey. So seeing him up close and getting to play with him and train with him was really amazing. So I was definitely excited about that.

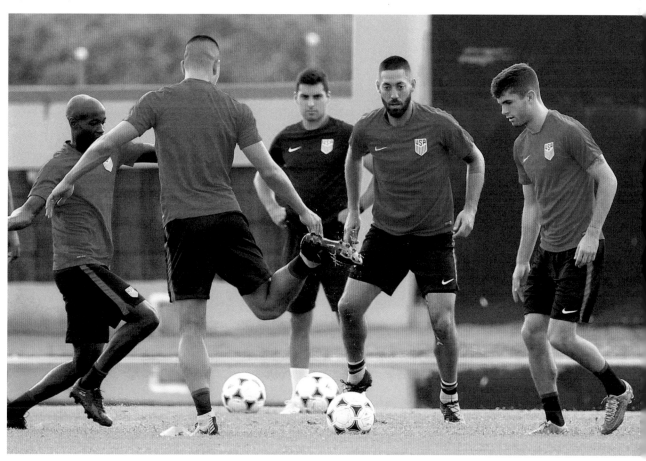

Practice with Clint Dempsey, Bobby Wood, and DaMarcus Beasley during a men's national team training session, Ato Boldon Stadium, Couva, Trinidad and Tobago, October 9, 2017.

What was it like meeting Jürgen Klinsmann?

He was a really nice guy. I didn't know a whole lot about him besides he had a good career. Obviously I had watched the team play in the World Cup and I respected him a lot. To be honest, he took really good care of me and was very nice to me. He brought me into the team slowly and trusted me and, yeah, I really only have good things to say about him.

What was the atmosphere like in your first training session with them?

It was definitely serious. I was very focused, and I wanted to make a good impression on the team and on the coach. But all the guys were really nice to me away from the pitch and they were all just really good guys. I was used to the intensity of training in Dortmund at the time. Everyone is competing. But that's how I am. That's how I like it. So it was quite normal.

How was playing in your first game for the US men's team on March 29, 2016, just two days after training with them for the first time?

So I went to Columbus to train with the team and once the game hit, I really didn't know I was going to play until Klinsmann called me over in the second half—I don't remember what minute—but he called me over and said, "You're going in." And that was how it happened.

Dribbling on the left wing during my debut for the men's national team, the 2018 World Cup qualifier against Guatemala at Mapfre Stadium in Columbus, Ohio, March 29, 2016. I wore the number 11 jersey for a while for the youth and men's national teams.

Was your heart racing? What do you remember from that game?

I think it was a whole other sense of pride playing for your country for the first time. It's a huge honor. It's different than playing for your club, you're representing your country at the highest level and trying to help them go to the World Cup. So I was just really honored and I was excited for the opportunity. I had always wanted to be there, so it felt like I had reached a certain goal that I had always shot for.

On May 28, 2016, at the age of seventeen, you came on as a substitute in the sixty-third minute against Bolivia and then just six minutes later you became the youngest goal scorer in the history of US men's national team soccer. What was it like scoring your first goal for the US?

I remember that moment quite vividly, obviously, with it being my first goal and just a really exciting day for me. I remember preparing for Copa America and being with the team. I don't remember every goal, but I remember that goal against Bolivia for sure.

Which do you recall more vividly, the goal or your prom the night before?

[Laughter] I mean both are really good moments. Obviously the goal and the game is what sticks out, but it was honestly just a cool experience

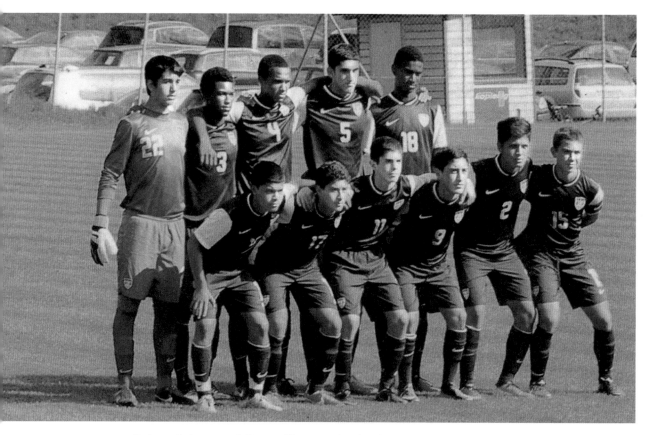

overall to get to spend time with my school friends and then go and play the next day. It was very cool.

You had to clear it with Jürgen Klinsmann first?

Yeah, I had to clear it with Klinsmann and he was very nice about it. It was quite the weekend for sure.

On September 2, 2016, you put on the number 10 jersey for the first time for the US men's team, and you've worn it when playing for the US ever since. The match was against St. Vincent and the Grenadines at Arnos Vale Stadium—a converted cricket field—in Kingston, St. Vincent, and you scored two goals.

That was quite the trip. We traveled to St. Vincent and the Grenadines—it's a very small country and we had to get there in really small planes—and then we landed in St. Vincent and played on a pitch that was, well, not very good. I came on as a sub in [the sixty-seventh minute of] the second half, and my first goal was a few minutes later [in the seventy-first minute]; Sacha [Kljestan] drilled a pass to me while I was running close to full speed on goal, and I controlled the ball with the outside of my right foot, touching it forward into my path. Then I passed it into the bottom right-hand corner of the net with my left. Just a few minutes later, I squared the ball to Sacha for him to score. Then in [the second minute of] stoppage time, I found space and was open at the top of the box where I received the ball, stopping it with the inside of my right foot. Then with my right foot again, I curled it just inside the far post. That one stands out because I feel like I don't score a lot of goals like that. It was a memorable one for sure.

You wear the number 10 for the US and for Chelsea. Did you always want that shirt?

I don't know about always. I wore the number 8 growing up, that was the number I liked. But with the youth national team I just kind of naturally played in the number 10 position, and so I started to wear number 10 for the youth national team. I grew into it, and then I was offered the number 10 for the full national team and I just started to really like the number. Then it came naturally at

US Under-17 team photo, Gorizia, Italy, fall 2013.

Chelsea, too, so it's become a number I really like.

Traditional number 10s roam the midfield area looking to orchestrate play and connect others, whereas you and some other modern-day attacking midfielders are more direct and go on more forward runs that break the defensive line.

I've naturally always been quite direct. I played as a winger a lot growing up and in central midfield. I think I have good dribbling skills, attacking skills. I'm very direct and I kind of use that to my advantage. Maybe I'm not a natural number 10 in the sense of the position, but I think I have qualities suited for multiple positions.

Absolutely. You regularly change a game by providing an assist. On March 28, 2017, in a physical match against Panama at the Estadio Rommel Fernández Stadium in Panama City, you chase down and steal the ball from defender Felipe Baloy just inside the penalty area. Then you dribble first with your left foot then with your right toward the goal, where center-back Román Torres blocks your path until you turn toward the touchline. Then you stop abruptly, opening your body, destabilizing Torres, and allowing you the space to square the ball with your left foot five yards to a wide-open Clint Dempsey, who passes it into the net. Did creating that goal feel the same as scoring?

That was one of my favorite assists, for sure. In that environment, in a very physical game, pressing and winning that ball and then kind of cutting

and playing a ball back to Dempsey, who was one of the guys I loved watching the most and my favorite US player, felt incredible. In a World Cup qualifier, yeah, that was definitely a special moment and one of my most memorable assists I would say. 100 percent.

At what point did you know you were going to pass to Dempsey?

Well, I definitely saw him there as soon as I looked up after winning the ball from the defender. I did not really have an angle to shoot and I saw I had to cut back because everything was being blocked, so I cut back and I saw him open right there. It was kind of a clear decision in my head that the ball had to go to him at the time.

That game ended 1–1, but later in 2017, on October 6, you played Panama again in another World Cup qualifier in Orlando [at Exploria Stadium] and won 4–0. You scored in the seventh minute.

We needed a win. And we were very focused going into that game. I was running down the center in anticipation of a through ball, and there's a defender [Román Torres] right on my back and three more Panama players very close by; the pass comes and it's just a bit behind me, so I hooked it forward with my left foot so I could take it in stride and beyond a tackle from Torres. Then the goalkeeper [Jaime Penedo] runs off his line, so I took it wide to my right and passed it into the net at a pretty tight angle. It felt like a huge goal, and that was one of my favorite celebrations. The feeling after scoring that goal because of the importance of it. Unfortunately we didn't get the job done after that, but it was still a very big moment for me.

On November 20, 2018, in a match against Italy at Luminus Arena in Genk, Belgium, you captained the US men's team for the first time, making you at twenty years and sixty-three days the youngest ever player to captain the US.

It was another huge honor. I never really set out a goal at that time to be the captain. I didn't really know what to do, honestly. I was rarely the captain for any of my teams growing up. I'd never really had experience doing it, so I was just kind of going with

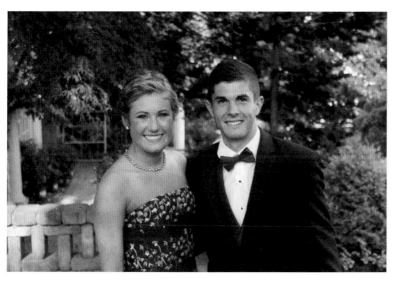

Above: Ready to go to prom with Grace Bruggemeier, Hershey, Pennsylvania, May 27, 2016.
Following pages: My first game captaining the US. It was a friendly against Italy at Luminus Arena, Genk, Belgium, November 20, 2018.
Pages 64–65: Listening to Antonee Robinson during the World Cup qualifier against Canada, Nissan Stadium, Nashville, Tennessee, September 5, 2021.

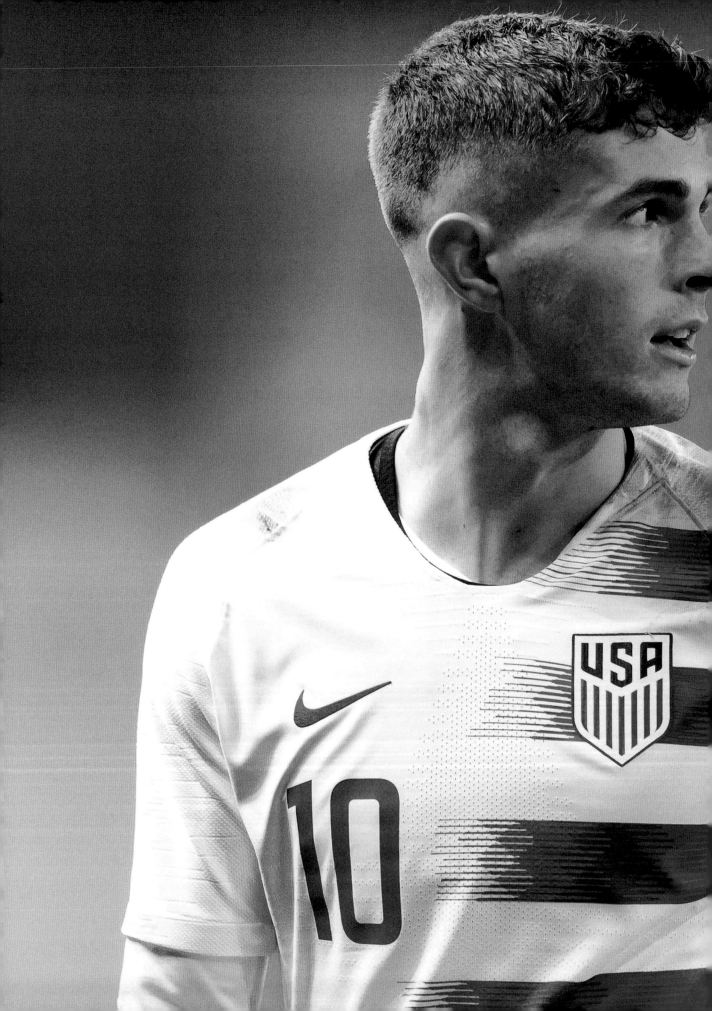

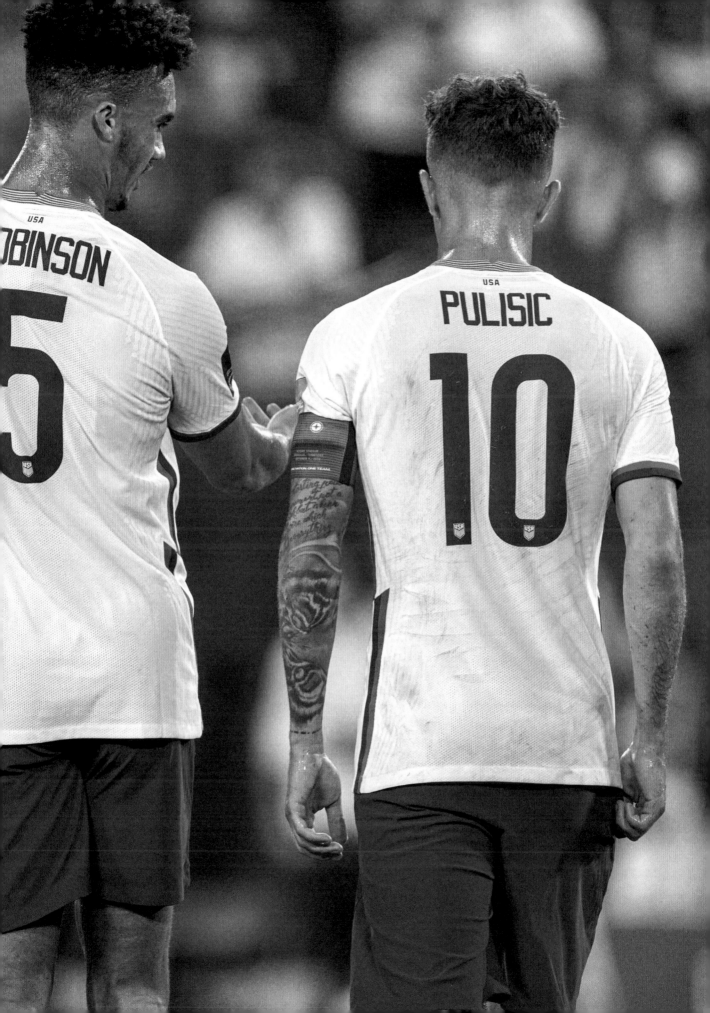

the flow and trying to lead my team by example. Because I've never been much of a vocal leader, someone who's shouting or screaming trying to motivate guys, I've always just tried to do it with my play. I try to continue to do that but it was definitely a cool experience.

So you're known as Captain America and you do actually captain the US team. Do you enjoy being a captain?

I just enjoy playing for the national team in general, whether it's being the captain or just being an important part of the team. Like I said, I like to lead by example. I hope guys can see my mentality going into games and the way that I compete. I hope that they can see that and want to do the same. As long as I'm doing that then I'm very happy, whether that's with the armband or not. It's obviously a huge honor to wear it and represent your country in that way—but I just love to be on the field and compete with my teammates.

How challenging is it to play with teammates when you have less time to practice together than you do at your club?

Well, we only get to train together when we have these national team windows every couple of months. It's normally maybe three days before a game, so it's not easy, but that's how it is for all the national teams. It can be tough because you don't have as much time to learn about each other, to talk about different tactics, to understand each other to the fullest, but I think that's what makes national team so much fun; you go in and everyone's doing their best to try to come together. You can have quite good chemistry with everyone being from the same country, which is a bit different than at club level. It can still be challenging, but I think everyone really enjoys it.

On March 26, 2019, against Chile at BBVA Compass Stadium, Houston—the fourth game managed by Gregg Berhalter—in just the third minute you score your tenth goal for the US, making you the youngest ever player in US history to score ten goals. But then you suffered a right quad injury in the thirty-third minute and had to come off.

That friendly against Chile had a very big swing of emotions for me. I scored early on in the game. I made a run down the center of the field anticipating a through ball pass from Gyasi [Zardes]—the ball was struck perfectly, it split the defense, and I got to it just before the goalkeeper [Gabriel Arias], who'd come off his line. His positioning and the fact the ball was still bouncing meant that chipping it over his head was my best play, and it went in. But then I got subbed out soon after because I was really hurting—I'd injured my quad. I liked that goal, but I remember that game more so for the injury because I was very disappointed afterward. We had a big game shortly after that for Dortmund, which I had to miss. It was a really big swing of emotions that day from scoring and then having to go out.

Bruce Arena gave you the freedom to go anywhere on the field. Is it the same under Gregg Berhalter?

I think I have a certain amount of freedom where I can go get the ball in different areas and try to change the game in that way. But there are some areas on the field where I'm going to be more of the time, so there is more structure I would say.

There have been a lot of highs for club and country, but there have been some lows too. The loss to Trinidad and Tobago in October 2017 meant the US wouldn't qualify for the 2018 World Cup—missing out for the first time since 1986. You scored in that game. And you were in tears at the end of the match.

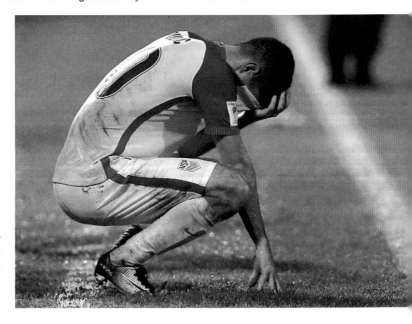

The lowest point in my career so far. After the final whistle and our loss in the World Cup qualifier against Trinidad and Tobago, which meant that we wouldn't be a part of the 2018 World Cup, Ato Boldon Stadium, Couva, Trinidad and Tobago, October 10, 2017.

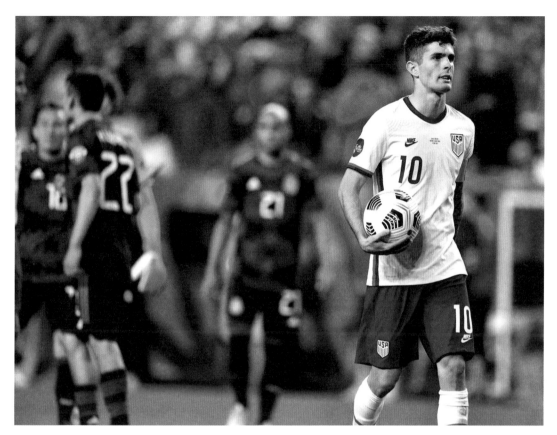

The game before it was very positive. We'd put ourselves in a very good position going into that last qualifier. We just needed a point to qualify for the World Cup. That was in our heads. We just needed to go and get a good result away against this Trinidad team. I just remember that feeling of shock in the first half when they scored two freak goals. Kind of crazy goals that you don't see every day. All of a sudden, we were down 0–2 and it was creeping in our minds—is this seriously going to happen, there's no way that this can happen. I remember going in at halftime, the speech, everyone just sitting there quietly thinking, What is going on? I remember going out in the second half and just saying, You know what, I'm going to give everything I have and if it's not meant to be, it's not meant to be. I scored quite early on in the second half, and I just thought in that moment, This is it, this is it, we've got this, we've brought it back to within one, we just need one more goal. And then just fighting and fighting that entire second half and nothing. We just couldn't break through. It just wasn't our day. It wasn't meant to be. I remember walking off the field at the end of the game and hearing about the other results and the coach just said we didn't qualify. And that was one of the toughest moments of my career. Because it's definitely one of my biggest dreams to play in the World Cup. There's no denying that. So that was extremely disappointing as a young player. That would have been an amazing opportunity for me, but since then it's been about realizing that it just wasn't meant to be. I think things do happen for a reason, and for some reason we weren't meant to be in that World Cup. Now we have an opportunity to redeem ourselves and hopefully put ourselves in a position to be in the next one.

Fast-forward three and a half years to June 6, 2021, and you're walking up to take the penalty in extra time of the inaugural Nations League final. You had a lot of time to think about taking that penalty. You were fouled at 107:44; the VAR [Video Assistant Referee] official signaled to the referee at 108:26, who then awarded the penalty at 110:04 but only whistled for you to take it at 113:39. You curled it into the top-right corner four seconds later.

Bringing the ball to the penalty spot during extra time in the final of the 2021 Concacaf Nations League, Empower Field at Mile High, Denver, Colorado, June 6, 2021.

The crowd was throwing plastic cups and other things onto the pitch; Mexico players were walking up to you, and you stood there and held the ball. You had to wait six minutes from the moment you were fouled to being able to take the penalty. What do you do to keep focus?

Only thinking about executing when the opportunity comes. Focusing on your shot. Not letting any outside distractions get into your head, which is easy to say, obviously, because there's a lot of things going on. But really just staying calm-headed, maybe speaking with my teammates and staying relaxed. Once the moment hits, taking a deep breath and trusting in your technique and your training. I know how to take a penalty. I've done it before. It's really just trusting in your technique and that everything is going to work out.

Before a game, what do you listen to in order to get in the right frame of mind?

I like all different kinds of music, so some days before a game I could end up listening to country. Luke Combs is one of my favorite artists. Some days I could listen to hip-hop. I think regularly in the changing room the team likes hip-hop, and that's something that's kind of a go-to that we all listen to, so that can definitely get me in the right mood. But sometimes I'll just see a song and I'll think, I want to listen to this right now. So there's no particular style that gets me more hyped than the others, to be honest, I just like to be in a good frame of mind, calm in my head but also ready to battle and compete.

So music plays over loudspeakers in the locker room?

Yeah, some guys like to put on their own headphones and listen to something specific, and others just like to listen to the music that's playing through the speakers.

Does the US team have a sports psychologist to help with pressure on and off the field?

I wouldn't say there's a specific team psychologist, but we do have, well, I'm not sure exactly what you'd call him, but a guy named Travis who's like a mindfulness coach. He does a lot of work with us and is always willing to speak with us. He has different kinds of games just to keep us sharp and motivated and is very good at teaching about leadership and things like that. So we do have people who help in that sense.

Have the club teams you've played on employed someone like Travis?

Yeah, they do have people like him. They have people who you can always speak to about really anything.

The World Cup qualifiers are happening. Do you let yourself dream about winning the World Cup?

I think there's no problem with dreaming and having huge goals, because why not? Obviously our first goal in mind is to qualify and give ourselves a chance to be in the World Cup, but there's no reason not to want to win it. It's every kid's dream who wants to play the game. Winning the World Cup would be amazing, so it's something that of course I've dreamt about. I'll always want to have the opportunity to do that.

In the game against Mexico on November 12, 2021, you come on as a sub in the sixty-ninth minute and just five minutes later you head home USA's opening goal. Your run made that goal. You found space, got yourself in front of the defender, and made it yours.

That was a huge goal. Going against Mexico, we really needed a goal to break them down. I thought the team

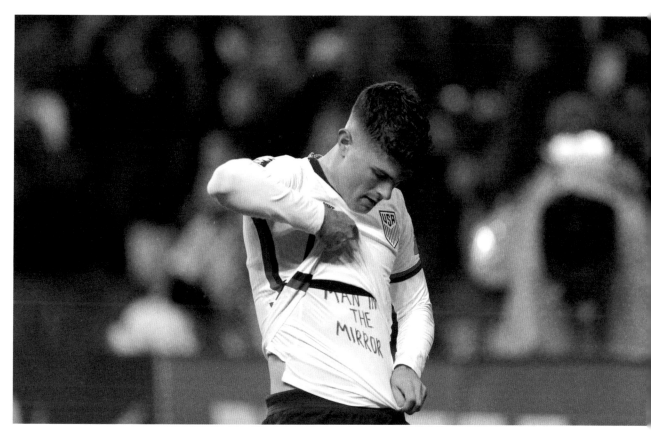

played really well up to that point. I remember specifically coming off a really tough injury that I had with the national team in the last game I'd played, so I had been struggling with that injury. It was a bit more serious than I had hoped it would be, so it had been a really tough time. Obviously I wanted to be playing with the national team and the timing was perfect to be back there, but I wasn't fully ready to start the game. So coming off the bench I just wanted to help the team and make an impact in every way I could. It was my first touch on the ball, and goals against Mexico are such important moments. Honestly, I was just really excited to be back on the field playing with my teammates—that's what I was thinking about most. I was very happy to be back out there, and to get a goal and to help the team made it even more special.

During your celebration you raised your shirt. What was on it?

It said "Man in the Mirror" on my shirt. I think people sort of got the message. It wasn't something that I'd thought deeply about; it literally happened five minutes before the game because of the comments that their goalkeeper had made. It wasn't that I was angry at him or anything, it was just some quick thinking. There's obviously a big rivalry there, and it was something that came to mind with one of my teammates. So I said, "Write this on my shirt and if I score I'll lift it." It was an "if it happens, it happens" kind of thing.

What did Mexico's goalkeeper say?

I don't remember exactly, but basically he said that when the US looks in the mirror we want to see Mexico or that we want to be like them. And we don't; we want to be ourselves. That was it.

There's a massive rivalry with Mexico. Which country are you most excited to play against?

Mexico has obviously always been a big rivalry of ours, and in recent times I think we're having some good battles with Canada. Some of the big teams within our region are our biggest games and the ones that I definitely enjoy the most; I like to compete against them.

And looking forward to the World Cup, when the groups are announced, is there a specific team

Lifting my shirt after scoring against Mexico at TQL Stadium, Cincinnati, Ohio, November 12, 2021.

you would like to have in the group with the US? No, I don't think there's any specific team. Playing against teammates from your club is always fun, though, that's always exciting. So is playing against any of the big teams across the world. It's always cool to test your ability against some of the big powerhouse teams around the world.

Who would you say has the loudest fans?
Some of the Central American teams, some of those games within Concacaf, definitely have some of the loudest fans. Going away and playing in Mexico, in Panama, Honduras, El Salvador, all those places, I'm always really impressed with the fans, with how many people come out and how much noise they make. The atmosphere is always really, really nice and really tough to play in, but also enjoyable. Those are some of the best places to play in.

Do you have a favorite defender to play against?
There are a lot of good defenders and I really do like having different challenges each week in the games, but I don't know if I can pick a favorite.

You've got so many moves to get past defenders. You used to work on them as a kid, like that double body feint. Do you still practice specific moves?
I practice them regularly in training. I mean, we're training just about every day. I have most of my moves that I use down, but I practice to keep sharp. If there are some new ones I'm trying, I'll definitely work on them in training and try to bring them out in games. I think I'm regularly working on moves, always trying to improve and just be more consistent with them, so I can constantly pull them off when I need them.

In the game against Honduras on February 2, 2022, you came on in the sixty-fifth minute and you score in the sixty-seventh minute. That strike was only your second touch on the ball. Your balance was perfect—you kept your head over the ball, striking it as clean as can be to the bottom-left corner.

Above and opposite, top: US fans cheer while I knee slide toward them with Clint Dempsey at my side after scoring against Honduras during the 2018 World Cup qualifier at Avaya Stadium, San Jose, California, March 24, 2017.

It was absolutely freezing. Coming off the bench, I was honestly excited just to run around because I was very cold. I remember I was setting a block for Walker [Zimmerman] on the corner kick, and the ball ended up bouncing right in front of me and my eyes just kind of lit up. It felt natural to strike it and get it on target. I hit it very clean, and it ended up going in perfectly.

Everyone in that game looked so cold!

It was freezing.

Are there differences between playing for club and playing for country? For instance, in terms of the media attention . . .

There are differences and similarities. Honestly, I love doing both. Coming home and playing for your national team is always amazing. Maybe I was expected, in a way, to do a lot more in the national team from a young age. I've been a part of the team for longer. Not that there's necessarily more pressure, but I get the feeling that people expect me to do certain things with the national team. Whereas with Chelsea, there's definitely a lot of other players who've been here longer than I have and a lot of experienced players. There's a lot of pressure in both and media attention, but I think the balance is OK dealing with both club and country.

VAR technology has just been introduced to the

World Cup qualifying matches; are you happy about that?

Before I would have said yes for Concacaf, because I've seen some things in Concacaf that I've never seen elsewhere in the way things are handled.

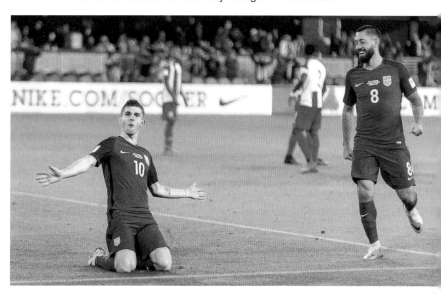

But after this window, specifically in that Canada game—they simply refused to look at certain plays and use it when there were clear and obvious situations when they should. What's the point if you're not going to use it? If it's available and there are obvious foul plays, potential red cards, and they simply don't use it, I just don't really understand it.

There were so many heavy challenges and what clearly looked like fouls in that game that weren't called.

Yeah, I've never been a fan of VAR, to be honest, but I thought it could potentially help in these games in Concacaf, which can be quite physical with a lot of crazy tackles and fouls. But I feel like they didn't use it to the extent that they could.

And you haven't been a fan of VAR because it's disruptive?

Having VAR affects the rhythm of the game. Technology can be really helpful as far as goal-line technology, for example, or making big decisions on whether a card needs changing from a yellow to a red. But at times with VAR, it seems like so many people are unsure about

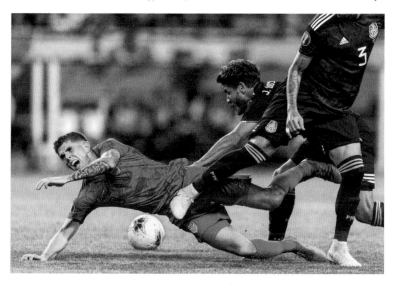

Fouled by Mexico midfielder Jonathan dos Santos (6) in the second half during the Concacaf Gold Cup final, Soldier Field, Chicago, Illinois, July 7, 2019.

72

what's going on, and it can take and change so much emotion in the game. For example, when you score a goal and then it takes five minutes to get checked, the celebrations are just off; it can be really frustrating to the players. I don't think people realize how much emotions swing in games and momentum can change in those moments.

When there is a major change in a game, let's say a player gets sent off or you go down a couple of goals, do you have prepared responses or do coaching staff communicate new tactics from the sidelines?

You kind of have a plan going into the game, but it's a sport where things constantly change and stuff happens. We have plans ready for a lot of things, like if a player goes down, but obviously you can't predict what's going to happen in football, it just keeps going. So when coaches need things communicated, maybe they'll quickly mention something to the nearest player, and he'll try to spread the message across the field. But we have a set couple of formations, a couple of things so when something happens it shouldn't be too

much of a change for us, we should be able to know what's going on.

The heat in Qatar—how much of a challenge is it playing in extreme heat, and how does it affect how you play?

It can definitely be difficult. I've always been someone who prefers to play in warm weather than cold weather. I lived in Florida for a year. I've played in a lot of warm temperatures. It can be tough, though. You don't feel like you can run as long in extreme heat since you can catch your breath easier when it's a bit cooler. But it's just another thing that both teams have to deal with, so it's about doing your best and trying to get fit and prepared for that as best you can, really.

Well, good luck with the qualifying and looking forward to seeing you at the World Cup.

Thank you.

[*Before this book went to press, the US qualified for the 2022 World Cup—helped by Pulisic's first hat trick for the national team—and is joined in Group B by England, so Pulisic may well get a chance to play against some of his teammates.*]

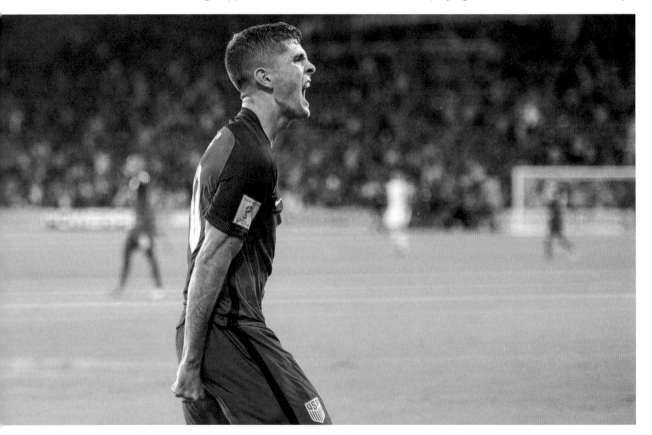

Above: Celebrating with fans after assisting Jozy Altidore for a goal in the World Cup qualifier against Panama at Orlando City Stadium, Orlando, Florida, October 6, 2017.
Opposite: Acknowledging fans as I walk back to the locker room during the 2018 World Cup qualifier against Trinidad and Tobago at Dick's Sporting Goods Park, Commerce City, Colorado, June 8, 2017.

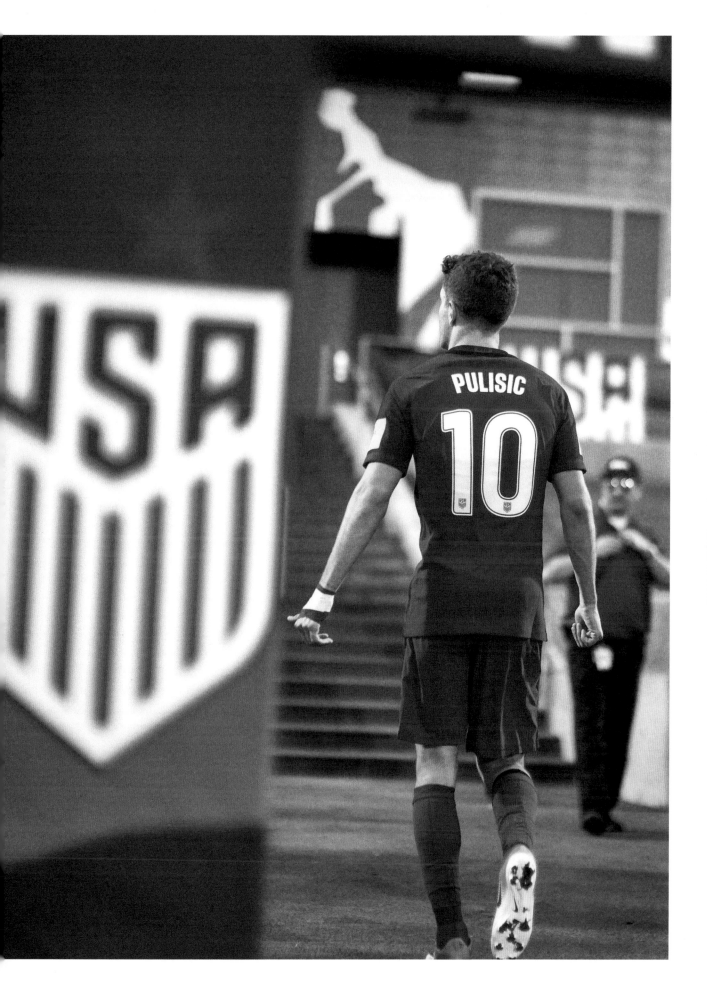

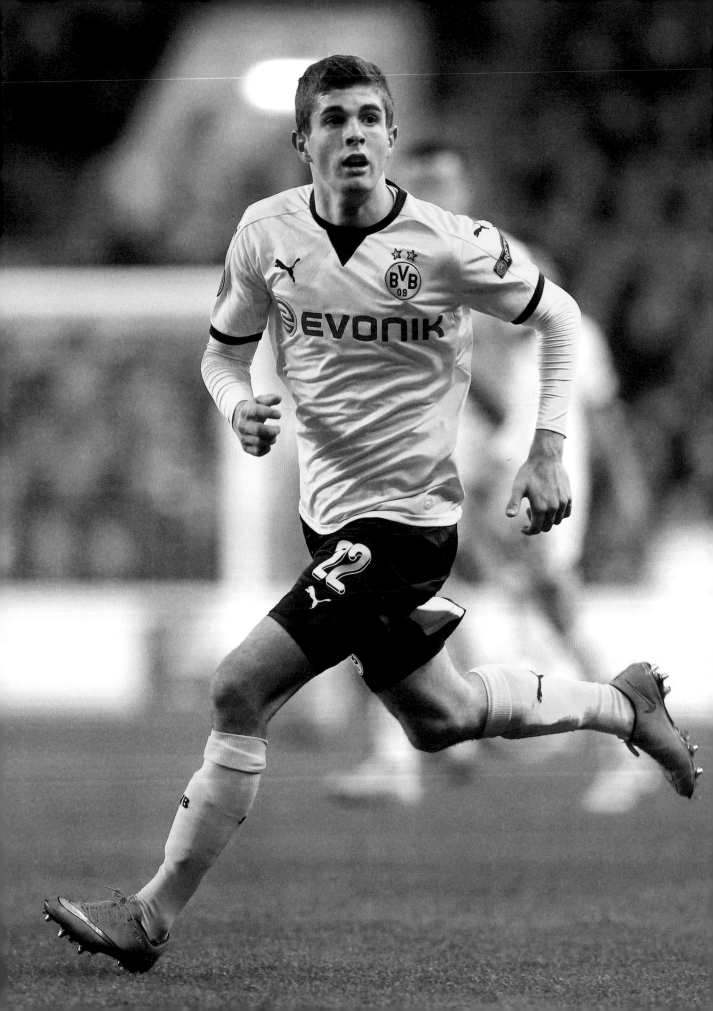

THE YELLOW WALL

On February 16, 2022, Christian was back in London after winning the Club World Cup championship with Chelsea. We video-chatted across the pond.

Hello!
Hi! Good to see you. First of all, congratulations.
Thank you.
FIFA Club World Cup champion. 2–1 in the final versus Palmeiras. Extra time game. One hundred twenty minutes. VAR.
Yeah, those types of matches are always different from just any normal game. The atmosphere when playing against a team like Palmeiras . . . that tournament means a lot to them and their fans back in Brazil. It was like a battle; they were fighting to hold on, and there was a lot of emotion going on in that match. It was very intense and just one of those games where it doesn't really matter how you do it, you just try to get the result in the end. Luckily, we did.
So you visited Chelsea, Tottenham, and Barcelona a few times as a child and got to train with other youth players. You always dreamt of playing for a European club?
For sure. That was always my goal because that's what I watched growing up. I watched the Spanish league, the Premier League, the Champions League. I always felt that that was the highest level in the world, and that's just where I wanted to be

for as long as I can remember. I realized a bit later on that I could actually make it a reality, but I always had that in my head and was working toward it.
What was the process? Did you make videos and send them out to clubs? Or did scouts come to watch you play?
I'm not so sure. I know my parents made some videos of me. I think there were scouts that would watch me. But to be honest, I really wasn't thinking about that at all—I don't think I ever had that in my mind. I wasn't trying to impress people or have people see me play; I just loved the game. I played because I loved soccer, not because I was trying to make it somewhere or go somewhere. I just liked the game. That's it.
You received a lot of interest from clubs after your MVP performance at the Nike International U-17 Showcase on December 13, 2013 [at Lakewood Ranch, Florida]. Did they call up your family or send letters or emails?
Well, I had kind of started working with my agency at that time, and I think I was still at a point in my career where they would handle anything like that or let me know about anything if I had any interest. I wasn't personally talking to these clubs; they told me about the interest at Dortmund, and that's when I first got really excited as it seemed like an opportunity I could definitely take them up on.
Do you rewatch that Nike International Friendlies match every now and then?

Playing against Tottenham Hotspur in the Europa League round of sixteen, second leg, White Hart Lane, London, England, March 17, 2016.

I've seen the highlights a couple of times. Maybe not regularly, but it's a moment that was really important in my career. I feel like it was a time when a lot of things changed. I had the opportunity to have a lot of people watching, and I had a good tournament. It started a lot of things for me.

Did that time ever feel daunting to you? Like it was too much?

Once I knew that the possibility of moving from the US to Europe could actually happen, there were times when it was a lot on me. I wasn't sure when I'd be ready for that. After a while I said, You know what, it's going to be a big change and a big sacrifice and I'm going to have to leave a lot behind. But, if this is really what I want to do, this is the opportunity to do it. So I really just had to go for it and trust in my ability and that things would work out. I had to take a risk. It was a really exciting time in my career but there were tough times and I was nervous about it for sure.

A month after the Nike tournament, from January 20–25, 2014, you represented the US Under-17s in the Aegean Cup in Turkey and that's when Dortmund discovered you. Their scouts were there to observe your teammate, forward Haji Wright, but they fell in love with you. And from that moment on, they tried to sign you. Did you know that scouts were there watching at that competition?

I didn't have any idea at that time. I really wasn't thinking about that. I was just playing. Just enjoying the games, playing the best that I could, and trying to compete and win the tournament for my teammates and for my team. That's always the way I looked at it. I never knew that someone would watch me and my life could change from someone scouting me. But you never know who could be watching. It could be a random game, and it could change your career path.

What did you think when you learned that Borussia Dortmund wanted you?

Dortmund presented my dad with an offer. I remember speaking with my dad about the situation, and we saw the great opportunity that lay ahead of us—that Dortmund would offer me a contract to come over there and play with the youth team and that I would start there and try to build my way up. Sitting down and hearing all that was exciting, and that the club really wanted me and saw a future in me was always very cool to me.

And apparently other clubs were interested too. Is it true that a few months after the Aegean Cup, you and your family visited Chelsea, Porto, PSV Eindhoven, and Villarreal, as well as Dortmund?

No, that never happened. I remember at that stage going to PSV a few times to train with them, but I didn't visit all those clubs at that point. I just remember speaking with my dad after that tournament. I remember that the Dortmund deal happened very fast; it almost felt too good to be true in a sense that it all just fell into place. Things didn't exactly work the way we wanted at PSV, and Dortmund just felt like a great fit at that time. I went and visited and knew right away that it was the right fit.

When you arrived at Dortmund on the first day, you were greeted by the sporting director Michael Zorc, then Under-17 coach Hannes Wolf [who has since coached at Stuttgart, Hamburger, Genk, Bayer Leverkusen, and the Germany Under-18 side], and first team coach Jürgen Klopp, now of course at Liverpool . . .

I didn't really know what to expect going into it. I obviously knew about the first team and what they'd accomplished and how many young players they'd developed—I'd studied up on that and knew I had a really good chance. But I just think that everyone was really kind to me and wanted to

Above and opposite: Relaxing with Dominik Reimann after a training session and moving a goal with teammates during a preseason training camp in Bad Ragaz, Switzerland, July 27, 2017.

Following pages, from top left: Winning the league with the U-17 Borussia Dortmund team, June 14, 2015; my new Dortmund home jersey, May 12, 2016; celebrating with Łukasz Piszczek, Raphaël Guerreiro, Marco Reus, and Pierre-Emerick Aubameyang after winning the Bundesliga match against Borussia Mönchengladbach, Borussia-Park, Mönchengladbach, Germany, April 22, 2017; schedule for the Champions League match against Tottenham at White Hart Lane, London, September 13, 2017; with my family after winning the U-17 Bundesliga, June 14, 2015; Nike Mercury launch with Pierre-Emerick Aubameyang, London, February 7, 2018; Presented with my first

feeling that way with the clubs that I signed for to the point that it was an easy decision.

In the summer of 2014, at the age of fifteen, you move to Germany with your dad, who takes on a job as a youth coach at Dortmund. How challenging was it for you to move there at such a young age without knowing any German and without knowing anyone there except for your dad?

It was the hardest thing I've ever had to do in my life. That first year in Dortmund was very difficult for me. Going to a German school, learning everything new, starting with a brand-new team, it was just a lot. And being away from the rest of my family and friends in the US where I'd lived for pretty much my whole life was just a massive change. There were definitely times when I thought, Why am I doing this? Is this going to pay off? What if I don't even make the first team? You know there are always those doubts in your head, but luckily I had my dad there to tell me that if this is really what you want to do, you've got to stick it out. You've got to see where it takes you, you have to just keep fighting. I'm really happy that I had him there and I was able to do that because things did start to work out in the end.

They certainly did. Where did you live? Did you spend the first few months in a hotel while you were looking for a place?

I was in a hotel for a couple of days. My dad had been there before looking at places. We found an apartment that we liked fifteen minutes from the training ground and, yeah, just a really small place that was nice at the time. A good size for just me and my dad living over there. It was a nice spot.

Your first day at work. What was it like? Who did you meet?

I met all my new teammates and my coach, and I got a tour of the training ground, the facilities, and saw the field and everything. And yeah, it was tough; a couple of the guys spoke English well, which was nice, and they would try to help me out. But not everyone spoke the best English. I was nervous and I was excited—there was a lot of stuff going through my head, but I remember there were some people who made me feel at home and helped me out a lot with that journey.

Anyone in particular who really helped you out?

One guy named Amos [Pieper], who still plays in the Bundesliga—he now plays for Arminia Bielefeld.

show me the ropes and really made me feel like they wanted me to be successful. They wanted me to be a part of the club and they could see a future in me, so I felt very comfortable meeting everyone. I remember Hannes Wolf was very well prepared, he'd seen pretty much every video there was of me online, so they made me feel very welcome.

What would you say were the biggest factors for choosing Dortmund?

The facilities, the coaches I met, the people I met there, the club history of playing young players; it felt like the right place to be at that time in my career. It almost felt too good to be true. Everything seemed like it was a good fit and a good chance for me to learn and grow as a player and to hopefully become a professional player. And people really saw that in me.

How does a club win you over? More specifically, how does Arsenal win you over? I'm an Arsenal fan, so it's confusing for me rooting for you when you're at Chelsea. It would make it a lot easier for me and my feelings if you would just sign for Arsenal.

[Laughter] I think it's the way they speak with you, like when I met with Chelsea and in the meeting with Dortmund when I was younger, it's the way they see you fitting into their team and how they think your style of play can make a difference within their team. Putting trust in you and thinking that you can help us and we can help you; there is a certain way of doing that, and I remember

Borussia Dortmund jersey by sporting director Michael Zorc and head of youth Lars Ricken after signing my first contract with Dortmund, Germany, March 20, 2014; taking a selfie with a fan at Dortmund airport prior to a flight to Madrid for the Champions League match against Atlético Madrid, November 5, 2018; renewing my Borussia Dortmund contract with my dad at my side, January 23, 2017; Gatorade photoshoot, Dortmund, Germany, fall 2017; André Schürrle and me walking onto the pitch for the Champions League match against Real Madrid at Santiago Bernabéu Stadium, Madrid, Spain, December 7, 2016; with Andrew Luck, Dortmund, Germany, February 2019; me and my mom after the Champions League game against Tottenham at Wembley, London, England, September 13, 2017; the first page of my first professional contract; signing autographs for fans from my first car, a VW Polo, at Dortmund, Germany, fall 2016.

Dienstag, 12. September 2017

10 bis 10:45 Uhr Frühstück
11 Uhr Abfahrt zum Flughafen
11:45 Uhr Abflug nach London
ca. 12:15 Uhr Ankunft, Transfer zum
 Hotel, Check In
14 Uhr Mittagessen
16:30 Uhr Kaffee/Kuchen/Imbiss
17:30 Uhr Sitzung
18:55 Uhr Abfahrt zum Stadion
19 Uhr Training
21 Uhr Abendessen
21:45 Uhr Sitzung

Mittwoch, 13. September 2017

8 bis 9:30 Uhr Frühstück
10 Uhr Abfahrt zum Training
10:30 Uhr Training
13:30 Uhr Mittagessen
16:45 Uhr Essen
18:15 Uhr Sitzung
18:20 Uhr Abfahrt zum Stadion

19:45 Uhr Tottenham – BVB

anschl. Regenration Hotel-Pool
anschl. Abendessen

Received: DFB-Regional- bzw. Landesverband/DFL Deutsche Fußball Liga GmbH (DFL)

FÖRDERVERTRAG

Between

Borussia Dortmund GmbH & Co. KGaA, represented by the general partner, Borussia Dortmund Geschäftsführungs-GmbH, legally represented by its managing director, Mr Hans-Joachim Watzke and the Sports Director, Mr Michael Zorc, all ibidem

the "Club" in the following

and

Mr **Christian Pulisic**, born on 18 September 1998, nationality: American / Croatian, legally represented by his father, Mark Pulisic, and his mother, Kelley Pulisic,

the "Player" in the following

10

His English was really good and he was really nice to me from the start, so we became friends. He helped me a lot right from the beginning, but there were a lot of good people there willing to speak to me and trying to help me out.

What was the training like?

It was extremely intense. I really felt like for the first time in my career there was truly a professional environment, that people were competing in training. That was sort of new to me. I felt like it was pretty hardcore—there were definitely kids who did not want to give me the ball at first, who didn't want to trust me. Obviously they wanted to play and they didn't want me to take their spot, which is normal. I think I got the first taste of that there, and it was really cool to see because it's not something I had experienced before.

Were there any drills you hadn't done before?

With every coach you have some new exercises, but what was different was that training environment.

Getting to feel that was the biggest change for me because I felt like some of my teammates didn't even like me; it's such a strange feeling, because you feel like we're teammates we should be on the same team. But at the same time you're competing for professional contracts, you're competing for this and that, so that was the biggest learning curve for me, I would say.

The Footbonaut was conceived by Borussia Dortmund to improve ball control and passing accuracy. It's a cage that you enter in which balls are fired at you from any and every angle, and then it lights up an area where you are supposed to pass the ball after controlling it. Is it true that your dad oversaw it?

My dad worked in that machine quite a lot. He took a lot of youth kids in there and worked in there. And I often used it too. It's quite a cool machine to help work on your touch. I thought it was a lot of fun. As a kid it's great to see all these lights and balls flying around; you have to control and play them into the

Warming up with the U-17 team before the Bundesliga B-Juniors semifinal match against RB Leipzig at Fussballpark Hohenbuschei, Dortmund, Germany, June 3, 2015.

right space. It was a really fun thing, and I think it helped a lot of kids learn and improve their technical ability.

And the human footballers, how advanced were they? Was it the highest skill level you'd been exposed to so far?

The level was extremely high. Nothing like I'd seen before. In that environment the kids were fighting to become professionals. A lot of good talent, a lot of players who've gone on to make it quite far and have had good careers. So there were definitely some really strong players.

What was your favorite part of training?

We used to play a lot of six-a-sides and seven-a-sides, and that's always the best part of training. I think everyone loves that the most. It's kind of a little tournament. It's competitive. You're just going against the other team and it's a lot of fun because it means so much. You want to win the tournament.

Do you remember the moment you found out you were going to train with the first team?

My first professional training with the first team—I was so thrilled. That was a big accomplishment, a big day for me. That was where I wanted to be, and I was finally there. The first team needed numbers, and it was the first day I was able to join them. I was in class when I found out. I got a text from my youth coach saying that I was training with the first team that evening. Obviously I didn't think about school for the rest of the day, I was just so excited for the training and ready to go.

What was it like meeting Marco Reus and Pierre-Emerick Aubameyang for the first time?

Going into training with them the first time, my youth coach gave me a really important piece of advice. He said make sure you go into training not as a fan but as your own player and your own man, because if you see them as these guys who are so good and untouchable—and they are unbelievable players—then you'll never really have a chance. So you have to go in and show your style. But then I met them and they're really nice guys. It was just a lot of fun playing with them, so it was cool.

That's good to hear. How was their English?

Both of them could speak English quite well. A lot of the guys on the first team can speak English quite well, but by that time I could understand German quite well too.

Did you have private German lessons, or did you go

to a public high school in Dortmund and take other classes too?

I went to a public high school and took regular classes that were all in German, so it was really tough. At the same time, from the first week I got there, I had an hour and a half of private German lessons after school every day for a year and a half. So I was always learning German, trying to learn as quickly as I could.

How long did it take for you to feel like you could communicate in German?

I'd say after my first year I could understand pretty much everything. My German will never be perfect, but I felt like after a year and a half I could carry out some conversations. I felt comfortable that if I needed to get my point across in an interview I could, so I got a bit more confident.

Do you remember any confusing moments due to the language?

I think my accent was probably the hardest part, because some German words are just very tough to say—especially the *r*'s in German and a couple of words that are very difficult for me as an American to speak. I felt like there were people at times, when you're trying to say something, who know what you're trying to say but they just want to hear you try to say it again.

Yep, I've definitely come across some jokers in my time. I wonder how they would have fared with "Connecticut"? So your dad got his EU passport through your Croatian grandfather, Mate Pulisic, who came to the US in his twenties. And then you received your Croatian passport in January 2015, which meant that during the first six months at Dortmund while you were waiting for your passport,

With my pop-pop, Mate, and sister, Devyn, Hershey, Pennsylvania, summer 2003.

you weren't allowed to play. You could only train and watch games. You were fighting for a spot on the team but knew you couldn't get on it because of your immigration status. How fun was that?

Yeah, that also made that first year extremely difficult. Because I felt like I was going through everything—school, German lessons, training every single day. And then I almost felt like there was no point to it all because I couldn't even play on the weekends, which was the time when I wanted to be there the most and prove to my team that I could really help them and be a part of the team. It felt like there was no end goal at that point, because I wasn't sure I was going to be able to play. I was working so hard in training trying to earn a spot, but in the end it just felt like it didn't really matter. So once the time finally came when I could start to play, that is when things became a bit easier and I felt like the team started to respect me a bit more. I was able to show what I could do in games and that was important for me.

Your middle name is Mate. How close were you to your granddad?

I spent a lot of time with my dad's side of the family growing up. I was always visiting my grandfather and my grandma. They didn't live too far from us in Pennsylvania, so we always got to visit them. All the cousins, we would go over and see them for Christmases. I was very close with him and obviously very grateful to him. Being Croatian, he helped me out a lot without even knowing. He made a big impact on me as a person and as a football player as well.

Did you ever consider representing Croatia and not the United States? They have got great kits.

Yeah, they do have cool kits. But I never thought about that because I grew up my whole life in the US and I obviously felt much more American than Croatian. It was always my dream to play for the US, but I was grateful for everything Croatia's done.

What do you remember about your first game for the Dortmund Under-17 team?

I remember being very frustrated leading up to it due to not being able to play in the games; that was the really tough part for me. And then once it came through and I got word that I could play in my first big game, I was so excited. I could finally earn my spot on the team and play on weekends. I could make an impact and help my team. I remember in the first couple of matches I really felt like I was starting to get a groove and improve game by game. I was definitely much happier in Germany being able to play with the team.

Did you train with the first team at that time or exclusively with the Under-17s?

My first year I was just with the youth team. I don't remember exactly when my first training session was with the first team, but during the first year I was mostly with the youth team and then I had a couple of training sessions here and there with the pros after that.

How long did you play for the Under-17s before you played for the Under-19 team?

I spent my first season with the youth 17 team, but I could only play for the second half of that season and then the season after that I was with the U-19s.

Did you then graduate to the first team or play for the reserve team first?

I went straight to the first team. After half a year with the Under-19s, the first team asked me to come on full-time.

Was competing for a place on the team your number one focus?

Yeah, that was always the focus. But when I first went in I felt like there wasn't much pressure on me, which was nice in a way. I was just a young player coming up through the system. No one was expecting me to be anything; I was kind of unknown. That's what really fueled me to put my name on the map and try to be a good teammate and work hard to eventually hopefully get my opportunity, which I did. So yeah, it was just about being confident and being myself and just trying

In my Croatia jersey with my cousin Will at Aunt Jen and Uncle Matt's house, Mechanicsville, Virginia, summer 2005.

to be ready for the opportunity. I didn't feel like I needed to start or I needed to push myself to be better than someone who'd been around for a long time. I just wanted to be the best I could and wait for my opportunity.

And then you got the call to go to Dubai.

Yeah, my first training camp. We had two friendlies in Dubai. Those were my first games. Putting on the shirt was really exciting. It was a very special moment for me.

Who was next to your locker?

Well, we didn't have changing rooms in Dubai, but in Dortmund when I was with the first team Mats Hummels was always next to me on one side and [Łukasz] Piszczek on the other. They were always my locker mates my first year.

What was the atmosphere like in the changing room in Dortmund? It was the first time that you were in a professional dressing room.

It was very different to anything I'd experienced before. I was next to guys who were ten years older than me and much more experienced players. Being in that environment where you know that age doesn't matter anymore—the best players play—it was exciting, it was where I had always wanted to be. It can be intimidating when you're first in there and you're kind of shy and not sure how everything works, but once you kind of get the hang of things it starts to become normal and you realize you're just a part of the team.

Do you keep something in your locker, from home perhaps, for good luck?

It's not always the exact same thing, but I do normally keep in my locker a list of Bible verses, something for each day. When I was in Dortmund I also had a list of ten things that basically you can control—such as your attitude, the amount of effort you put in—and if you do those ten things

The Borussia Dortmund dressing room with teammates (from left) Shinji Kagawa, Andriy Yarmolenko, Dan-Axel Zagadou, Pierre Emerick Aubameyang, Roman Bürki, and Raphaël Guerreiro, Dortmund, Germany, fall 2017.

you should be successful, so I'd look at that list.

Those first games, were you more nervous or more excited?

I was very nervous in the first games for the first team, for sure. But at the same time I was also excited because I had always wanted to be there. I'd finally gotten that opportunity, and the best part was I didn't have to go to school every day anymore—I just sat and thought, Man this can't get any better!

[Laughter] What was it like walking through the tunnel into Signal Iduna Park—a stadium often filled with more than 80,000 fans?

It felt surreal. Going from being in the stands and watching the first team play to being down there and looking up at the 80,000 people, it's intimidating but it's a huge thrill. It was a moment I tried to take in and enjoy because it was incredible. The first couple of times, I remember I couldn't believe it.

What was it like being on the pitch during your first professional game?

During my debut I remember playing on pure adrenaline; I was running all over the place. The nerves were there, but as soon as I started to get in the game and play I felt like myself and I was playing without even realizing it—it was all kind of instinctual the way I was playing and how I felt.

You'd made it. All the hard work paid off.

It hit me afterward what I'd just done. I remember after the game my dad was driving me home, so we had to leave the stadium and walk a mile or so to our car just like we were fans. My dad parked somewhere far away as he always does, and it all hit me driving home. I was like, That's crazy. He was just really proud, and I was still very excited about the game.

How was your dad watching the games?

During those first games he couldn't relax—he was really nervous for me—and he'd pace up and down until the game would start and call my agent while I was playing. He's better now. My dad's always been really proud.

What was your work ethic like? Were you the first to go in to work and the last to leave?

I was always trying to do as much as I could and be a good professional. I think it's really important to

Playing in one of my first home games in the Bundesliga. Borussia Dortmund versus Hannover 96, Signal Iduna Park, Dortmund, Germany, February 13, 2016.

find a balance with resting, but when you're young you feel like you can just keep going and I was definitely like that. I tried to push as much as I can, continue to get stronger because I was very small, very thin, and needed to strengthen up against some of these big guys. So I did a lot of work in my first couple of years in the gym, getting better, getting stronger. I tried to always be on time, getting in especially early and being ready for everything.

What did you learn most from that time?

When I first went in I felt like I wasn't sure if I could fully hang or if I was ready or if I was going to be good enough, so I think it was mostly just learning to be confident. Saying you know what, I think there's something that I can bring to the table that other players can't, that I'm special in this way and I should be confident and try to show that instead of just shying away from it. So I felt like I learned a lot about myself in trying to be confident and trying to make a difference. Not just being there and accepting that these guys are better, more experienced players. Trying to really be myself and be the confident player that I know I can be.

What was it like to get your first paycheck?

[Laughter] Yeah, it was pretty crazy. It was an interesting moment because I never understood how you could get paid for playing soccer. That didn't make sense to me because I loved it so much. Then, when it starts to become a job and you continue getting paid for it, well, it was definitely cool and it started to feel more normal. But I was very excited. I didn't go spending it all or anything.

Do you remember treating yourself to something special?

I definitely wasn't making a ton of money right from the start, but I remember my first big purchase—after about a year of playing—I bought myself a watch and I was so excited about it.

What kind?

It was a Rolex Datejust. I was really excited to have a Rolex. I thought it was so cool.

On April 17, 2016, you became the youngest non-German to score in the Bundesliga—it was a really nice goal too; you took a short corner then got the ball back and buried it under the Hamburg goalkeeper at his near post—which you celebrated by dabbing. And then in the very next game [against Stuttgart on April 23], at seventeen years and two hundred eighteen days old, you became the youngest player of any nationality in Bundesliga history to score two goals. You were also the youngest Dortmund player to compete in the Champions League and the youngest American male player to play in a European competition. How well do you remember these moments?

That first goal will always stand out. I had come on a couple of times as a sub, and I got the chance to start that day. It was a home game and I was

thinking, You know what, today is the day I'm going to score. Sure enough, the moment came and I was so excited. And I'd planned to do that dab thing, which was popular at the time. That moment will always stick with me for sure—my first professional goal. And then the Champions League was big for me. It is a competition that everyone grows up watching. It's the biggest competition in the world, and just to be playing in it and being a part of the whole experience was amazing. So I really enjoyed playing in it in my first year especially.

So with goal celebrations—how long in advance do you think of them, or are they usually a spur-of-the-moment thing?

Above: Dabbing after scoring my first goal for Dortmund (and my first professional goal) during the Bundesliga game against Hamburg, Signal Iduna Park, Dortmund, Germany, April 17, 2016.
Following pages: Celebrating Pierre-Emerick Aubameyang's second goal in the 2017 International Champions Cup match against AC Milan, University Town Sports Center Stadium, Guangzhou, China, July 18, 2017.

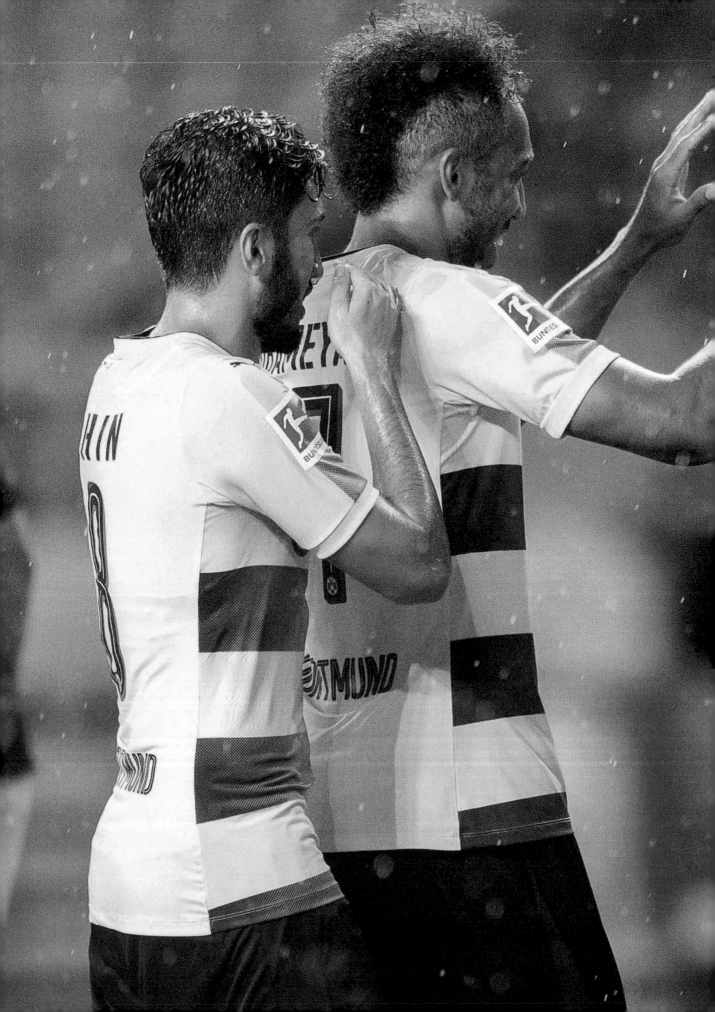

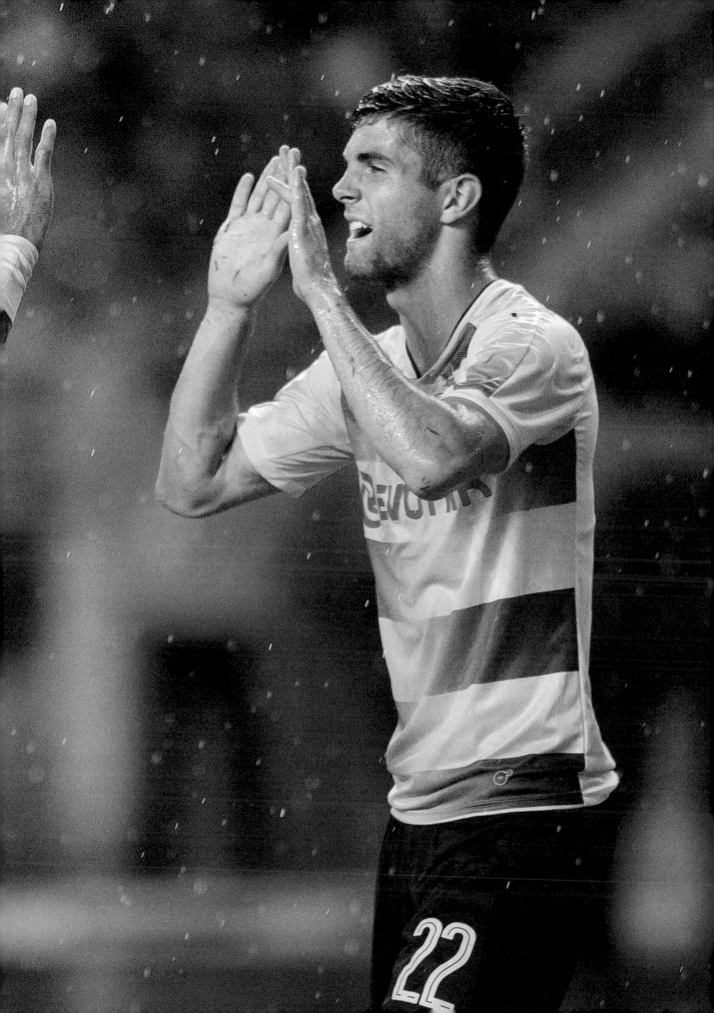

Mostly it's right before the game honestly. You'll just think, It'll be cool if I did this. You score and you kind of go with it. Like the goal against Mexico—it was literally ten minutes before we walked out for the game.

The "Man in the Mirror."

Yeah.

Your tiger tattoo—which is amazing, by the way—was integral to a goal celebration at the beginning of this season. You covered your eyes with your forearm, giving you the eyes and nose of a tiger. Aubameyang has put masks on, but yours is always at the ready.

I remember when I got the tattoo we wanted it to line up so I could cover my eyes with it, but I wasn't planning on it being a celebration. I'd actually done that celebration once before, but no one really saw it—I don't remember when it was—so when the first game of the season came around, it felt right to do it again.

It's the year of the tiger and you were born in 1998, the year of the tiger—did that factor into why you got the tattoo?

Yeah, it's part of it. I have always loved tigers, but also probably my favorite athlete growing up was Tiger Woods. I loved watching him play. So yeah, I was thinking what kind of tattoo I could get and I knew I was born in the year of the tiger, and I had always loved tigers, and I was a fan of Tiger Woods, so it all kind of just felt right.

I'm born in the year of the tiger too. Just not the same one as you. When did you get your first tattoo?

My very first tattoo was back when I was seventeen in Dortmund, and it was just something that was really personal and not something that anyone would understand the meaning of. . . . I just wanted to get something that was meaningful to me. It has to do with my family and it's never something I would really share with anyone, just a special one to me.

Did you get the others soon after?

I think it was like a couple of months between each one. I would just think of an idea. I always kind of wanted to fill my left arm out, so whenever I

came up with a cool idea I would just kind of go for it. It took me about . . . I mean, I didn't completely finish this arm sleeve until a couple of months ago. So it took a while, a couple of years.

And the chess piece tattoo, you have "Mate" written on it. Your granddad taught you how to play.

He always had a chessboard around in the house right next to him. He had one of those chessboards that would tell you where to move. The computer would move, and you'd play against it. Me and my cousin Will . . . we always found it fascinating, and we wanted to learn the game. So my granddad taught us and we'd try to play against him, but obviously we were never at his level; we couldn't compete with him.

And now you play with N'Golo Kanté?

Yeah, we still play a good amount.

Is he still ahead?

I think I took over. I think I'm a little bit better now. He might say otherwise [laughter]. We have good games, though. We're both at a pretty high level.

By the fall of 2016, two years after you'd arrived at Dortmund, you'd become fluent and were conducting interviews in German. Do any interviews stand out from that time? Any memorable questions?

I'll always remember my first interview I gave in German. It was new to me, and my German wasn't great. It was after my first goal, I think, and they asked me how I felt; I said it was a very special moment for me. Looking back on it, you kind of

Giving an interview after a training session during the Borussia Dortmund Asian summer tour, Guangzhou, China, July 17, 2017.

cringe, but it's a moment you have to go through. After that, I got more and more comfortable speaking the language. You'll never be perfect is what you realize. So I just do my best.

How much talking happens on the field between players?

I think there's a lot. Obviously when there are a lot of fans it's difficult to hear each other on the field at times, but I think a really strong team is one that communicates a lot. So I think players are always trying to motivate and help each other out in any way they can.

Was it mostly in German or English?

It was a mix of both English and German. We actually had a lot of international players from all over the world during those years at Dortmund, so it was mainly English. That was kind of the universal language that everyone would use, but to some of the German players I would try at times to speak German. They also loved to speak English with the American guys, so it was mainly English on the field.

Would there be any banter about accents? Would your teammates try to do American accents?

Yeah, everyone finds the American accent funny I guess, and they would all try to imitate it for sure. They'd always do that, even now.

So when you started playing for the first team you were managed by Thomas Tuchel, because shortly after you began training with the first team Klopp moved to Liverpool. After he left he tried to bring you to Liverpool, and you also received interest from several other European clubs. What made you stay at Dortmund?

I was in a good place in Dortmund. I was trying to really earn a spot with the first team and be a regular player. It felt like a good place to develop at the time. I moved on when I felt that the time was right and when I was ready. I'm happy I got to stay for as long as I did, and I think everything worked out very well.

On March 8, 2017, you scored your first Champions League goal. It was a goal that got Dortmund into the quarterfinals of the competition.

We were playing Benfica at home and in the [fifty-ninth minute of the] second half Piszczek, from a good twenty yards outside the box, makes an

Speaking with Thomas Tuchel during the seventh day of a training camp in Marbella, Spain, January 11, 2017.

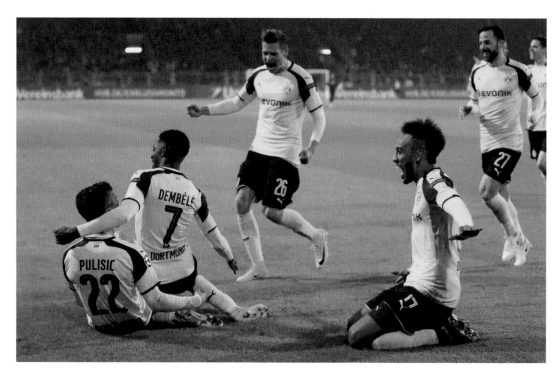

inch-perfect pass through the Benfica defense to meet my run into the penalty area. I just needed one touch to chip [the goalkeeper] Ederson, who had come off his line. . . . I was running to the right of goal and lobbed Ederson to my left in one movement. That's probably my most memorable goal that I've scored, to be honest. It was such a big moment. Champions League. It was all tied up at the time. We were down 1–0 from the first leg, but we'd managed to go level early on in the game. Getting the opportunity to start and scoring that goal . . . I mean my first Champions League goal in such a huge moment. It meant so much to me. There was so much emotion in me when I was celebrating. I did a knee slide towards the fans by the corner flag and then was greeted by the whole team, I'll never forget; I was so excited. That entire night I felt like I was on top of the world.

Do you remember how you celebrated that night?
I actually had some friends over from the US who were staying with me. So we just went back to my house and celebrated and hung out there. It was a really fun night.

When you'd score at home the stadium announcer would shout "Christian!" And then the fans—the yellow wall—would yell back "PULISIC!"
That was always really cool. Yeah, I loved that, it was so loud the way all the fans really tune in. It just makes you feel really proud that they are even chanting your name and they support you through it all.

When your dad moved back to the US in 2017, after being with you in Germany for over two years, you moved to a place just five minutes' drive from Dortmund's training facility. What was it like living alone for the first time?
It was difficult at first. I remember when my dad left I was definitely sad; it was a big step, but I also felt I was ready for the experience. A part of me was really excited to have my freedom. But it was tough being on your own and not having anyone around to talk to. It was a real learning experience, but all in all I think it was the right time and it went very smoothly. It was a fun place to hang and really enjoy yourself. There was a pool, a pool table, a Ping-Pong table. It was the first time I felt like I'd moved into a really nice place where I could relax and have all the things I like to do. I just like having those things around to keep me busy when I'm resting; I could chill and shoot pool or go for a swim. It was a nice apartment.

Describe a typical day in your life at that time.
Going to training in the morning—it might be eleven o'clock or so—and then coming back from training

Celebrating after scoring in the Champions League for the first time—making it 2–1 in the round of sixteen second-leg match against Benfica, Signal Iduna Park, Dortmund, Germany, March 8, 2017.

at around three o'clock. And you know it's very physical. It's a really tough day at the training ground, and you come home a bit tired. Then you have the rest of the day to relax and prepare for the next day; you get a nice meal for dinner and really just get ready for the next day. So it's a lot about the training and also a lot about the rest. Sometimes you have to travel, but a normal day at home would be something like that.

Before training, do you have a massage at the training facility? Or do you get one after, or both?

It's all kind of personalized; you can do as you wish. They have trainers there at the ready when you need a massage or any work done. If there's something that's going to help you, they're absolutely there to do it. Some players like a massage before training, some like it after. Some days you're feeling good and you don't need one. There's a lot of different things you can do to prepare; you can go in the gym before training to stretch, which is what I did a lot of the time, and just try to make sure your body and your mind are ready for training. It's kind of up to you to do as you like before training and afterward as well. It could just be relaxing and stretching.

And so you'd personally go to the gym and stretch before and after the training sessions.

Normally we'd go ride on the stationary bike after training to cool down a bit. Then we'd go and stretch and do some foam rolling and stuff that's good for your body. Yeah, it's all about cooling down and preparing to just go home and rest.

So you started off playing on the wing at Dortmund but then a few games into the season you would sometimes take on a more central position. Were you keen to do that?

I think I was comfortable in a lot of the attacking positions. I'd played a lot in youth football in that number 10 spot and in the center and on the wings—really everywhere—so it was something I was comfortable with.

What differences are in your mind when you're playing centrally and when you're on the wing?

Centrally you have even more options and you need to be aware of both sides of the field and things around you. You're constantly looking around seeing what's going on. Whereas on the wing it's a different job, you're mostly looking at the field from one side and you have to do your work from there. There are differences but also a lot of similarities in the way I would attack and the way I would try to bring my creative skill to the match and try to change the game.

What kinds of skills do you bring to the kitchen? In Germany you started cooking for yourself. Any signature recipes I can try?

Nothing superspecial to be honest. My favorite thing to make was tacos. I remember when my cousin Will was staying with me for a bit, we would always make tacos. That was my favorite thing to cook because I enjoyed having that a lot at home growing up. We'd normally have tacos once a week with my family, so when I got a chance to do that I really enjoyed it.

What do you like to have in your tacos?

It's a whole mix of things, but refried beans, rice, beef, cheese, sour cream, hot sauce, a lot of different things I like.

You're making me hungry. And your favorite German dish?

Schnitzel. Is that German?

Yeah, German and Austrian I guess.

I like having schnitzels, but other than that I wouldn't have German cuisine often.

I really like schnitzels and occasionally make them too; they're easy to make: egg, flour, bread crumbs. Add some pasta and you're good.

After five years in Germany, you played in your last match for Dortmund. You were in tears as you ran out onto the pitch for your last home game. You scored in it, and before the match you gave a speech in German to the fans thanking them for their support. You were given a standing ovation.

They told me I could talk to the fans before the game, so I was just thinking about what I could say. I basically wanted to tell them that Dortmund would always feel like home to me and I was thankful for that. I was grateful for the five years that I spent there, and it was really even more than I ever could have expected—and it got to me. You know it was really the perfect step for me, so I was very thankful and I remember just a lot of emotions. I didn't think it would really hit me before the match because I thought I was just preparing for the game, but it was very tough saying good-bye to the fans and playing there for the last time. I still had one match after that, but that was the last home game. The game was great and I scored and we won, so it was a perfect sending away.

Following pages: Thanking the Borussia Dortmund fans before the Bundesliga match against Fortuna Düsseldorf, which was my last home game at Signal Iduna Park, Dortmund, Germany, May 11, 2019.

LONDON IS BLUE

On March 7, 2022, Christian was in London after scoring for Chelsea against Burnley the past Saturday. In his first four games against the Clarets, he has scored four goals and made two assists.

Hi!

Hello!

Burnley must really love you. [Laughter] That was a nice goal.

Thank you.

So, Chelsea. In January 2019 you signed for Chelsea for a fee of $73.1 million, breaking the transfer record for the most expensive US soccer player by a long way. It seems your path was destined to lead back to Chelsea although there was reported interest from Paris Saint-Germain, Liverpool, and Tottenham. How difficult of a decision was it to leave Dortmund for west London?

I think it was difficult leaving Dortmund in general because I really enjoyed my time there. But the decision to move to Chelsea was easy; Chelsea was just a club I always looked up to, and it was always a dream of mine to play in England especially. I'd lived in England earlier in my life, and I'd always wanted to be back here. I think to be in London was the right decision and a decision that came at the perfect time. It felt like it was the right decision throughout it all, but that didn't make it easy to leave Dortmund. I enjoyed it there a lot, but I was also super excited for the next step in my career.

What was the single biggest reason you thought Chelsea was the best club for you?

I was thinking about the next step of my career and where I wanted to play. The Premier League was exactly that. It had always been a dream of mine to play for a club like Chelsea. In a way, it was kind of a gut feeling. It felt like everything just lined up perfectly. It was the right decision; sometimes that feeling is what it comes down to, and you just don't look back.

Had Cobham changed since the last time you visited? And Stamford Bridge [stadium]?

It was definitely different being on the professional side and seeing all of the cool things they had and the beautiful training ground. The stadium was as I remembered, but I could now see more parts of it and walk on the field. It was different in some ways, but it was really cool to remember being there and having seen some of it.

What was it like being in London? Did it feel at all foreign?

It felt closer to the US and the culture I was used to than being in Germany. Obviously the language is a huge factor in that—hearing English and being around it. And having more people around me in London. My agent and his family and other people are around here. I felt closer to home in that sense too. It was pretty easy as moving goes. It felt quite nice.

How much time are you on the telephone with

your family and friends back in the United States?
A good amount. I didn't keep too many close friends in the US, to be honest, because I left quite early; mostly youth national team players I'd stayed in touch with. And I'd definitely talk to my parents—at least once a day I'd text or call and we still stay in touch pretty much every day like that.

Was there any hazing at any of your clubs? At Wimbledon in the 1980s and 1990s when a new player arrived they'd burn his clothes, and at Manchester United you might be put into a tumble dryer for a spin cycle.
Definitely nothing that serious. The biggest thing I'd say is at both clubs I've gone to, when you're at your first game with the pros, they make you sing in front of the team. So you have to stand up and sing in front of all your teammates, which is just like a tradition at most clubs. I'll never understand it because I don't enjoy watching young players have to get up and sing. It makes me cringe, but it's just always been a thing.

Do you remember what you sang?
Yeah, at Chelsea I sang the Miley Cyrus song "Party in the U.S.A." You just have to think of something that you kind of know the lyrics to, a song that's normally going to make people laugh. Something that's good, something funny. And just get up and sing it loud and proud. Everyone has to do it, so it is what it is.

Did you sing Miley at Dortmund as well?

In Germany somehow I got off doing it. At my first camp we didn't end up doing it, and at the next one they went round and I just said I did it already and they just kind of went with it. Somehow I got away with it in Germany, but people have to do it there too.

Does everyone get on well with the kit person? Are they the most likable person in the club?
I don't know about that [laughter]. I've got along fine with my kit men [laughter], but I don't know if there's anything about them in particular that would make them more likable. They've all been good people as far as I could tell.

[Laughter] I think in stories they're generally depicted as very affable. Maybe that's just me.
Yeah.

[Laughter] What is it like in the locker room? Is everyone on their phones doing their own thing, do you chat with each other, or is it a mix of both?
It's a mix of both. We always have good conversations with each other. Once training starts and you're in the rhythm of things, no one's on their phone. You know when it's time to focus and get down to business. And then a lot of the time—and obviously we spend a lot of time in there—you're relaxing and doing recovery. Going to cold baths and the pool and all that kind of stuff. And then guys are just chilling, having a good time, talking with teammates. Sometimes you're on your phone doing something. It's pretty relaxed in there once you have the time to relax after the training is done.

Has your attitude in the dressing room changed over time?
You get more used to it and more comfortable. I feel I haven't changed that much. I've always been more quiet than a lot of other players, I would say. When you start you're obviously more shy and more hesitant to be yourself. But as you grow into it, it feels quite normal. Once you're in the changing room it's just a bunch of good guys and everyone messes with each other and you have a good time.

Who's always at the gym? Is there someone constantly there working out?
I guess [Mateo] Kovačić is always doing some very specific exercises in the gym. He's always there doing something.

My shirt and shin pads in the Chelsea dressing room before the Champions League game against FC Krasnodar, Stamford Bridge, London, England, December 8, 2020.

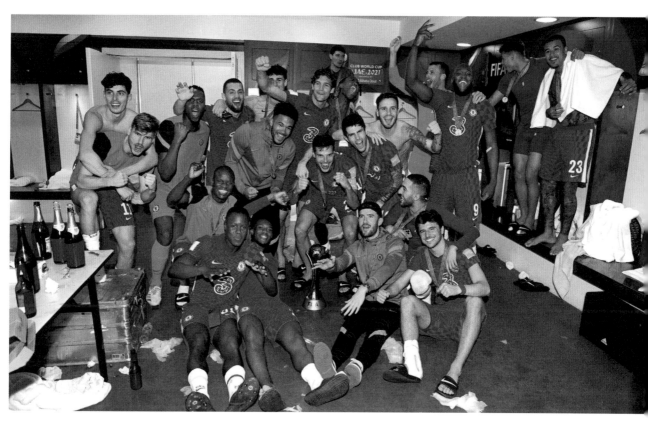

Do you tend to spend more time doing cardio or weight training?

You get a lot of cardio just from playing the game and training, so it's mostly weights. A lot of different types of exercises to keep your muscle strength up and also for injury prevention. You don't want to go lift a ton of weight and be tired and have tired legs for the games and the training. Finding the right balance and the right times to do a little bit each day I think is important.

How structured is the physical training? Do you decide on your own how much time to put in, or is it decided for you?

It's decided on your own. People are always there to help you if you ask. A lot of players follow a personalized program that Chelsea has made. And then some things are good for others. For example, I had an injury to my abductor and I had to do a lot of work to keep strengthening that and keep it in good shape.

Do you have a favorite workout?

When I go on the pitch and get to train. We just love to play football. It's obviously the best part. Just getting to be around the ball and to train and then of course playing is my favorite thing to do.

What is your least favorite workout?

I've never been a huge upper body guy where I love to lift a ton of weight and curls, that kind of stuff. I don't need to do it a whole lot, but when I do it's OK.

How do you know when your body needs a break? Do you just feel it, or do you have a regimented schedule set in stone?

There are people who are constantly keeping track of the distances we run and how much workload we have done each day in training. For instance, the amount of sprints we do. They will tell you about that, and you can look at it each day. And obviously if you're just feeling tired, then express that and do what is necessary to be fresh for the next game because that's the most important part.

Your parents are both certified PE teachers, and your dad's coached several soccer teams. Of course you've had a number of coaches over the years, including Maurizio Sarri, Jürgen Klinsmann, Jürgen Klopp, Thomas Tuchel, Frank Lampard, and Tuchel again. How have their management styles impressed you?

Celebrating with the FIFA Club World Cup trophy in the stadium's dressing room following our win in the final against Palmeiras, Mohamed bin Zayed Stadium, Abu Dhabi, United Arab Emirates, February 12, 2022.

You learn from every manager you have. I think there are lots of different styles, and you just try to make the best of the situation that you have. Coaches have different opinions and they want certain things from players. Also adjusting—not necessarily the way you play—but understanding the little things that these coaches might like. You start to learn that and you can add them to your game. I think you can learn a lot from different coaches and I've definitely had a good amount in my young career.

This is the second time you've been at a club managed by Tuchel. What's he like? How often do you speak? What's his management style like?

I would say he's very intense. I think he's very focused on little details and he can get very intense on the sideline. He wants things a certain way, and he'll let you know if it's not the way. I think tactically he knows the game well and it's a very organized team. I'd say you have to be mentally strong to play for him as well. He can be tough at times. Always fighting and trying to help the team.

Who does the behind-the-scenes coaching? Who says, "Do more of this" or "Try doing that"?

It can be your coaches or at times you'll speak with your teammates. You watch videos sometimes as a team.

Is your dad still involved in your coaching?

He still plays a big role. He obviously knows the game very well, so I'm always discussing things with him about my game and things that I can improve. Of course he knows me well. He's not my coach anymore, but he knows the game and he knows me, so he always has helpful pointers that he discusses with me and things that maybe he thinks I can slightly improve on—I take that in and I really listen.

Who are the other people you interact with at the club?

You say hello to everyone every morning, all the physios, all the athletic coaches do the warm-up with you normally, all the coaching staff, the kit man, you see everyone. It's really all a team effort; they are of course very important as well.

What's a typical training day like for you at Chelsea, from waking up to turning off the light?

You go into training, you get prepped, you go to the gym, it's very similar to Dortmund. The training ground is like your second home. You spend a lot of time there and you get the absolute most of it before you go home, especially when that's all you have to do for the day. We really just try to spend as much time there as we can.

How often do you train? How many days a week do you go to Cobham [training facility]?

Pretty much every day, and then the days we have games we prepare and get ready for the games. Most days we'll have training. There'll be occasional off days.

Can you describe a typical training session? How long does it last?

The training itself will start at maybe 10:30 a.m., so we'll have to be in by 9 a.m. or 9:30 a.m. or so to prepare for the training that's on the pitch. And that will normally last an hour or an hour and a half, sometimes more. That's the main part of the session, but you're there for hours and then you spend maybe a couple of hours afterward cooling down and getting recovered and ready.

What kinds of games do you play during training sessions? There's that keep-away game where you form a circle and one or two of you have to intercept the ball . . .

There are all kinds of passing drills and possession

Olivier Giroud to my right and Andreas Christensen behind me during a training session at Chelsea Training Ground, Cobham, England, August 16, 2019.

drills; a lot of teams have similar ideas about things like that. It could be one or two touches that you have each time you get the ball. Sometimes we'll use mini soccer balls to improve our control and tackling skills. The areas we train on are much smaller than a full-sized pitch so that you need to be very quick and accurate with your passing. We'll practice short passes, long passes . . .

What was your best day in training?

We always enjoy easier days after matches when we'll play fun games like soccer-tennis, which is kicking or heading a soccer ball over a tennis net. You're only allowed one or two touches to control the ball and get it over. Those are always good days when you kind of relax and rest in a way, but you're also still playing and enjoying time with your teammates.

How do you come up with new moves? And do you still study other players?

Trial and error and things you do in training. Things that you pull off and then you try to perfect. It's all about repetition until it becomes instinctive. I absolutely still watch football, so you take things from other players. You'll see they'll do one thing well that you'll try and then work on. There's a lot of time that goes into it and then also developing your own style and knowing what works for you.

Your dribbling skills are phenomenal; the ball just hugs your feet. Are there specific exercises you can do to help get to that level of control?

The first touch is super important. Constantly receiving balls, whether it's kicking against a wall or having balls fly in from all over. Really doing your best to receive the ball and keep it as close to you as you can. It's something I've always worked on with both feet. My dad would even kick the ball up really high in the air, and I would have to receive it right next to me. We'd always be working on my first touch, because I think having that control and being comfortable with keeping the ball very close to you is just super important. We constantly worked on dribbling too—that's the fun part. It all kind of came natural to me. I always loved taking guys on. It became very natural to keep the ball close to me, and that came with a ton of practice and just always having a ball around.

How long before a match do you learn the manager's game plan, including the team formation? Does the entire team hear it from the manager together, or is it communicated individually through coaching staff?

It depends on the coach. A lot of times now you might not figure out the way you're going to line up until a couple of hours before the game when we'll have a meeting. You don't always know in advance who's going to play and what exactly you're going to do. As a team we'd normally look together at a video of the team that we're going to play against the day before the game at least.

Top: Sprinting with teammates in a training session at Chelsea Training Ground, Cobham, England, November 1, 2019.
Bottom: Training with Mason Mount during a preseason training session at NACK5 Stadium Omiya, Saitama, Japan, July 21, 2019.
Following pages: Training days at my second home, Chelsea's training ground in Cobham, and around the world—in the bottom center photo, I'm stretching with David Luiz at Mitsuzawa Football Stadium in Yokohama, Japan.

Some coaches like to let the team know a day or two beforehand to prepare, but a lot of coaches are different.

Do you identify specific matchups?

Sometimes you do, but it's mostly just to get a broad understanding of the team and how they're trying to play, as well as highlighting some of their key players and things to expect. Football is a game where a lot of things can change. You can go in prepared to play one way and then the opposing team can play differently than anticipated; you don't know what they're going to do. So it's about being open and ready to adjust as well.

What sort of details does the manager point out?

Where you can hurt the other team. The way they defend and ways, even slight ways, you can take advantage of that. The manager also shows some of their strengths and ways we can prevent them from playing their game and doing the things that they tend to do. They identify certain players and ways we can shut them down.

Are you given videos to review personally as homework?

A lot of the time I'll like to watch back clips of my play in games just to see things that I feel I can do better. I'll watch specific moments so that I can think about trying out different things in similar situations in the next match. So I do look at things on my own. Occasionally a coach will want to show you a video of something they feel you can improve on, that can happen, but it's usually as a team.

What's the best team talk you've ever heard?

The most memorable one would be before the Champions League final when we just got together as a team. It wasn't really a talk. We kind of huddled up and sat in silence together and envisioned the game before it happened, envisioned winning. It's something that's very memorable to me in just the way we prepared for that final game.

What pregame rituals do you have?

I have the same sort of routine. Not necessarily something superstitious, but I like to eat at the same times, go to bed at the same times, wake up at the same times. It's just about going through a routine that I normally do on game day. It's a routine of similar things and making sure that I'm in a good space—a good head space and my body's in the right space.

Are there any phrases you say to yourself to help stay focused?

I have some personal things that I say to myself before a game. I learned growing up that sometimes just having little words can get you back into focus. I also make sure I'm enjoying playing, because I feel like when I'm enjoying it and playing free, that's when I'm playing my best as well.

How difficult is it to be constantly up for it? As fans we're up for every game, but we're sitting on a couch eating chips.

I'd say it's easier to get motivated for some of the big games, but then there's a lot of important games throughout the season. It's not always easy to get up every day and have 100 percent motivation to go and train and work extremely hard, that's just unrealistic. It's extremely difficult, so you have to push yourself through those situations the best you can and do your best, especially when the games come around. You have to be 100 percent motivated and ready to help your team do whatever it takes.

What kinds of instructions do coaches give to players during the game?

You can hear what our coach says now on the sidelines. He is yelling a lot of different things, like something he wants you to do. Sometimes you don't really understand what he's trying to tell you on the field, which can be difficult because it is very loud and sometimes you don't get all of it. There is instruction, but to a certain extent

Arriving with Mason Mount for a training session ahead of the Champions League match against Lille OSC at Chelsea Training Ground, Cobham, England, December 9, 2019.

you have to play your own game because you're out there and the game isn't stopping constantly. So you have to do your best and try to work with your teammates and communicate as best you can.

Do teammates ever try to make you laugh during a game?

That can definitely happen. Sometimes a player can do things that can make you laugh just because you know him so well. Toni Rüdiger will sometimes laugh in almost an evil way that I just find very funny. Like you know he's not an evil guy, it's just the way he carries himself on the field. Certain players do things like that, that you just can't help but laugh at I guess.

Have any opponents tried to wind you up?

Some guys will obviously say things, but it's mostly the way they play or try to kick you or try to get in your head in that way. That happens for sure, but it's just about staying focused the best you can.

You get a lot of attention on the pitch, and you get fouled a lot. Are there any players you've had battles with who stand out especially?

A lot of the games in Concacaf with the US can be very difficult, especially when you're playing against some Central American teams. Those games are very physical, and sometimes the conditions are tough with very hot weather. I remember having some good battles with them.

You've got a direct creative style—often when you receive the ball, you go right at players and show great balance in doing so. What are you thinking about when you're defending? What are you trying to do?

As an attacking player you're the first line of defense, so you want to really get yourself in the right position. It's not necessarily about making a big tackle or winning a big header. It's just constantly focusing on a position that you're in and making sure that you're maintaining structure and helping your team in that way. So yeah, just being very clever in your exact positioning on the field is the most important thing I think.

When you're taking someone on, what are you considering? Do you keep in mind his tendencies from past games?

You can learn things about the teams you're playing against and certain players, but at the end of

the day as an attacking player there will always be moments when you have to use your instinct, skill, and creativity to throw the defenders or get them off-balance a little bit. That's the beauty of the game—no two situations are exactly the same; you can't study and know exactly beforehand where you're going to get the ball, in what position you'll be in, and what the situation of the game will be at that time, so you just have to be ready. You have to be confident and ready to try to make a difference.

When you have a free kick, does everyone on the team know his place? How many different kinds of set plays do you practice for a certain area of the field?

There are set pieces that we work on. Some games we might have something more advanced planned—some kind of play that we think could possibly work in a certain match—and if you see the opportunity in the moment, you give a signal that says to the team, "Let's do it." We normally have a couple of set plays going into the game that we can potentially do and then we also have standard plays, kind of the basics that we can always go back to if a new plan is not on. There's nothing crazy to try to memorize because it's a game where a lot of things happen, but we do have set plays going into a match.

How do you let the team know? When taking a

Taking a shot with Reading's Danny Loader challenging for the ball in the preseason friendly at the Madejski Stadium, Reading, England, July 28, 2019.

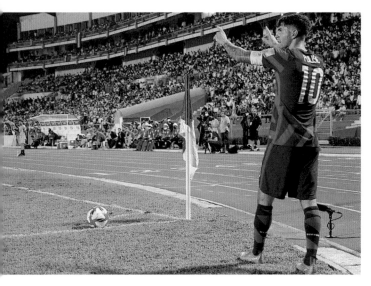

the opposition's defense or help your teammates. *October 26, 2019. Chelsea against Burnley. Your first Premier League goal was also the first goal of a hat trick. And not just any hat trick—a perfect hat trick. In the twenty-first minute you score with your left foot; in the forty-fifth you score with your right foot; and then in the fifty-sixth minute you scored with your head. [It had been ten years since a Chelsea player had scored a perfect hat trick in the Premier League—Didier Drogba against Wigan in 2010.] Half the Chelsea fans started chanting "PUL-IS-IC" and the other half shouted "U-S-A" and the sounds melded into one. At the end of the game, you got to walk away with the match ball. Do you still have that ball?*

I have that ball framed in my house. It was an incredible experience. Just getting my first goal was honestly the biggest part of it for me, and then it turned out to be a perfect day. I mean everything just kind of fell into place. It was pretty unbelievable scoring a hat trick and for everything to work out the way that it did.

At the Under-17 and Under-19 levels you scored a lot of headers; you've always been confident in the air.

Yeah, it's a part of the game that I've worked on as well. It can help you to score goals at times.

How much time did you practice trick shots like airborne back heels, overhead kicks, rabonas, scorpion kicks . . .

I feel that those are things that kind of come naturally from growing up and just messing around with the ball. Stuff that

you are comfortable doing and when the time comes, if you really think that it can help you, then you go for it. It's not something that you're constantly trying. I think the most important thing is to be extremely good at all the basics of the game; obviously there are special skills that you can learn and certain tricks that you'll pick up that can help you along the way too.

corner, you'll raise one arm to communicate a play and two arms to communicate a different play—is that near post versus far post? How do you convey other corner plays you have practiced?

There are all kinds of signals. Having one or two arms raised could signify near and far post. You can change it right before a game and let your teammates know what it means—it could simply be a signal for when you're going to take the corner, so the guys know when to begin their runs into the box. There are a lot of different things you can do. Lifting arms has always been kind of a standard one.

What other kinds of signals are there?

There are lots of ways you can communicate a play. You can touch the corner flag; you can touch the top of your head; you can put the ball down in a certain way. There are different things you can do for sure.

During a game, when you're not on the ball, what are you focusing on?

I think it's about trying to make your teammates look good. It's trying to put yourself in a position where you are helping your team. Sometimes you'll make runs that are not necessarily for you to get the ball—your movement can open up space for others. Spacing and positioning on the field is super important, and it's not always about you being on the ball; most of the game you're not, so it's about being constantly prepared to get the ball but also thinking about what is best for your team and how you can maybe throw off the

Top: Signaling to teammates before taking a corner for the US in the World Cup qualifier against Honduras at Olímpico Metropolitano Stadium, San Pedro Sula, Honduras, September 8, 2021.
Right: Holding the match ball and the Man of the Match Award after my hat trick in the Premier League game against Burnley FC at Turf Moor, Burnley, England, October 26, 2019.

Do you have a favorite way to score?

I love all types of goals. Some of my favorite goals are runs that I've made followed by tap-ins. In the end, they all count exactly the same. You always love to score a special goal, like when you strike it perfectly from twenty yards out. But it's not always the case, so I think all goals are nice.

You must have been happy with your goal against Manchester City on June 25, 2020. It was clearly one of the best goals of the 2019–2020 season.

That was a goal I'll never forget. It was in the [thirty-sixth minute of the] first half . . . I intercepted a pass from [Benjamin] Mendy to [İlkay] Gündoğan in our own half and then ran at full speed down the field until I was one-on-one with Ederson at which point I curled the shot along the ground so it beat his outstretched arm diving to his left and the ball ended up just inside the right post. It was a special one for me. Dribbling from so far away from the goal; it was kind of a solo goal and a really cool moment. It was a big game against a tough team. It was a really tough goal to score, but it all happened so instinctually with all the touches that led up to it; a memorable goal and one of my favorites that I've scored.

When you reflect on all the games you've played so far, do you have a favorite match?

The hat-trick game against Burnley will always stand out for sure. The Champions League semi-final legs against Real Madrid are right up there, especially scoring in the first. Those were some of my favorite games.

If you start on the bench, what are you thinking about? Are you looking for potential opportunities, areas you can exploit such as identifying opponents who are maybe not in great form?

There's a lot of things you can learn from the bench. You can really see how the other team is playing and identify certain areas where you can go in and help make a difference. And just making sure that you're ready to come on and bring energy to the game because that's the most important thing as a sub; you want to bring something different and a lot of energy to help your team over the line.

On July 22, 2020, you came on as a substitute in the fifty-ninth minute against soon-to-be-crowned league champions Liverpool at Anfield. Two minutes later you receive the ball by the touchline on

the left flank and take on four defenders, weaving through them while running diagonally toward goal. You go past [Georginio] Wijnaldum, Fabinho, Trent Alexander-Arnold, and nutmeg Joe Gomez. Once you're inside the penalty area, you curl the ball along the ground—almost like a pool shot just beyond the outstretched leg of Virgil van Dijk, who was running back, yet out of reach of the goalkeeper Alisson—with perfect pace on the pass for Tammy Abraham to score.

That was a really cool one. I remember wanting to start in that game, so coming off the bench I was almost frustrated; I wanted to make a difference, and I was so ready to go in and play. As soon as I got the ball I wanted to go straight to goal, and I did. That was another play that happened very naturally—with every touch I felt like I knew exactly what to do. It all came together kind of perfectly. It was a very nice assist.

I guess it was the result of all the repetition, all that practice you've put in.

Yeah, absolutely. All the dribbling and the work I'd done and how much I had the ball around and playing and learning for sure.

Then in the [seventy-second minute of the] second half of that game you scored . . .

I sprinted toward the box in anticipation of a cross, and when it arrived I controlled it with my chest—at this point I was standing right on the

Fabinho on my right and Trent Alexander-Arnold on my left as I head for goal in the Premier League game against Liverpool at Anfield, Liverpool, England, July 22, 2020. There weren't any fans in the stadium due to Covid restrictions.

Scoring the first goal of the game (and my first in the Premier League) during the match against Burnley FC at Turf Moor, Burnley, England, October 26, 2019.

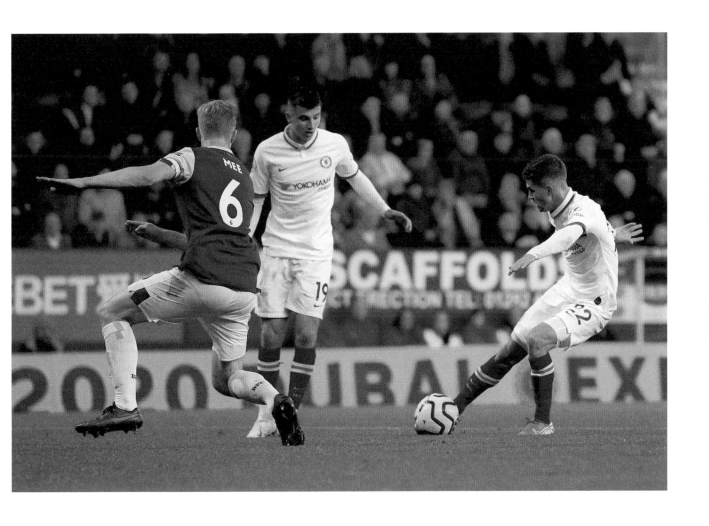

Above: Scoring my team's second goal against Burnley at Turf Moor, Burnley, England, October 26, 2019.
Following pages: Heading my hat-trick goal in the second half of Chelsea versus Burnley, Turf Moor, October 26, 2019.

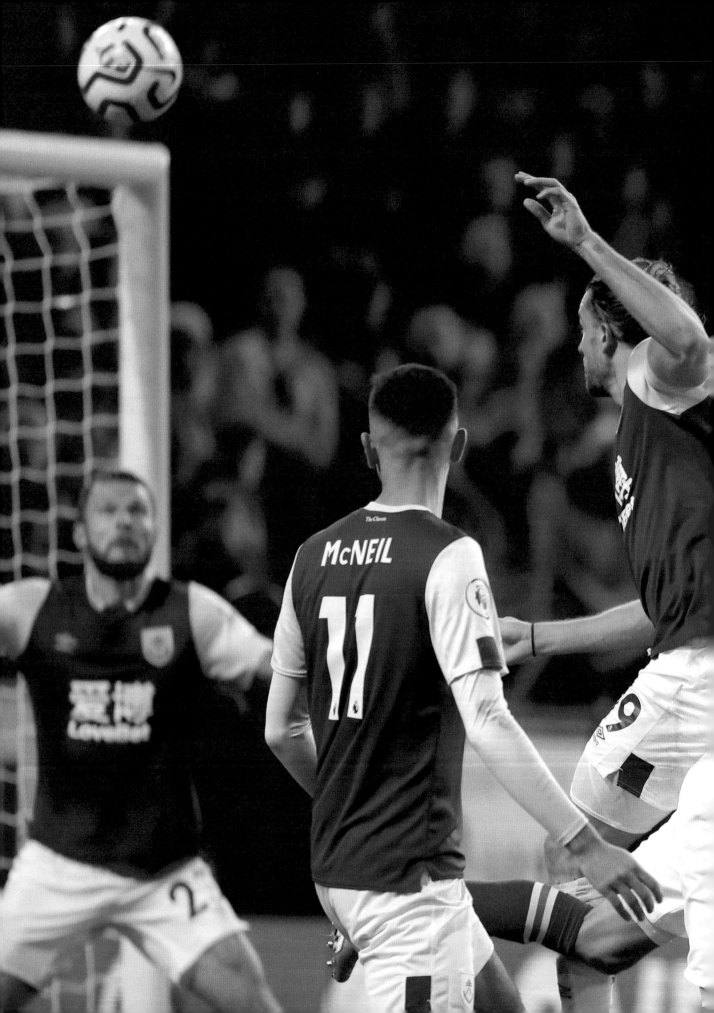

penalty spot, covered by Trent, then I took two touches, both with my right foot, to turn away from him and toward goal, then shoot around Joe Gomez into the top-right corner. We were down in the game and I was feeling very confident, especially after that assist. It was another moment where the touch was very good, and I just turned and thought I had the opportunity to shoot so I did. It was a nice goal and it got us closer to coming back in the game, but we lost in the end and I remember being really upset.

A week later, on August 1, you scored against Arsenal in the FA Cup final. What's it like walking out at Wembley for the FA Cup final?

It was amazing to play at Wembley and be there in a cup final. It was during Covid times when there were no fans, which was disappointing, but it was cool to be in the final and scoring in the final was great. The emotions were also very up and down in that match, so scoring and getting injured and then losing that game was very tough.

Growing up in Hershey, were there specific competitions you dreamed of winning?

Really all of them. I think the Champions League was definitely the biggest of them all, though. The Champions League is an incredible tournament. Watching it growing up—it was always my dream to play in the Champions League and try to win it and now to be able to do that was just really crazy.

Do you relish the challenge of playing a cup game against a third division side on a muddy waterlogged pitch, or do you prefer playing on a pool-table surface against the world's elite?

The nicest games to play of course are the ones in the Champions League on a perfect field against a top team—that's always very nice. But you do have to embrace the battle sometimes, like in Concacaf where there are very difficult games, a bad pitch maybe. You have to get used to it quickly, especially when they are knockout games and you know in the end there has to be a winner. But it's definitely nice to play in the best conditions.

What's it like playing against ex-teammates like Aubameyang when he was at Arsenal and Jadon Sancho at Manchester United?

It's great. I have a lot of good friends who I compete against, but really as soon as the game starts you don't think of it in the slightest. You're just playing. It can be cool to see them, play against them, and compete with them, but when the game starts they just become regular opponents.

So you scored in the FA Cup final and then you were injured—you pulled a hamstring. You could see as you were running and preparing to shoot that you'd pulled your hamstring, but you somehow still managed to strike the ball. What was going through your mind?

I had made the burst through and was entering the box when, out the corner of my eye, I saw [Granit] Xhaka coming across. So I knew I had to get my shot away, but the split second before I pulled the trigger, I felt it go—unbelievable pain—and I immediately knew that this was bad news. But the shot was on and I just had to at least give it a go, because it was going to be the last thing that I'd be doing for the rest of that season. I suppose it was the adrenaline

Scoring against Arsenal in the FA Cup final at Wembley Stadium, London, England, August 1, 2020.

that made me go through with the shot. It was really tough—it was my first English cup final, we were doing well, I'd had a good game up to that point and thought I'd taken my goal well . . . and then that. It was a hard one to take.

Rehab—you've had your fair share of spells—what is the most challenging part? Does it get lonely at times? Do you think that when players are injured for long periods, like that hamstring, clubs should

let them spend some time at home, especially players who live far from their families?

Going home certainly helps because it is an environment change when your mind may be most in need of it. So a spell surrounded by family and friends just helps to recharge your batteries and prepare for the road ahead. But probably the most frustrating aspect is that although you're there at the club . . . you are not actually *there*. It's that feeling that you are in the training ground but you are not really a part of the group. Players live off that dressing-room banter, the competitiveness of every exercise in training, the wind-ups that go along with winning and losing in even seemingly meaningless drills— we all love that. When you're on a treatment table, you are on the outside looking in. And when it's a longer injury, you're sitting there day after day thinking to yourself, When I get fit again, how far am I going to be behind the other players? The guy in my position—he's playing really well, so

I'm going to need to prove myself all over again when I come back. And then when you finally get onto the field, it's that proving to your coach that he can rely on you again.

You're constantly competing for your place. Do you have a favorite place to go on holiday, where you can get away from it all?

That's my house in Jupiter, Florida. I bought it in 2020. It's on the water, and typically I love having my family and friends come stay. Most of them are or have been teammates of mine from my US youth national team days, and we're all competitive! So whether it is a two-touch keep-up elimination game or chipping and putting on the golf green that's next to the swimming pool—we're all there hanging out and having fun. Other big favorites of mine are the Jet Ski and a speedboat ride out into the ocean. After our World Cup qualifier against Honduras [on February 2, 2022], Chelsea allowed me to take a forty-eight-hour break, so immediately after the game I left the -2 degrees Fahrenheit [-19 degrees Celsius] Minnesota weather and headed straight for Florida. Just those forty-eight hours at home, with some sun on my back, seeing family; it was a total recharge. I love going there, it's my happy place.

Describe an ideal day.

For sure, that's at my house in Jupiter. Having a morning coffee on my deck that overlooks the water. Later I'll play some chess online while I'm tucking into my favorite Chipotle for lunch—a bowl with white rice, pinto beans, chicken, green salsa, sour cream, cheese, guac, and lettuce. There may also be some messing around with the guitar or going out for a Jet Ski ride. Then onto the boat and I'll head for my favorite restaurant in Jupiter, U-Tiki Beach.

You have two dogs in the US at your parents' place. Have you thought about bringing one over or getting a pet in London? Did you always have pets growing up?

Receiving medical treatment after pulling my hamstring during the FA Cup final, Wembley Stadium, August 1, 2020.

Actually, no. As a family, we first got a dog around 2017—Timone—an Italian greyhound and basset hound mix. He's a rescue dog. Then more recently we got an Italian greyhound, Fynley. And then there's the cat, Bitty. We're really attached to our pets. I remember one Christmas, in 2017, when I was at Borussia Dortmund . . . I went home for Christmas, but instead of flying direct to Hershey, I flew to Richmond and went directly to my cousins there. I was so attached to Timone, who was just a puppy at the time. It was going to be no Christmas for me without him, but I didn't know how I was going to get him to Richmond. So I did something crazy—I posted a photo of Timone wearing a Dortmund scarf on my Twitter with the caption, "Anyone willing to drive my pup from Hershey to Washington DC so I can see him for the holidays :)" I really didn't expect anything, but two of the kindest fans I know responded with a "yes" and promptly delivered him to me on Christmas Day! I was just knocked over—really incredible. But having a dog when I'm living in London on my own—it's not practical when we are traveling so much to away games and then for international duty for ten days at a time and then vacation.

Of course. What nice fans! How often are you asked for autographs and selfies—has it increased since moving to London? Does it happen a lot in the US?

The fans in Europe are quite different than in the US. Most of the attention that I get in the US is centered around the match-day situation or the days leading up to it. When I'm on my holidays at home, it's pretty relaxed and the attention is manageable. But Dortmund was obviously my first introduction to the real intensity of how the fans see their heroes—it's a fairly small city, but with a club that has a massive following and where the club is everything in that city. So it's important to interact with the fans and try to be as accommodating as possible. London is a little different—there's so many more people. Many are interested in football, but then there's also a lot of tourists who won't necessarily recognize me. But it's not easy to have an uninterrupted meal or drink—even if people don't come up and ask you directly, you often notice them observing you or subtly taking photographs. I try my best to accommodate the requests because the fans are so important—they're the heart and soul of the game and if anyone had any doubts, we certainly missed them when we had to experience playing in empty stadiums during the pandemic.

What's the most memorable question a stranger has asked you?

This is crazy and maybe I shouldn't be saying this, but after I scored my first goal for Dortmund, I was leaving the stadium and a lady came up to me and asked me to sign my autograph on her chest! I thought she must be joking, but she said, "No, sign here please!" So there I am, seventeen years old, totally embarrassed and not knowing what to do, so I put my head down and made a

Top: Our hounds, Fynley on the left (wearing the Nations League winner's medal) and Timone on the right (with the Champions League winner's medal), Lebanon, Pennsylvania, 2021.
Right: Signing autographs for fans before the Premier League match against Sheffield United at Stamford Bridge, London, England, August 31, 2019.

quick exit without signing! For me, a world-first!

Fans can't always keep abreast of your presence. How about media attention? How is it in England compared to what you experienced in Germany? How is it in the US? It seems like an integral and challenging part of the game, especially when you're being asked questions broadcast live around the world just minutes after you've played. The big increase in Germany obviously came when I made the breakthrough into the first team. It started to pick up then and really started to escalate when I was promoted to the US men's senior national team. When I'm with the national team, more often than not, at each camp the press officer nowadays sets up one round table interview session attended by multiple media representatives. Otherwise it would be impossible to get through all the individual requests. But it went up another level when I joined Chelsea, and it was a bit overwhelming to be honest. Mainly the media requests come from the USA and Germany, but also from countries all around the world. The UK media interest will generally be up and down, based on your form and whether you are "hot" at that moment. I find it much easier to talk about the game before and after it. But to be honest, it is the non-match stuff that is a bit more challenging for me because I'm quite a private person. This whole transition from being a quiet guy minding my own business to having to be a footballer talking in the media about everything and anything still doesn't come easy for me. I think if you look at the total spectrum with Messi on the one end—in terms of the privacy of his lifestyle—and someone more flamboyant like Neymar at the other extreme, I'd definitely put myself at the Messi end.

What's it like dealing with fame?

I'd say I've really enjoyed meeting successful people in other sports and other walks of life. Just hearing their stories over a private and quiet bite to eat has been really cool—whether it's a lunch with Justin Bieber or a dinner with Jason Sudeikis—you get a great insight into their professions and how they handle things. London is amazing because many interesting people come through this city and a number of great entertainment and sports events take place here, so there's been a number of opportunities for me

to meet interesting people. The things that I've found challenging have been this pressure of having to be public about aspects of my life and this expectation that celebrities must be vocal and out there with their opinions. Even going black-tie—those events are just not me. At heart I'm just a simple guy who wants to hang out with his mates and do what other people my age do. I'm not interested in feeding social-media clickbait. I know that's not possible but I try to follow that path as much as possible.

Have you ever asked anyone for an autograph?

Sure, my most treasured autograph is my Pelé-signed Santos shirt. I was about nine years old and living at the time in New Jersey, and Pelé was doing a promotional visit. I made sure he wasn't going to leave without signing my shirt. Then there's the most famous selfie that I ever took—it was with Leo Messi when we played Argentina in the 2016 Copa América Centenario. Argentina killed us that day, and afterward Messi and I were chosen for doping control tests. We were sitting together in this room waiting to do the doping test, and it was a bit awkward because I didn't speak good Spanish and I think he didn't speak much

English. But it was a time when he was absolutely the king of football, and I couldn't let the moment pass. So I asked one of the USA staff to please go get my phone in the locker room and bring it to me so that I could ask him for a pic. It was a bit fanboy, I know, but I was only seventeen at the time so I'm sure I can be forgiven.

Yep, you can be forgiven for looking up to Pelé and Messi at any age. Do you have a favorite social media site to share pics on?

Instagram. It's a great way to keep up with my friends and see what they are up to. I used to enjoy Twitter but it's become very toxic—not necessarily toward myself but just in general—

Meeting Pelé, Newark, New Jersey, December 1, 2007.

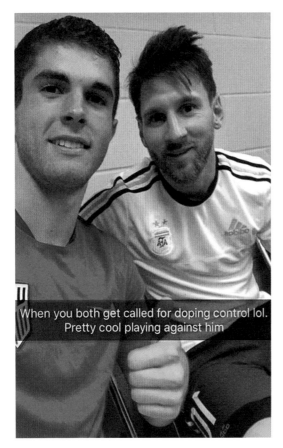

When you both get called for doping control lol. Pretty cool playing against him

Mustang, which was brought over from America. Some players have five, six, seven different cars, but I'm not that kind of guy. When I'm back home I like to drive around in my dad's VW Taos—we're a VW family.

What were your favorite toys as a child?
I only had sports stuff. Aside from soccer balls, there were basketballs, footballs, baseballs, even a tennis racquet. I knew only one childhood—that was sport. I just loved being outside playing with my friends.

Me too although I had cricket balls instead of baseballs. You have a chef in London. What's your favorite meal that he makes?
He does this Brazilian-style dish of rice and chicken—it's top.

When you go out to a restaurant, do you have a favorite dish you look for on a menu?
Chicken wings—and they must be really hot! When I heard that one of my friends in London was working at a place that sold really hot wings, I said, "Take me there." It's called The Orange Buffalo and it's on Brick Lane. It's New York–style buffalo wings—super hot and they're off the charts. They had this Viper Challenge, where you try to eat eight wings covered in the hottest sauce of the house as fast as you can. The tales are legendary. My mate tells me that one of the braver customers got taken away in an ambulance!

Is there any English food you like? Have you tried Yorkshire pudding? Extra bland?
Closest I've got is probably fish and chips. I tried Yorkshire pudding, but it wasn't for me.

Any American snacks you miss?
Luckily not, because one of my sponsors, Hershey's, makes sure of that! When I was a kid growing up, we all used to sit around the fire and roast s'mores, then add a Hershey's chocolate bar and make a sandwich out of them using graham crackers. Unbelievably good. Nowadays I really like Reese's Outrageous, and it's been a real bonus for me to be an ambassador for the brand. One of my favorite sponsor launches was when Hershey's had me at their Times Square store for the announcement, and they unveiled a specially designed football boot for me that truly looked outrageous.

Do you go out much, or do you mostly stay in?
I mostly stay in, I'm quite a homebody.

so I tend to stay off that. Don't know if you can count this as social media, but I also enjoy playing chess on Chess.com.

So do I! I'm sure you'd beat me thoroughly. Wages in football are famously high. What do you like to spend it on?
I'm not a big spender, although I do open my wallet a little more than what N'Golo Kanté does! [Laughter] My occasional treat is a watch. My favorite one is a Patek Philippe.

How about cars?
The first one I ever bought was a Volkswagen Golf when I was at Dortmund. But I was too young to have a driver's license in Germany, so my dad had to drive me to training each day. We'd arrive in this little VW, and all the other guys would have their Porsches, Ferraris, Bentleys; it was a bit embarrassing for me at first! I used to tell my dad to drop me off at the entrance gate to the training ground and I'd walk the rest of the way to the first team building! Since then I've had a couple of Porsches, and at Chelsea I have a Ford

Waiting to get a doping test with Messi, NRG Stadium, Houston, Texas, June 21, 2016.

Do you like watching films or TV series? Any favorite actors?

I enjoy watching movies and series—I've just finished *Euphoria*, which was really great. I like documentaries as well, some football but also other non-football ones. My favorite actor? Nina Dobrev—she was my celeb crush growing up.

In Ted Lasso *the coach puts up a sign with "BE-LIEVE" written on it in the locker room, and the players often touch it before going out to play. Your dad painted the word "CONFIDENCE" on the wooden wall of your garage.*

Yes, and my mom put it on a canvas; it's up on the wall in my bedroom in London. It's almost like I've had these kind of "Post-its" around me at key moments—things that I like to remember at the times when it counts. In my apartment in Dortmund, right at my front door above the light switch, I had a sign with two quotes: LeBron James's "Outwork your teammates every day" and the other from his former coach at the Cavaliers, Paul Silas, "He's not intimidated by anyone. He has that swagger that most of the great ones have." Every morning, those were the last words I'd read when I left my apartment for training.

Nice. Are players allowed to take their swagger out the night before a game? What time do you go to bed before a match?

At this level of performance, there's no way a player can go out the night before a game. In fact, if I go out forty-eight hours before a game, I make sure I'm home and in bed early. One thing I've learned as a pro is that sleep is so important. The night before a game—regardless of when kickoff time is—I go to bed between 11 p.m. and midnight and generally try to get eight to nine hours sleep.

Do you eat lunch at Chelsea with the other players? What do they serve?

Generally I sit in the Chelsea canteen with Andreas [Christensen], Timo [Werner], and Kai [Havertz], although I also like to try to move around and join the others as well. As you can imagine, the chefs make really healthy meals—my favorite is any pasta dish they do—they're really good at it.

What do you wear when you're not at work?

Pretty casual things—denim jeans, sneakers, jumpers, hoodies. I really like my Puma stuff—I think I must be close to maxing out my Puma clothing allowance! Around the house I'm happiest in shorts and a T-shirt.

So the Champions League run in 2021. Atlético Madrid was your first opponent in the knockout stage and then the quarterfinal against Porto . . .

Playing the Atlético away game in Bucharest was definitely strange. Both those Atlético games fell in the middle of me going through some personal challenges. I was just not 100 percent there, mentally speaking, and that's probably why I played only a total of sixteen minutes over the two legs. The two Porto games were both played in Sevilla, and we enjoyed it to be honest. The weather was a great break from England; I'd love to live and play in La Liga one day, sunshine 90 percent of the time! In the first Porto match I was a sub, but then immediately after it in our next game, which was against Crystal Palace, I scored. I could feel myself getting stronger, my confidence coming back, and it was a great boost to start the second leg against Porto, with Mason and me playing in behind Kai. I was playing really well at that point, and even though we lost 0–1 in that second leg, I still got the Man of the Match Award. I was kicked all over the field that night; it was a brutal game. Porto was really up for it.

You were fouled eleven times in that game, a record only matched by Messi. What was it like the night before the first leg of the semifinal against Real Madrid—what time did you go to bed; what did you eat; what did you do to relax; did you walk around Madrid?

Above: At Reese's Outrageous launch, Times Square, New York, New York, May 24, 2018.
Following pages: Christmas lunch at Chelsea Training Ground, Cobham, England, December 18, 2019.

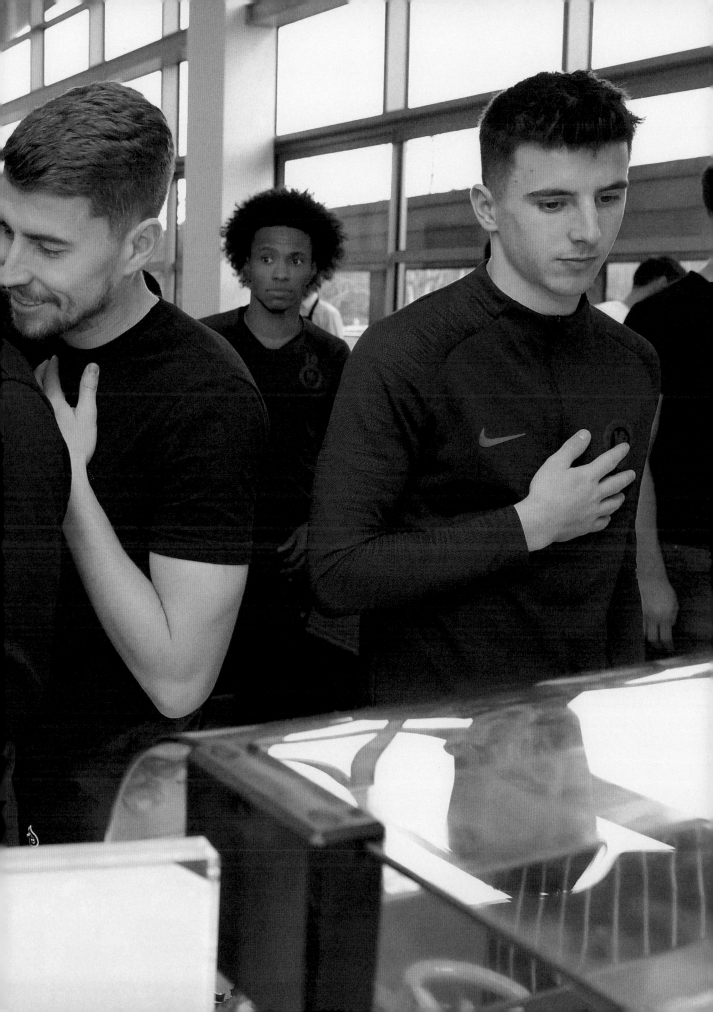

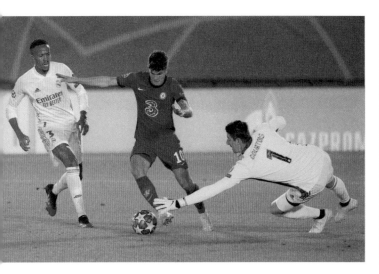 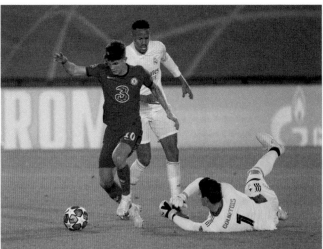

Nothing out of the ordinary in the buildup to the semi against Real Madrid, but of course, you are fully tuned into the fact that you are 180 minutes away from appearing in a cup final that 99 percent of pro players will never play in their careers. Playing Madrid at their training ground in front of no fans almost never felt like a Champions League semi, so that was probably one thing that was a bit of a disappointment on the night. As far as a spectacle goes, these kinds of nights you want to walk out to a full Bernabéu Stadium. Even though that wasn't the case, I definitely wouldn't say that they didn't have home ground advantage. We played really well in the first leg, and I felt that I had a great game. I was in good form, and even though they equalized, that night gave us the belief that a place in the final was on.

The goal. You scored in the thirteenth minute. It was the first goal by a male American player in a Champions League semi. Walk me through it . . . how you walked by Thibaut Courtois . . .

The untold story behind that goal is that when Rüdiger has the ball, I can see he's looking to play it long over the top and I started my run to get in behind the Madrid backline. But as I take off on the run, I hear Thomas Tuchel yelling from the sideline, "Christian, stay in the pocket, don't make the run!" But I just had the feeling I'd find the space and get on the end of the pass, so I continued the run. I cut across the front of Nacho and behind [Raphaël] Varane. When I got the ball I thought I was going to have to shoot straight away, but then I realized that I had far

more time than I thought I would have because Nacho had run to cover the goal line and Varane was more concerned about marking the arrival into the box of Werner. So I thought that I would create a better angle for myself by rounding Courtois and then being able to pick my spot.

You were so composed taking that shot. It was another physically tough game for you: you were fouled six times during that match; the rest of your team were fouled a total of five times. In the past ten years only these players have been fouled six times in a Champions League semifinal: Lionel Messi, Neymar, Eden Hazard, Mesut Özil, and Sergio Ramos.

Part of the job, I suppose! Of course it's tough to be taken down time and time again but if it's going to happen, you always want it to be as near to the opponent's danger areas as possible. Free kicks often win games, so if you are an attacking creative player, you need to try to put a positive spin on the treatment the opposition is giving you and take it as a compliment. Then there's the other aspect—when you need to draw a foul to wind down the clock near the end of a really tight game—much like what happened against Porto. Sometimes pleasure and pain go hand in hand! But the downside is when you get taken out like I was for the USA in the World Cup qualifier in Honduras, and it ends up costing you twelve games—that's really annoying.

What about the second leg against Real at Stamford Bridge?

What happened before that game was hugely

From left: Taking the ball around Thibaut Courtois to shoot and score against Real Madrid during the Champions League semifinal first leg at Estadio Alfredo Di Stéfano, Madrid, Spain, April 27, 2021. Social-distancing laws due to Covid prohibited fans from attending the match.

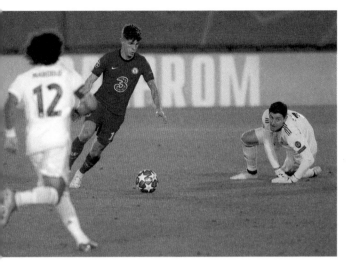

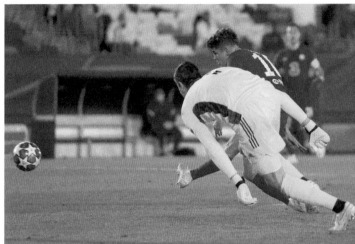

disappointing for me. I'd had a really good first leg performance, and our following match was against Fulham in the league. Tuchel told me that he was resting me for the second leg and as a result I didn't play a single minute in the Fulham game. Then on match day of the second semi, Tuchel tells me he's changed his mind and he's going with Kai. I honestly was dumbfounded and very disappointed. I thought that I'd earned a start and, most importantly, he had assured me previously I was going to start. So by the time he brought me on with about twenty-five minutes left, I was just so wound up. [Edouard] Mendy made some big saves that game, especially two off [Karim] Benzema, and it was a great night at the Bridge. I'd say my assist for Mason was probably my favorite I've ever made. It came at just the right time and closed the game for us. Kanté played me in on the right side of the box, but Courtois had his near post covered—he's a giant, a huge guy. I didn't want to just try my luck with a shot in the hope that he might spill the ball into the path of one of my teammates. I wanted to be more calculating. I noticed Mason nearest to the goal, but he was more central and I needed him to come to the near post and get in front of his man. So I stood on the ball waiting for what seemed like forever for Mason to make his run to get in front of his man. But then there was still a lot for me to do—if you watch closely, I had to lift my pass over Ramos's foot and find the gap with a pass being hit with just the right weight. Going into that game, I was

under strict instructions to get Luka Modrić's jersey! Our family have always been huge admirers of Modrić—my grandfather Mate, my uncle Matt, my dad, and myself. It's the Croatian roots coming out. My uncle Matt even named his dog Luka—so before the second semi I told Kovačić that I was going to swap with Luka. Luka was good about it, and I then gave it to Uncle Matt as a gift. I've also got one of Kova's [Kovačić's] Croatian national team jerseys.

Cool, the chessboard of jerseys. It's great to hear what goes through your mind when you're on the ball. What factors are you considering when you receive a pass?

Being aware of player positioning and space. The pace at which we play means that you've got to know what you're going to do with the ball before you even receive it, and that comes from constantly looking around in a game—where are my teammates; where are the opponents; what spaces currently exist and what looks like it could open up. If you aren't clear on those things, the chances of being caught in possession are so much greater. At this level, losing a ball can result in conceding a goal and losing the match. Barcelona's Xavi was a master of the art; when you look at how often he looked around in a game, you could understand why this guy was hardly ever caught in possession and why he was able to see and make the passes that he did.

What factors are you thinking about when you make a pass?

There's a number of things. First, there's the correct weight on the pass. Second, you want to avoid unnecessarily losing the ball, particularly in your own half. But as an attacking creative player, my job is also to try to help the team win, and that's only achieved by scoring goals. So you need to take some risks at times to try to make the pass that can make the difference and either open things up or directly lead to a goal. Risks have a chance of failure, so you need to be part of a team that is well drilled to anticipate and recover possession. A lot also depends on the movement of your teammates into spaces that you can anticipate, and that comes from player intelligence and playing a long time together—you get to know each other really well, so you can anticipate things.

What are you considering when you take someone on?

At our level, attackers aren't judged in terms of one versus one. You've got to think of one-versus-two and one-versus-three situations. So in one versus one and with some open space, you are considering whether your opponent is quick enough to catch you in a straight sprint and whether you may need to slow down for a split second to either throw the opponent off balance or lure him into lunging at you. Then with a bit of skill and a change of pace, you can get away from him—like my goal against Manchester City in 2020. Other times, when it's one versus two, one versus three or even one versus four, like my assist versus Liverpool at Anfield, in a split second you need to sum up the space between the players that surround you and think, If I can get through these two, will it be enough to throw the others off-balance or wrong-foot them so that the space opens up enough for me to have a good chance of continuing the run? Dribbling is a lot about confidence. When your confidence is up, it's like you can dance or float past players—how often throughout his career did Messi go past players like they weren't even there? But when your confidence isn't there, it can look ugly—you take on a player, he dispossesses you easily, and then you can look clumsy and awkward.

That I can relate to. The Champions League final, what was it like leading up to the game—the flight over, the hotel, the food, the training? Did you sleep well the night before?

The whole routine of the flight over, the food, the sleeping—it is pretty consistent with all the Champions League matches that we play away from home. We always travel the day before the game, and then most times we'll train at the venue around twenty-four hours before the game to get a feel for what the conditions could possibly be around the time of the match. At a big club like Chelsea, you are fortunate that you get more chances to play in cup finals than what

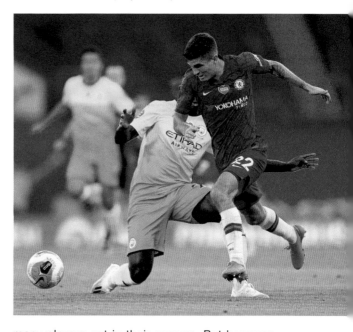

many players get in their careers. But however prepared you may be for these types of special occasions, the biggest thing you still notice in the week leading up to the game is that there's just that little bit more fire among the squad. Everyone has one eye on the game, and that seems to add that extra yard of quickness in your play or that extra bit of bite in your tackles. You want to impress, right, because you want the coach to know you're ready and fired up.

You had an immediate impact when you came on as a sub. In the moment, what were you thinking? What were Tuchel's instructions to you?

By that stage, everything is just about the team—you've come this far, you're desperate to win. I knew I'd make a difference, and I feel that I did. Tuchel's main brief wasn't anything special; just

Running past Benjamin Mendy before scoring in the Premier League match against Manchester City at Stamford Bridge, London, England, June 25, 2020.

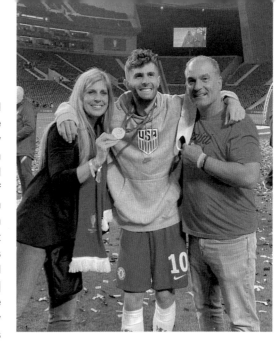

how I needed to hold our shape, how he wanted me to defend and hold the lead at that point. He wanted me to use my speed and dribble to try to take us up the field as much as possible. In games like this—as in all the big games—you feel a bit anxious. Then once you've had a couple of touches and you feel good, you kind of lock in and are fully focused on the game. The coach will talk tactics and different plays in different situations. He may make some major changes in playing formation or certain minor positional tweaks to the team. For example, in the [2022] Carabao Cup final against Liverpool, he put me as the right number 10 because he thought my pace could possibly unsettle van Dijk. Things like that. But ultimately when you get on the field, players need to think for themselves and improvise and find their own solutions, in order to try to outsmart your opponent.

At the end of the Champions League final, you collapsed as soon as the final whistle went. What's the feeling when the whistle goes at the end of a match like that?

You can't really describe it. It's almost surreal. You think that you will feel it more than you actually do, but in the moment I just had to tell myself what had happened here—I'd become a Champions League winner! You think back to all that's happened in the buildup to that point; the moment you first touched a soccer ball, the amount of work that you've put in to get to that point, the things we've sacrificed. It sort of flashes in front of you for a split second. Then you get yourself together and you celebrate with your teammates. It's just that moment the final whistle goes, you get lost in your own world.

After the final whistle, during the celebrations, you wore a USA soccer hoodie. It was poignant, since you are the first American-born player to play in the men's Champions League final.

My dad was actually wearing that hoodie at the game, and initially family members were not allowed onto the field. So my dad gave the hoodie to Thomas Tuchel's wife and asked her to give it to me. You always see players celebrating with their country's flag around their shoulders and that sort of thing; it's a moment that you feel you have been part of something unique and special, and you want to share it with the fans back home

because you're saying, "Even in this incredible moment, I'm proud to have represented both my club and my fellow countrymen. Thanks for watching and supporting me." My mom and dad then made it onto the field, and while we were walking around celebrating, we called a few friends by FaceTime, Nick [Taitague], Danny [Barbir], Matthew [Moore], and also Bob Lilley. I'd say Bob was like one of my idols growing up, my mentor. He's a coach in the USL Championship with the Pittsburgh Riverhounds. He never coached me as part of any team when I was growing up, but he's my dad's best friend and he was always there when I was a kid. We played countless rounds of golf together, and we used to go out to the fields to kick around. At any family event, he was always there . . . he was just such an important person in my life.

That night there was a lot of dancing, singing . . .

It was a bit surreal on the night because the Covid restrictions didn't allow for a full house in the Porto stadium. But at least it wasn't empty like the FA Cup final the previous season. We stayed and celebrated in the locker room for a long time. It was just completely crazy. Guys were singing, dancing, and filming to post on social [media] and to send to their friends and family. Then back to our hotel where we celebrated all night. I just kept having to remind myself, This is actually happening!

A perfect end to the season. That year at Chelsea, what was it like losing Frank Lampard? What was it like going through all the ups and downs? How did you stay motivated and fit?

Above: Celebrating with Mom and Dad after winning the Champions League final against Manchester City, Estádio do Dragão, Porto, Portugal, May 29, 2021.
Following pages: Raising the Champions League trophy with the team (Toni Rüediger on my right; Kai Havertz, Tammy Abraham, and Jorginho on my left), Estádio do Dragão, May 29, 2021.

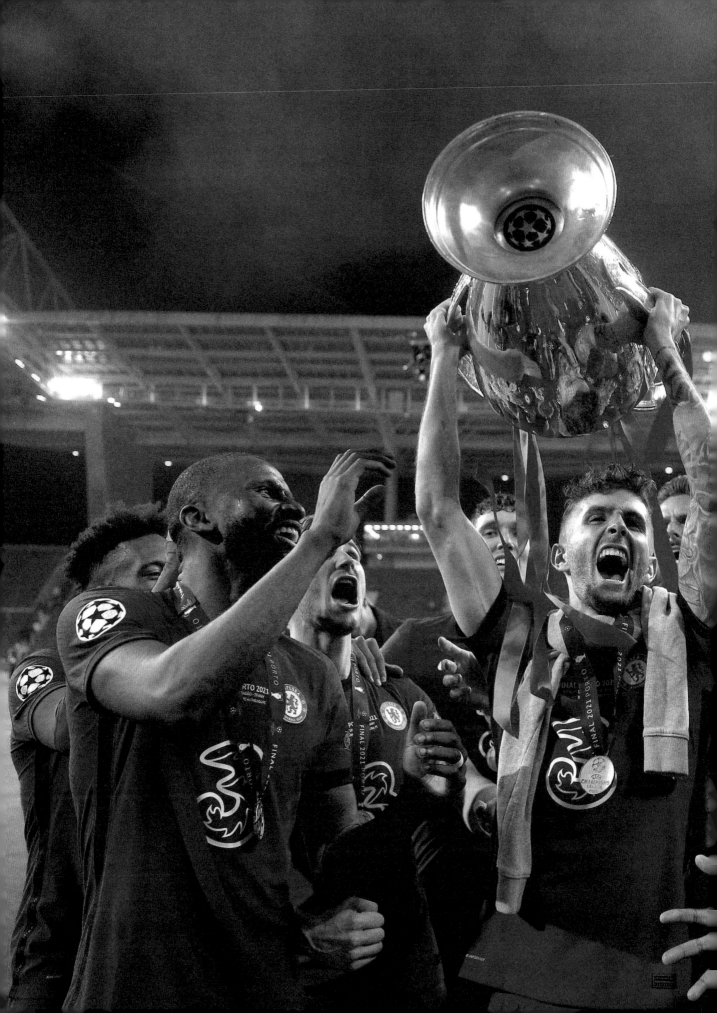

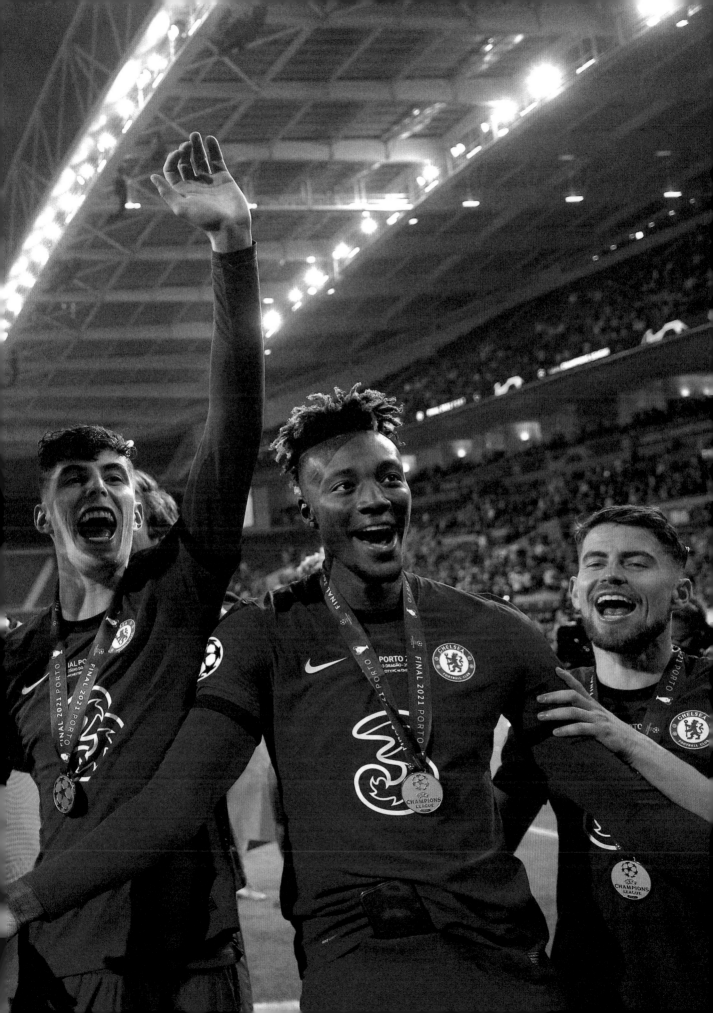

That season ended spectacularly, but going back right to the beginning, in July 2019 when I joined Chelsea, it was a really tough start under Frank. On the one hand I could sense that I wasn't his signing, so to speak. On the other, although I was relatively young, both he and Jody [Morris] wanted to give the academy graduates the maximum chance of succeeding. So there were times when I felt a little caught in no-man's-land. It was a bit of a battle trying to win him over. In particular, in my first season there was a spell of five games after the September FIFA international break which, if you take out the Grimsby Carabao Cup game, I didn't play one single minute—that was one of my toughest spells at Chelsea. You're a big-money signing, you're fully fit, and your manager's not giving you a single minute for a prolonged period; you start to have some doubts and your confidence takes a knock. But I just had to keep my head down. Eventually when I got three sub appearances against Southampton, Newcastle, and Ajax, the pressure was enormous to have to do something special to convince him I was worthy of more playing time. I made a good assist for [Michy] Batshuayi's goal versus Southampton, had a hand in the goal for the 1–0 win versus Newcastle, and then assisted Bats again for the game winner at Ajax in Amsterdam. And then I had a good run of games after that. But throughout Lampard's time as my manager, and with the injury setbacks I had, plus the Covid phase; it was probably characterized by me constantly feeling that I had to prove myself over and over again. I remember having this conversation with Clint Dempsey—he said that he also felt that throughout his time in England. Looking back, by the time Frank left I felt that I had finally convinced him of my value to the team. I had started to gain an appreciation for him as a manager. It was not an easy journey, but at least under him I knew that if I had a couple of good performances, he'd then give me a reasonable run of games. That's all that a player asks from his manager, "Give me a run of games to show you what I can do." I was sad to see him go. The end of Frank's reign also coincided with me having my darkest days off the field. I was battling depression, and it was a very tough period that saw me probably hit rock bottom in February of 2021 and have to reach out to get professional help—quite frankly, without the support of my family and my absolute closest circle of friends, I don't know how I could have come through that period.

Thank you for sharing that. Mental health is amazingly still taboo in certain circles. The more it's normalized, the more people will realize it's completely OK to reach out for help. Therapy is a good thing.

Yeah, going to a therapist is not something that anyone should be ashamed of. It's important to be able to speak to someone.

Absolutely. Pretty much everyone in New York goes to a therapist. So, the Premier League doesn't stop for Christmas and New Year's. How do you celebrate?

In Germany it was great—I was always at home and had family around. We're a close family and all of us cousins get on really well, so occasions like Christmas are important to us. At Chelsea it's been different—no such thing as Christmas break. Last year

Preseason training with Frank Lampard at Chelsea's training ground at Cobham, England, July 24, 2020.

with Covid, it was difficult for my family to travel to London, so I spent Christmas Eve at a friend's house, put my Christmas crown on, pulled the crackers, and had a glass of red wine and a nice roast beef just like most other people. Then it was off to work on Christmas Day, which most people don't do!

No, most people watch you at work! We should have Christmas crackers in the US. You brought the Champions League winner's medal and Concacaf Nations League winner's medal to PA Classics on June 11 just a week after winning the inaugural Concacaf Nations League trophy and only two days after playing Costa Rica in a friendly in Utah. During that game, a commentator said that in a couple of days you'd be on a sunny beach relaxing away from it all. But in fact you were back home in pouring rain opening a new training facility you'd helped design and donated the funds for at your childhood club and spending time with hundreds of young players and fans—quite a few of them interviewed you for a good ten minutes. So what do you prefer, the English media or being grilled by five- to ten-year-olds?

I definitely enjoy being grilled by five- to ten-year-olds! You know that they are asking innocent questions without any ulterior motives, and their questions are a welcome break from the same sort of questions one always gets asked in the media conferences. Just in general, I really like to interact with kids and my aim is to have a positive impact on them developing a passion for the game. I feel that the way I can do that is by helping inspire more kids to play soccer. I want to get them excited about the game, and I guess that this goal also inspired me to open the Pulisic Stomping Ground at PA Classics. I really wanted it to be a place where kids could go train, develop their skills, and—most importantly—have fun playing the game.

Did you feel it was important to give back to PA Classics?

PA Classics was my boyhood club, I had many happy memories there, and they were brilliant in the way they dealt with my transfer to Dortmund. Classics never went to Dortmund demanding any money, like so many clubs do these days and end up placing hurdles in the way of a youngster trying to make it just to first base in the pro game. So I felt that I wanted to say "thank you" in an appropriate way. My dad was great with the input that he gave to the design and development of the skill challenges that we built and also the various upgrades—it added some fun and skill elements for the kids, and at the end of it I felt very proud to have made this contribution.

You're very approachable, and unlike many athletes today you look relatable, like a regular person—a very fit regular person—which I'm sure is inspiring to kids dreaming of playing professionally. You hear accounts of athletes in some sports being told they're not big enough or strong enough to play. Did you ever encounter anything like that?

Many times over the years! "Lightweight," "Won't be able to compete with the big boys"—I've had a few things thrown in my direction ever since I can remember. But you can react by either letting it annoy you, destroy you, or drive you on to greater heights because you want to show them. I've always adopted the motivation approach, and my advice to kids would always be to keep quiet and do your talking on the pitch. Lack of size is a challenge at the very highest level, but some of the game's greatest players haven't been the physically big ones—Diego Maradona, Leo Messi, Xavi, Andrés Iniesta, N'Golo Kanté; the list goes on. When you are smaller, you definitely need to bring something extra to get the coaches to sit up and take notice. In my case

Christmas Eve with my mate Terrell Lowe, London, England, December 24, 2021.

that was speed, and I also worked really hard on first touch, technique, and my dribbling skills.

You've been working on your English accent too. You did a very decent Cockney accent on Good Morning America on June 14, 2021, after winning the Nations League. How's your rhyming slang, as in "my shot hit the beans" . . . beans on toast—post!

I actually starting picking up the English accent and the rhyming slang words when I spent that year as a kid in Tackley. You're with locals all day, every day, so you hear the way they talk. It was a little crazy at first because I'd never heard anything like it. At Chelsea a few guys say a few words, but as in every dressing room, there's a lot of foreigners so you don't hear too much of it.

When did you first hear your nickname Captain America? Do you like it?

I think I first heard it when I was at Borussia Dortmund, and the whole thing just blew up when I started playing and scoring for the US national team. It's not a nickname that I particularly like because there's a lot of sports people that get this nickname, so I'm like a Captain America version 4.0 or something. I'm looking forward to the fans giving me a more original one. Maybe I'll run a competition on my social [media], or something.

Before a game you like to keep a routine, to eat at the same time and sleep at the same time. What's an example of a meal you'd have the evening before? What's for breakfast on game day? Do you have an OJ? A coffee?

Match day depends on so many factors—is it home or away? Is it a lunchtime, midafternoon or evening kickoff? If it's a home game, are we camping together the night before the game or are we going direct from home to the hotel meeting point on the day of the game? But generally, there are a few things that I keep constant. The night before the game I always try to go to bed between 11 p.m. and midnight and get eight to nine hours of sleep. For breakfast I'll usually have some avocado on toast and scrambled eggs, or some fruit. And then we normally have a short walk together

as a team, followed by a team meeting. If it's a night kickoff, I'll have about a one-hour nap later in the afternoon.

In the locker room just before a game, how do you prepare mentally?

Normally the preparation starts some time before that. When we're on the bus, some guys get into the "zone" by putting in their earbuds and listening to music. But I'm not big on needing a song to get me pumped up. I prefer to just look out the window and get a little lost in my thoughts. Not about the game, just other things. We get to the locker room around ninety minutes before kickoff, and at that stage, the music is on and the guys are getting into the vibe. At Chelsea, if the kit guys are responsible, it's for sure going to be house music. If it's with the US national team, then it's hip-hop and rap. Some guys like a good rubdown before going out onto the field, but not me.

At the end of every game, do you personally reflect on your performance in any specific way?

My dad thinks I'm maybe a bit too hard on myself. I'm constantly pushing myself for error-free, for five-star, for world-class. I very rarely need to be told when I've been excellent, average, or poor—I know it deep down. Whether that's a good or bad thing, it is what it is. But my dad knows me inside out—all aspects about me—and he's been brilliant throughout my career with the guidance and encouragement he's given me. Sometimes if

US fans during the World Cup qualifier against El Salvador at Lower.com Field, Columbus, Ohio, January 27, 2022.

I'm going through a more lengthy tough spell and I need an extra set of eyes and a bit of a deeper dive into the technical analysis of my game, I will have a session or two with Fran [Rubio] of Ekkono Soccer Services in Barcelona. He'll analyze my recent games and then pick out three or four things to go through with me and tell me to concentrate on during the next three months. I also chat with my close friend, Nick Taitague, who himself was a great player before his career was cut short by injury. Nick and I played together for the US Youth National Team, so we communicate from the perspective of being ex-teammates and again, during the course of those conversations we pick up on small things that I then apply to my game.

So you've won the Champions League, the Super Cup, and the Club World Cup with Chelsea; the Nations League with the US; the DFB-Pokal—Germany's cup competition—with Dortmund, and individually, the US Soccer Young Male Player of the Year in 2016 and the US Soccer Male Player of the year in 2017, 2019, and 2021, among many *other awards. Do you set goals for yourself? Are there any competitions or awards or specific achievements you have your sights on?*

In the club context, I'm probably like every player —when a competition starts, you want to win it, especially at a club like Chelsea—winning trophies is part of the DNA of the club, and even our playing contracts are geared to only rewarding ultimate successes, like winning trophies. But yes, I'd like to win a cup final at Wembley! I've played there three times and lost each one, and that sucks. Losing on the twenty-second penalty kick to Liverpool was particularly brutal. [Two months after this conversation, Pulisic made it to his fourth final at Wembley—the closely contested FA Cup final between Chelsea and Liverpool—unfortunately losing once more on penalties.] National team—I'd like to go one better and win a Gold Cup after losing to Mexico in the 2019 final. As far as the World Cup goes, I suppose that anything can happen with knockout football, as Greece in 2004 and Denmark in 1992 discovered in the Euros. But the World Cup

Relaxing with friends Nick (wearing Nikola Jokić's Denver Nuggets #15 jersey) and Alec Taitague on my left, and Matthew Hoppe on my right at home in Jupiter, Florida, June 26, 2021.

is another level, and in my lifetime, my realistic target would probably be to become a key member of the generation of American players who went furthest in the competition. Individually, of course all players dream of being a FIFA Best or Ballon d'Or winner, and I'm no different. I've actually got another "Post-it"—the screen saver on my laptop, which is a photo of the Ballon d'Or.

You have played in the USA, in Germany, in England—are there differences?

I'd say that the atmosphere at club games in England and Germany is pretty similar—fans singing throughout the game; there'll be songs they've created for certain players. It's all very intense—they don't want to lose. When playing in the USA for the national team, it's different; there's not really much of the singing of songs of individual players, not as intense an atmosphere, not as "end of the world" if we lose, not as "tribal" is maybe one way of describing it? USA fans are different but nevertheless very supportive of our national team—just in a different way. Maybe it's got something to do with our relatively young history in the game compared to Dortmund and Chelsea—clubs that are more than one hundred years old; have won many, many trophies; and have had legends of the game play for their teams.

How about the training?

Training is really down to the type of coach that you have. In my experience, if you have an English coach, he's likely to demand harder sessions and be very intense, for example. If you have a German coach, he will probably be more strategic in his approach; he'll select which days to go harder and which days to take the foot off the gas a little. So it does not matter what league you are playing in, it's more about the philosophy of the coach. During match days it is pretty similar in intensity, Germany compared to England, but I'd say the games are more difficult in the Premier League because overall, the teams in the Premier League have a better quality on average than in the Bundesliga. There's rarely an easy Premier League game—even the guys near the bottom of the table come out and really have a go at you.

Are there any grounds you like in particular?

There's a lot of good stadiums. The Bernabéu

is unbelievable, the Azteca is just ridiculous. At the Bernabéu you can smell the history, the great players who have played there, the trophies that they've won. Their fans expect and demand the highest levels of success. Azteca Stadium in Mexico is also pretty wild because of the fan support for Mexico. It has a superhot atmosphere, and it's always a big occasion when we play there for the USA. So that's always a game you look forward to. Then of course, there's Dortmund. When you're a teenager and you have the privilege of playing a Borussia Dortmund home game in a full Signal Iduna Park—that's 83,000 fans—and score; it really is hard to beat that. It is not super high-tech like some of the latest stadiums are. It is a real "football stadium"—a stadium that the working-class fans can identify with and feel good about as equally as the business guys can in the areas that have all the frills, the food and drinks, and entertainment. The Yellow Wall is just phenomenal, and you get a real sense that the home fans are proud of their team, their club, and their heritage. Wembley is also iconic, fantastic locker rooms, a beautiful stadium when it's full. But I have had some bad luck there—lost three cup finals [unfortunately, four before going to press], a Champions League match against Spurs when playing for Dortmund, and an international for the USA versus England. My only successes there have been two FA Cup semifinals, both against Manchester teams! [And, recently, a win against London's Crystal Palace.]

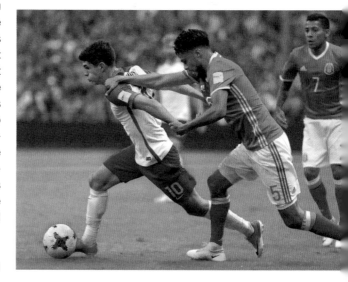

Battling with Diego Reyes of Mexico at the Azteca Stadium in the 2018 World Cup qualifier in Mexico City, Mexico, June 11, 2017.

Has any player walked over to swap shirts with you who stands out or who came as a surprise?
Probably the one that stands out was when I was a young player making my way at Dortmund. After a game against Bayern Munich, Arjen Robben came up to me to ask to swap—that was pretty neat because he was a huge player, he won it all.

Have you ever been in awe of playing against someone?
Not really, it's more like being motivated for a match which involves a great player. But not in awe. I suppose the closest you could say that I've come to really feeling something extra special was that Copa América Centenario match in 2016, when we lost 0–4 to Argentina. I so wanted to start that game. I was still seventeen years old then and obviously had to be content with minutes here and there. But I thought that I'd done well in the limited time I had played up until that point, and with Leo Messi having won his fifth Ballon d'Or a few months prior and Barcelona having won the Champions League a few weeks earlier, he was at the height of his greatness and I couldn't wait to be out there on the same pitch as him. Messi was incredible—two fantastic assists either side of an unstoppable free kick into the top corner makes you just sit there and think that this guy is from another planet.

During tournaments where you travel and spend time in hotels, like during the Club World Cup in Abu Dhabi, what do you typically do to relax?
Generally during tournaments the coach will focus on training and tactical preparation for the next game. In between we're pretty much left on our own to do whatever we want during our free time. In preseason there will be a few sponsor events to attend, but when it's a situation like a Club World Cup, we don't really have those kinds of commitments. I just use my time to continue doing the things I normally do, like playing online chess or watching a movie or series on Netflix.

Do you get to sightsee a bit?
Sightseeing very rarely happens. Everything is focused on the game. I could say that I have been to many, many cities in the world but seen virtually none of them!

How often do you go out with the Chelsea squad? What do you usually talk about?
We go out a few times each season as a group, often when there's something to celebrate or if we're going through a rough patch then to bond a bit more. We never talk about football—everything else except football. Music, whatever is news at the time.

You've mentioned that you get on well with N'Golo Kanté and Andreas Christensen. Are they friends you confide in, or are your closest friends back in the US?
My best friends are Nick Taitague and Danny Barbir—both former US Youth National Team teammates of mine. I first met Danny when we

Getting snapped by Mason while recovering with air compression pads at Cobham, England, September 4, 2021.

played together as fourteen-year-olds on the id2 [National Identification and Development Program] representative team. And Nick I've known since we were both at the IMG Academy in Bradenton with the USA U-17 national team, I think around 2013. We became really tight when I was playing for Dortmund and he was playing down the road for Schalke. And naturally, I'm also very close to my parents. They are my confidants, and they know me better than anyone else.

How about video games? You've met up with Ninja and you occasionally stream on Twitch. Do you connect with fans through gaming?

I've streamed with Bugha, and I met Ninja and went for dinner with him in London. He is a really cool guy. I do enjoy playing video games; I normally play *Fortnite* or *Call of Duty: Warzone* if I'm playing with my friends online. If I have people over in person, then I usually play *FIFA* [*EA Sports*].

Do you pay attention to your numbers on [EA Sports's] FIFA ranking cards?

Of course I pay attention to my *FIFA* ranking. I was pretty happy with my card this year but not so happy with a thirty-seven for defense. I definitely think I put in a better defensive shift than they are giving me credit for!

Do you still enjoy Ping-Pong and swimming?

Yeah, I still enjoy swimming. I have an indoor pool at my house. I also have a sauna that I like to jump in after I do a few laps. I do have a Ping-Pong play area in my house as well, but lately it's taken a bit of a back seat to my chess and guitar playing.

How often do you play guitar? Do you have a favorite guitarist?

Besides video games, I'd say that probably chess and playing guitar are my two favorite things that I do at home. I have got an electric guitar, a Gibson Les Paul Studio, and I like to practice when I get home from training. It helps me wind down. The song that I can play best is "Fast Car" by Tracy Chapman, and as far as guitarists go, I really admire Jimi Hendrix. But I don't dive too much into the history of guitarists—I just like to play.

How did it feel to play and score in front of fans for the first time after a year of Covid restrictions? What was it like playing in empty stadiums?

It was really difficult playing during Covid times and in empty stadiums. The lack of atmosphere was like playing an eleven-versus-eleven game in training—it was definitely not easy at first. We felt as though we never had a home game, but also it was far less of a deal when you played away. It was just weird, and quite honestly, I hope that I never need to go through that again in my lifetime. As players we live for the passion that this game brings us, and we live for the emotional outpouring that the fans bring to a match. Scoring an important goal in a packed, red-hot stadium—for me, there's just no feeling that can come close to beating it. If you're the goal scorer, it's like you have an umbilical cord that goes right to the heart of every fan in that stadium.

What are practices like during Covid?

At first there was the lockdown, and we were forced to stay at home and basically train there. Chelsea delivered an exercise bike to each player's house and between that and doing some work in my back garden, that was pretty much it for trying to maintain some sort of level of fitness. Then Chelsea allowed me to go back to my house in Jupiter, which was a huge relief for me, being closer to my family. While there I was able to do some training with my dad and guys in my bubble at the time—my cousin Will and my former USA U-17 teammate Logan Panchot—and the main aim was just to try to maintain sharpness. When it eventually came down to being allowed back onto the training field with

At home playing my Gibson Les Paul Studio, which helps me unwind after games, London, England, February 28, 2022.

Chelsea, it was with small groups of players and staggered at different times. The environment was super controlled, and there were a lot of unknowns and things that unsettled many of us because no one had experienced this situation in their lives. But one thing that I found amazing during the whole time was how we, as players, managed to adapt to the Covid experience and it psychologically became like a new normal for us. From home training to small groups to expanded groups to playing in empty stadiums, all the different rules and protocols—all totally weird stuff for us as high-performance athletes—but you just need to be able to adapt. But looked at from a different perspective, at least during certain times when the greater population had to stay indoors, we were able to get outside, exercise, and have some sort of interaction with our workmates.

How does it feel to have your own book?
Really cool! The concept of my career so far, in pictures, seemed like a neat way to celebrate the first twenty-four years of my life and my first seven years as a professional. I hope the book gives fans an insight into this period of my life in my words and with some never-before-seen pictures. I didn't even know some of these photos existed.

Your mom's a really good photographer—all those shots from your childhood are amazing.
Yeah, she is.

And so nice to talk to.
Yeah, she's the best.

Are there any books you especially like?

At the moment I'm working through the *Harry Potter* series, and I'm really enjoying them. My favorite character is Dobby, the house-elf. When I was young I was scared of him in the movie theater according to my mom but slowly I've gotten to like him and he comes up really big in the end. I like a lot of *Harry Potter* characters. There's a *Harry Potter* studio tour in north London that I'm hoping to visit soon when the weather gets better and we have a day off. When I was a kid I used to love poems, and my favorite poetry books were by Shel Silverstein. I used to try to memorize all of his poems. I still have those books today, including my three favorites, *Where the Sidewalk Ends*, *A Light in the Attic*, and *Falling Up*.

Cool. Silverstein also wrote that Johnny Cash song, "A Boy Named Sue." If you didn't become a soccer player, what do you think you would have been?
A professional in another sport.

Your sister loves horses and has made a career out of training and housing them. How are you with horses?
I can ride already; I know what I'm doing, but I'm not going to get into jumping or anything like that! It's always been Devyn's dream to work with horses. Watching her in action is awesome. She weighs like 100 pounds and you see her on the back of a horse of a thousand pounds or more, jumping four feet into the air—it's

Top: Horsing around while visiting [grandma] Momma Joy's house, Burke, Virginia, 2000.
Bottom: With my mom at home. I'm wearing a Holland jersey, Canton, Michigan, 2008.

ridiculous to me that she can be that small and have total control of a massive animal like that. Her dream was always to work with horses, and I'm very happy that she's been able to do it.

What are you most proud of so far? What are your favorite personal highlights?

To single out one thing is impossible. I've been blessed to have represented my country and played for such huge clubs; to have won many trophies; met famous people; been able to secure my future, financially speaking; and to have played a small role in helping my family and my community—basically, at twenty-three years old I've been able to live my dream. But probably what I am most proud of, and what I thank God for every day, is having the willpower and the drive to come back from times of adversity. For having a spirit of never giving up, even in the most challenging times; being able to get up from the canvas time after time and continuing the fight. So in a way, you could say that my favorite personal highlight has been the way I've coped with the "lowlights."

Your parents recently moved to Florida and you have your own place there too. Is Florida now home, or do you still think of Hershey as home?

Hershey will always be home. You know, it's that special bond that is created and the never-to-be-forgotten memories that you build up when you are growing up.

What are your favorite things to do in Hershey? Are there favorite roads you like to bike on?

When I was young, there was no question about

my favorite Hershey "thing"—riding the Great Bear at Hersheypark! It's an inverted roller coaster that was frightening, a real adrenaline rush. The most frustrating days of my life were waiting to grow to fifty-four inches so that I could take the ride! Nowadays when I'm in Hershey, I enjoy just hanging out with my friends and family. I've also enjoyed my interaction with the community—whether it's paying a visit to the Pulisic Stomping Ground or to the Milton Hershey School and interacting with the kids and trying to add some additional value to their life experience.

The kids at PA Classics asked what's next after football. You said working in soccer with kids. It's a long way away, but do you think managing youth teams would be the next step?

I enjoy working with kids, but right now, I can't really imagine what's next. I'm so focused on my career and haven't given it much thought. But whatever it is, I'm going to approach it with the same determination to succeed.

There's a long-running interview program on BBC Radio 4 called Desert Island Discs. *The interviewee selects eight records from which songs are played throughout the interview. At the end they are asked if they could take only one record— album or song—to a desert island, what would it be? They are also allowed to take one book and one luxury item. What would be your record, book, and luxury?*

The one book would be *Harry Potter and the Goblet of Fire.* One record is tough. We used to have three CDs in my dad's car, and we listened to them all the time. Kelly Clarkson, James Blunt, and Kid Rock—we just rotated through those. They became like my staples. So it would have to be one of them. I'd say Kid Rock and his good vibes—and it's probably got to be "All Summer Long." Luxury item? If it could be called a luxury and if I know there's guaranteed to be a signal on the island, then it's my iPhone.

You've traveled all over. If you were to have three homes anywhere in the world, where would they be?

One is already there, in Jupiter, Florida, and then one home in Hershey. And the third one would be somewhere in Spain near the beach. I love the lifestyle and weather in Spain—I definitely want to play there at some stage in my career.

@Christian Pulisic

Hey you can't always get your tik tok right on your first try 🤣😵 #fyp #firstvideo

♫ original sound

If you had the chance to play with anyone—you could travel in a time machine and be a teammate of Pelé, Figo, Ronaldinho, or someone else—who would it be?

No need to! He's here in the present and I'm playing with him—N'Golo! What a player. Man, he's a machine. He's got it all and he's a classic example that size doesn't matter, even when playing in one of the most combative roles on the field.

Your mom has kept your fan mail—there's so much fan mail from all over the world. I saw letters from patients you'd visited in hospital; you'd really made an impact on their lives. And you regularly donate jerseys you've played in to be auctioned for charity. When did you first start doing that kind of work?

Back when I was with Borussia Dortmund. The good thing that clubs do is to make players aware of how fortunate they are in their lives and how important it is to try to bring some happiness into the lives of those less fortunate. So I've identified a few projects that I support from time to time. The years leading up to the 2026 World Cup in the USA will obviously be massively important for the game in our country, and they also will provide opportunities for players to play a role in spreading the soccer gospel. So together with Puma, we're working on creating a legacy program that can add value to communities across the USA, and I'm looking forward to contributing toward that.

You get thousands of comments on an Instagram post. Do you personally check your social media?

As you say, I get many, many messages—most of which I appreciate, but some of which are just destructive and negative. Sometimes when I'm under time pressure I just quickly flick through my messages without reading or studying them thoroughly. If I notice they are from a friend, I send them a "like."

TikTok. Your first post was amazing. And then your freestyling when you're not falling over is truly a thing of beauty.

Yeah, that TikTok was pretty funny! I remember I was bored during the Covid lockdown, so I was just filming myself doing a few kick-ups and tricks . . . but then I stood on the ball by mistake and wiped out! I was like, Oh that would be a super funny TikTok. So I put it up and it kind of blew up. You've got to be able to laugh at yourself sometimes.

I hope by now you've had a chance to sample Cadbury's milk chocolate. What's the verdict? Hershey's or Cadbury's?

You can't ask that question! It's like being a passionate Manchester United supporter your whole life and your whole family support Man United . . . then you go watch them play a match against Liverpool, and someone asks you, "You've watched Liverpool, who do you like better?" Not even close—of course Hershey's!

I have a pretty unusual name, and it often gets mangled when people try to say it. What's the worst thing anyone's done to your name?

I don't like it when they say "P-eU-le-sic."

And just for the record it's Puh-LISS-ic.

Indeed.

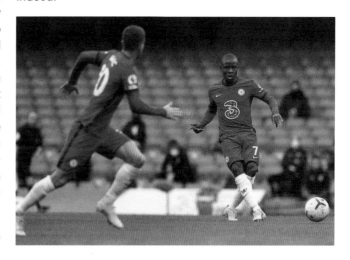

Opposite: On the Chocolate World ride with my cousins (a family tradition over the holidays), Hershey, Pennsylvania, winter 2009.
Top: My first TikTok video at home in my garden, London, England, March 19, 2020.
Right: Receiving a pass from N'Golo Kanté during the Premier League match against Southampton, Stamford Bridge, London, England, October 17, 2020.

SHOTS
Commentary by Arlo White

October 26, 2019. Turf Moor, Burnley. "What a moment for Christian Pulisic—his first Premier League goal!" I had waited a few months to deliver that line. Since his arrival at Premier League powerhouse Chelsea FC from Borussia Dortmund that summer, Christian Pulisic's introduction to the world's greatest and most competitive soccer league had been understandably difficult. The weight of expectation from a demanding Chelsea fan base and the scrutiny from hordes of US fans across the pond were both extraordinarily high.

Turf Moor is not an easy place for skillful and highly technical footballers to express their talents—not least when they should still be figuring out the extra pace and physicality of the English top flight. Burnley is a proud working-class northern town. On the approach to the stadium, Pulisic may have noticed Burnley's sandstone cotton mills, with their slate roofs and tall chimneys. They are a legacy of the town's prosperity during the Industrial Revolution. The stadium is four-sided with open corners, which allow chilly gusts of wind to swirl over the pitch. Burnley's team reflects the community: gritty, hardworking, uncompromising, and tough as old nails.

This was only Pulisic's fourth Premier League start. Upon seeing his name on the Chelsea team sheet up high on our commentary gantry, my fellow commentators—Lee Dixon and Graeme Le Saux—and I raised a collective eyebrow. We know that Pulisic is good, but he has not yet scored a goal. And this is Turf Moor! What followed was simply magnificent.

Twenty minutes into the game, Pulisic stole possession from the Burnley full-back, Matthew Lowton, and sprinted toward the Burnley penalty area with the ball under his command. The veteran no-nonsense defender James Tarkowski blocked his path to goal. Pulisic slowed. Tarkowski knew that the American could embarrass him in either direction. Suddenly, a step over with the right foot, and Tarkowski bit. He was off-balance, and Pulisic knew it. One touch with the right foot and the Burnley number 5 was flailing. Reinforcements had arrived to bolster the Clarets defense, but no matter. Pulisic arrowed a perfect left-footed shot through the forest of Burnley legs and into the far corner of the net. Goalkeeper Nick Pope—an England international, no less—helplessly flopped to the ground. It was a physical admission that he had no chance of keeping the ball out.

Pulisic simply oozed confidence and assertiveness that afternoon. Every touch had a purpose, every movement was designed to sweep Chelsea into attack with quicksilver skill and panache. This was the Christian Pulisic that the Chelsea fans had craved to witness, and they roared their approval just before halftime when he beat the hapless Tarkowski once again, scoring with his right foot.

The crowning moment of Pulisic's afternoon arrived in the fifty-sixth minute. Mason Mount crossed the ball from the Chelsea left. Burnley pride themselves on their aerial dominance, but Hershey's finest leaped the highest at the near post and glanced a delightful header into the opposite corner. It was a perfect hat trick. Left foot, right foot, header. Wow!

Pulisic announced himself to Premier League followers as a special soccer player that afternoon. He showed himself to be one of those players who can set pulses racing. Whether it is with a turn of speed down the wing or a lightning piece of skill to move past a defender, he raises the excitement level of any game. In the pages that follow, we relive some more of those outstanding moments with him. I hope that you enjoy his journey as much as I have.

Preceding pages: With street artist Solomon Souza at his art installation to commemorate International Holocaust Remembrance Day 2020 at Stamford Bridge, London, England, January 13, 2020.
Opposite: Raising the Champions League trophy after we beat Manchester City in the final at Estádio do Dragão, Porto, Portugal, May 29, 2021.

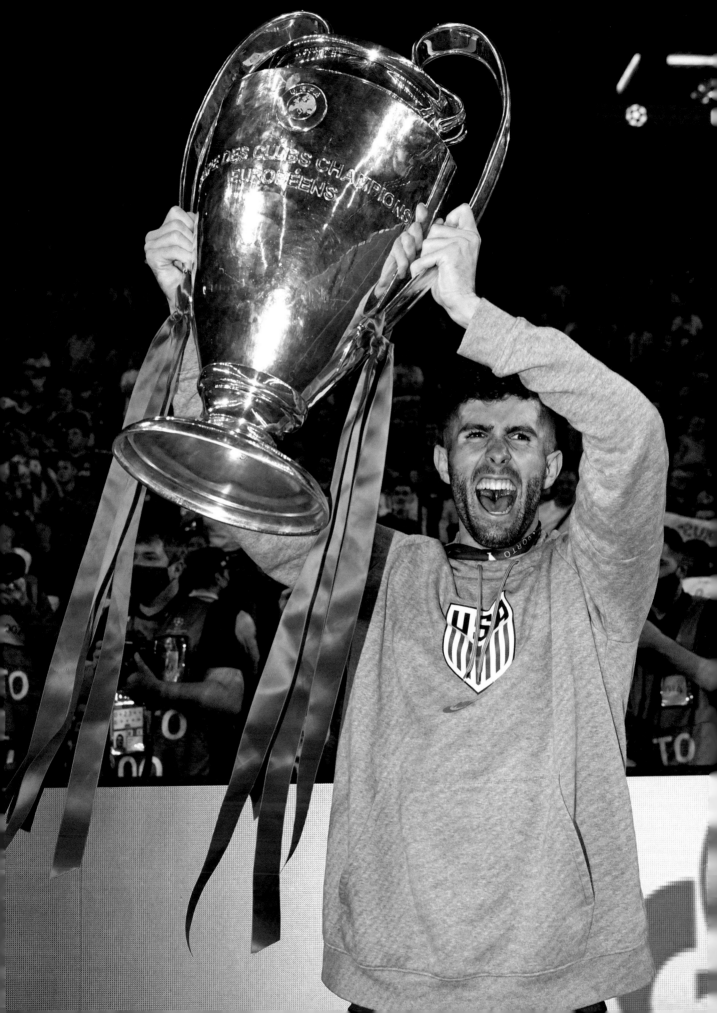

Right: Celebrating Adrián Ramos's goal in the first game I started for Dortmund's first team—a friendly against FC Union Berlin, Stadion An der Alten Försterei, Berlin, Germany, January 24, 2016.

Following pages: Taking on Carlos Castrillo of Guatemala in my debut for the US men's team, a World Cup qualifier at Mapfre Stadium, Columbus, Ohio, March 29, 2016.

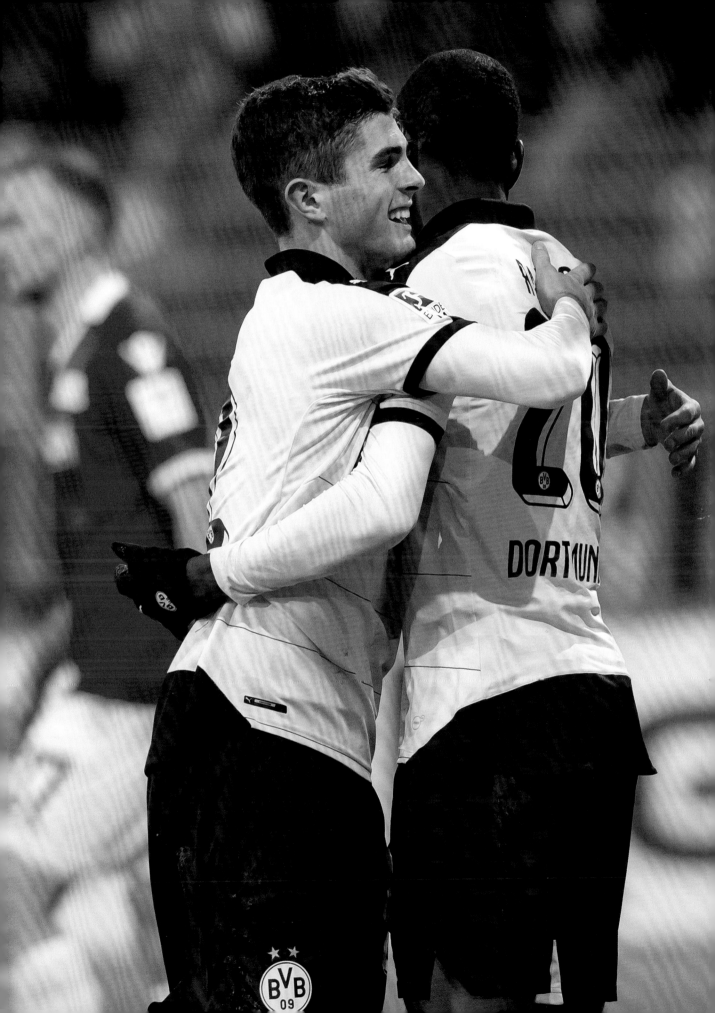

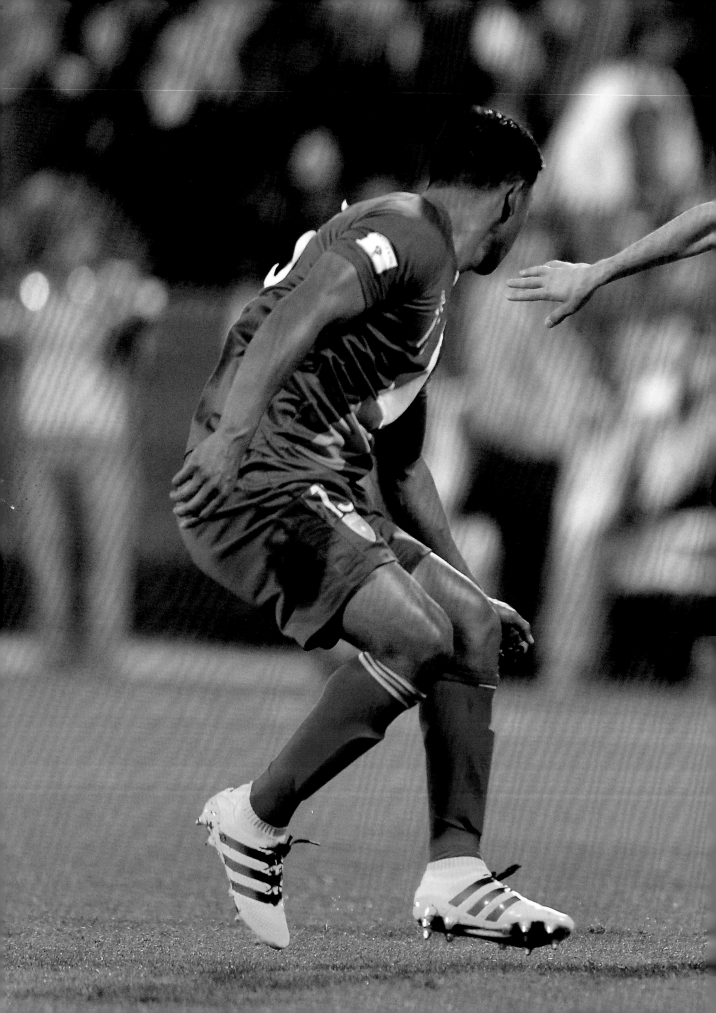

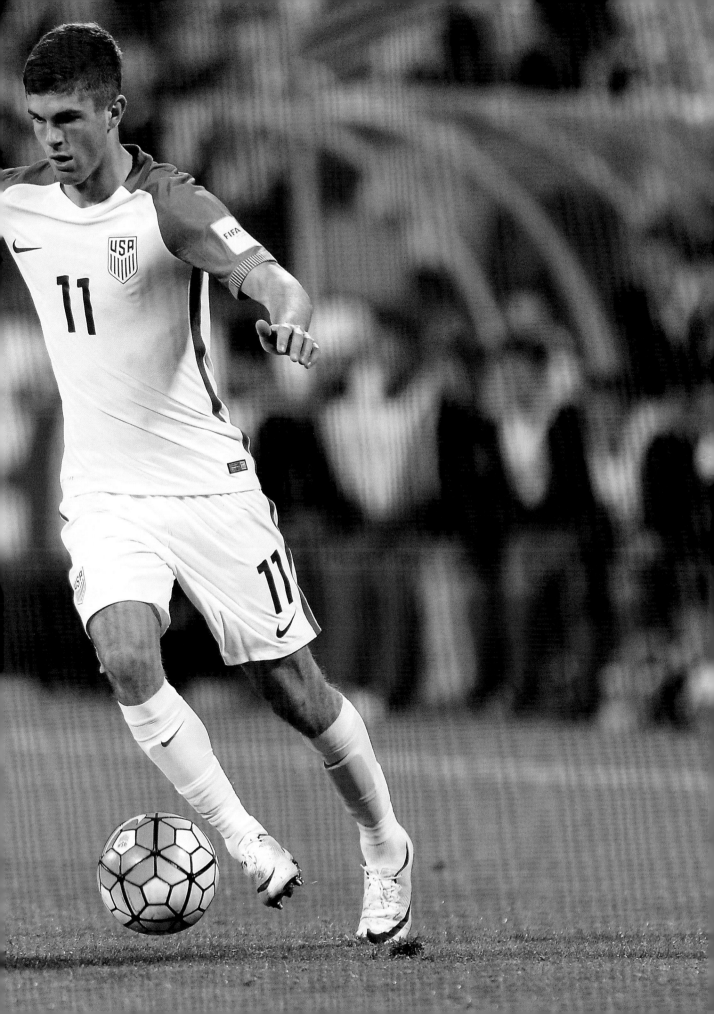

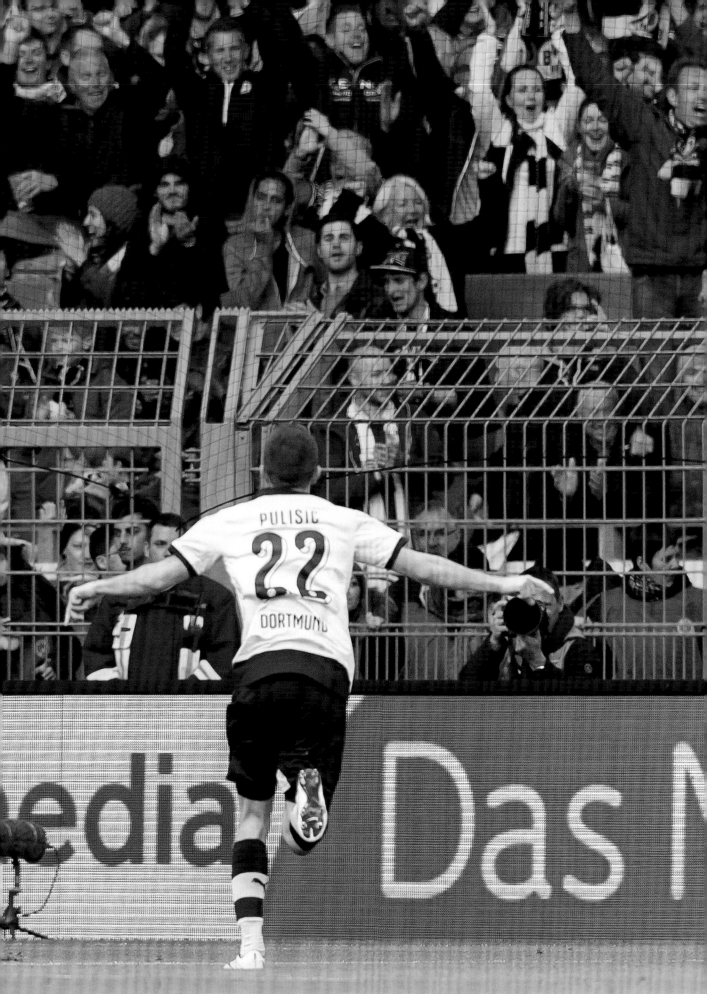

Left: Celebrating my first Bundesliga goal for Dortmund and the opening goal of the game against Hamburg, Signal Iduna Park, Dortmund, Germany, April 17, 2016.

Following pages: Playing against Lionel Messi and Argentina during the 2016 Copa América Centenario semifinal at NRG Stadium, Houston, Texas, June 21, 2016.

Pages 146–47: Playing in the Champions League against Real Madrid with Luka Modrić on my right and Marcelo on my left at Santiago Bernabéu Stadium, Madrid, Spain, December 7, 2016.

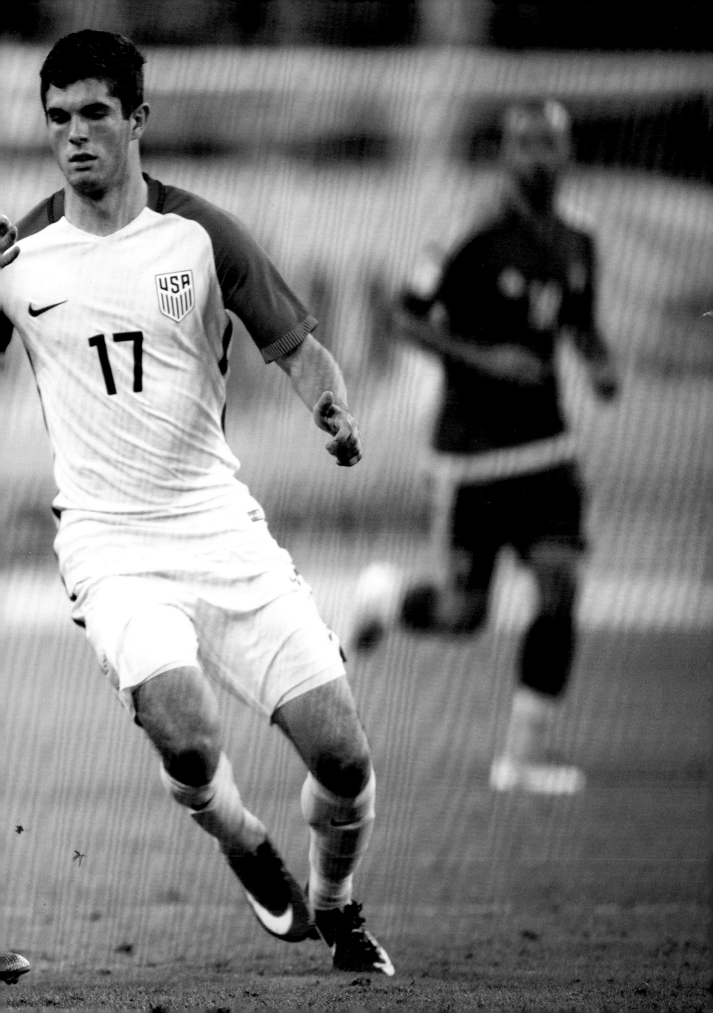

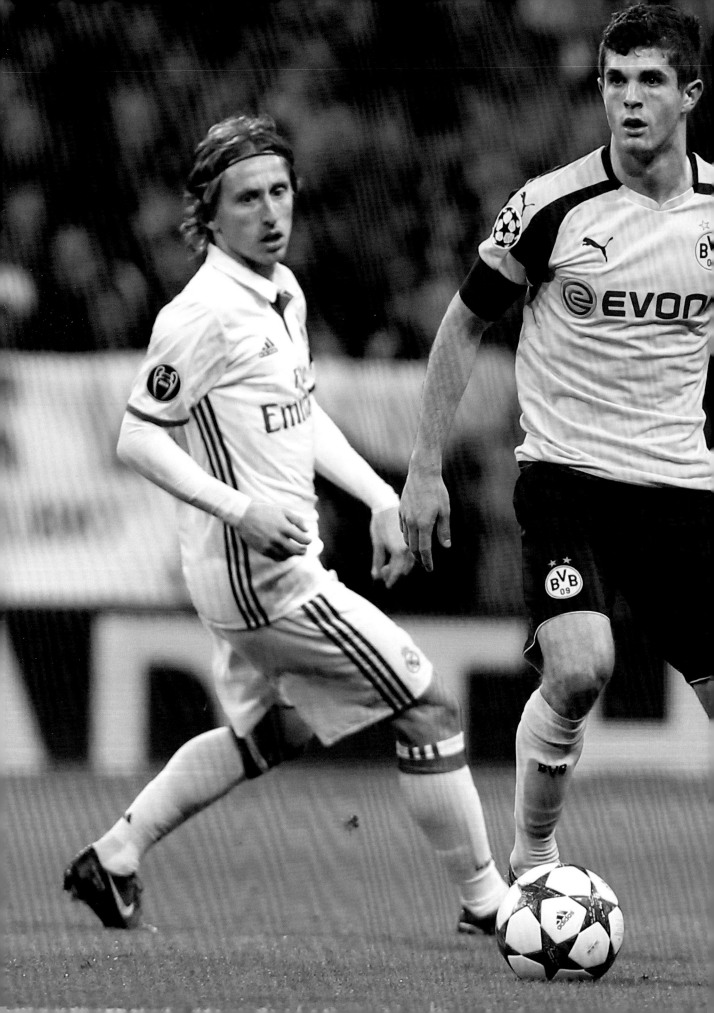

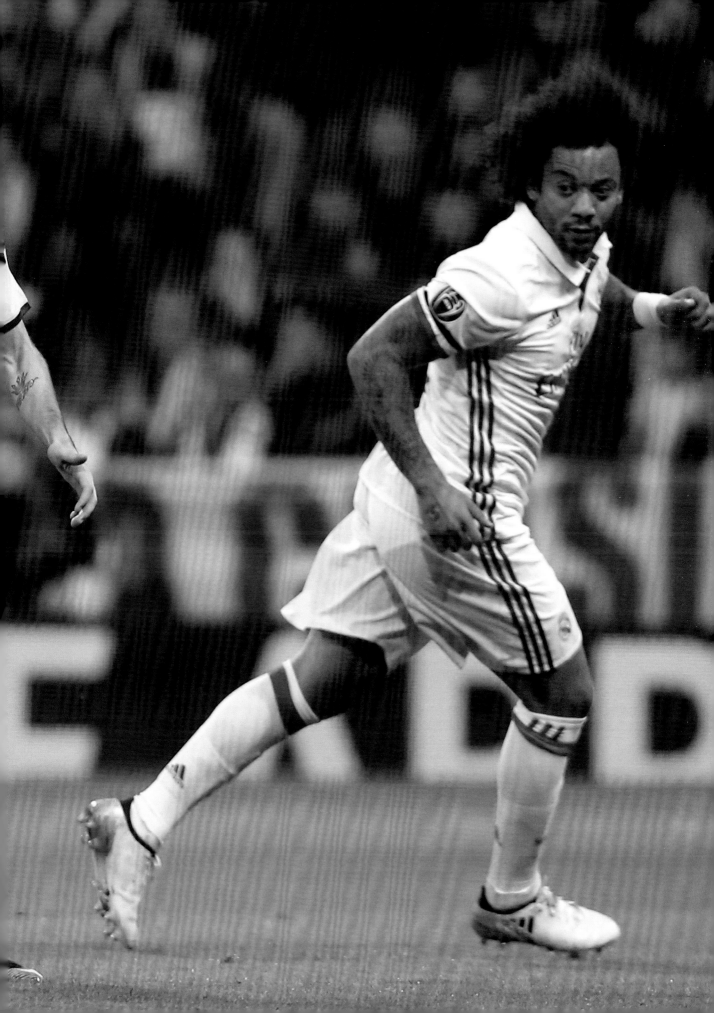

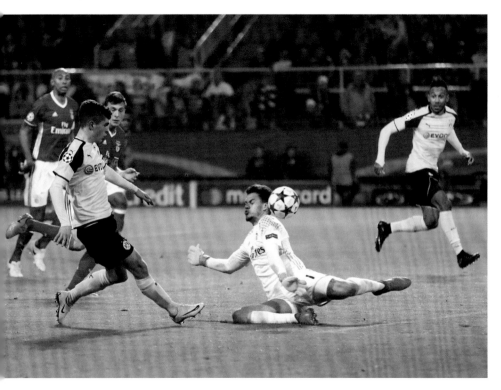
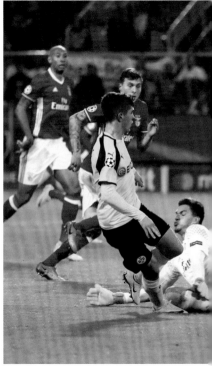

Above, from left: Scoring the second goal (and my first Champions League goal) during the round of sixteen second-leg match against Benfica at Signal Iduna Park, Dortmund, Germany, March 8, 2017.

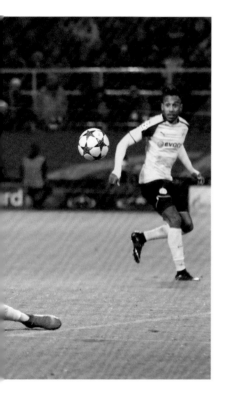

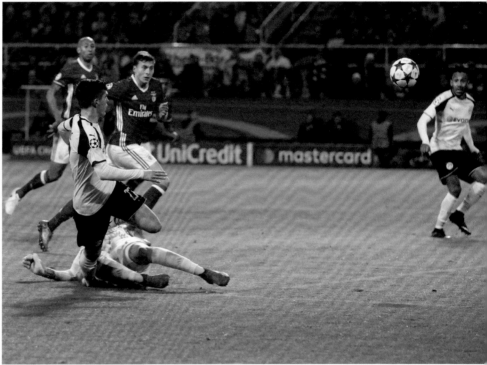

Following pages: Taking on Fabian Holland of SV Darmstadt 98 during the Bundesliga match at Stadion am Böllenfalltor, Darmstadt, Germany, February 11, 2017.

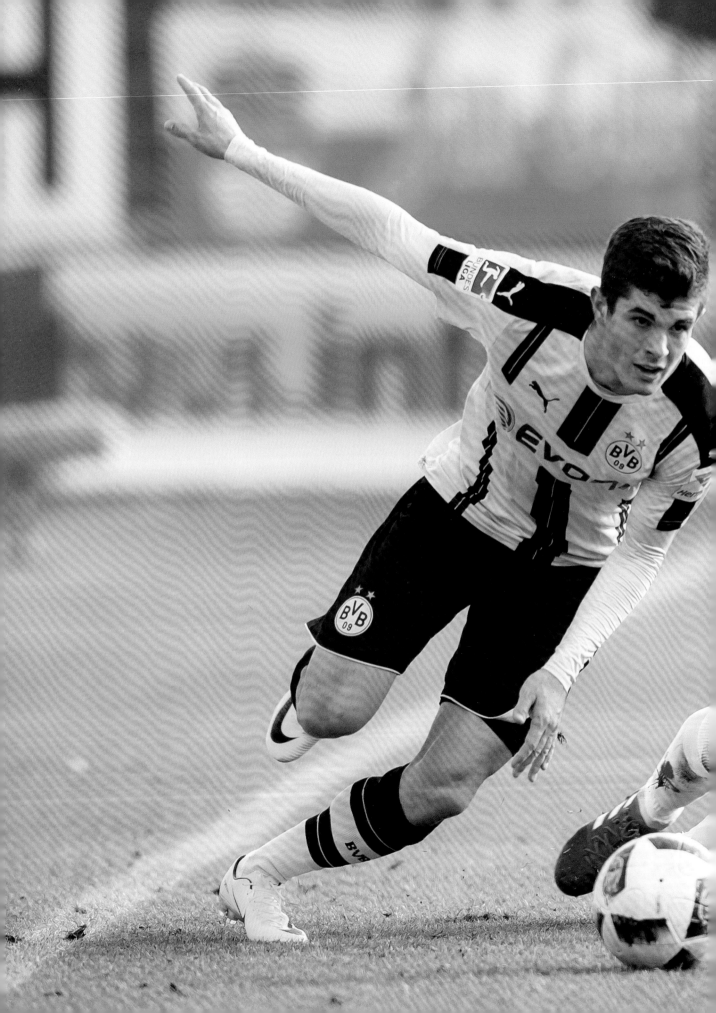

Page 152: Celebrating with Clint Dempsey after scoring during the World Cup qualifier against Honduras, Avaya Stadium, San Jose, California, March 24, 2017.

Page 153: Celebrating my first of a brace in the World Cup qualifier against Trinidad and Tobago with DeAndre Yedlin, Dick's Sporting Goods Park, Commerce City, Colorado, June 8, 2017.

Pages 154–55: Celebrating with the German Cup (DFB-Pokal) after winning the final against Eintracht Frankfurt at Olympiastadion, Berlin, Germany, May 27, 2017.

Preceding pages: Flanked by Fabio Borini (left) and Ignazio Abate (right) of AC Milan during the International Champions Cup game at University Town Sports Centre Stadium, Guangzhou, China, July 18, 2017.

Left: Celebrating scoring the third goal with Gonzalo Castro in a 3–0 Bundesliga away win against Hamburg at Volksparkstadion, Hamburg, Germany, September 20, 2017.

Following pages: Warming up with kick-ups before the friendly against Bolivia, Talen Energy Stadium, Chester, Pennsylvania, May 28, 2018.

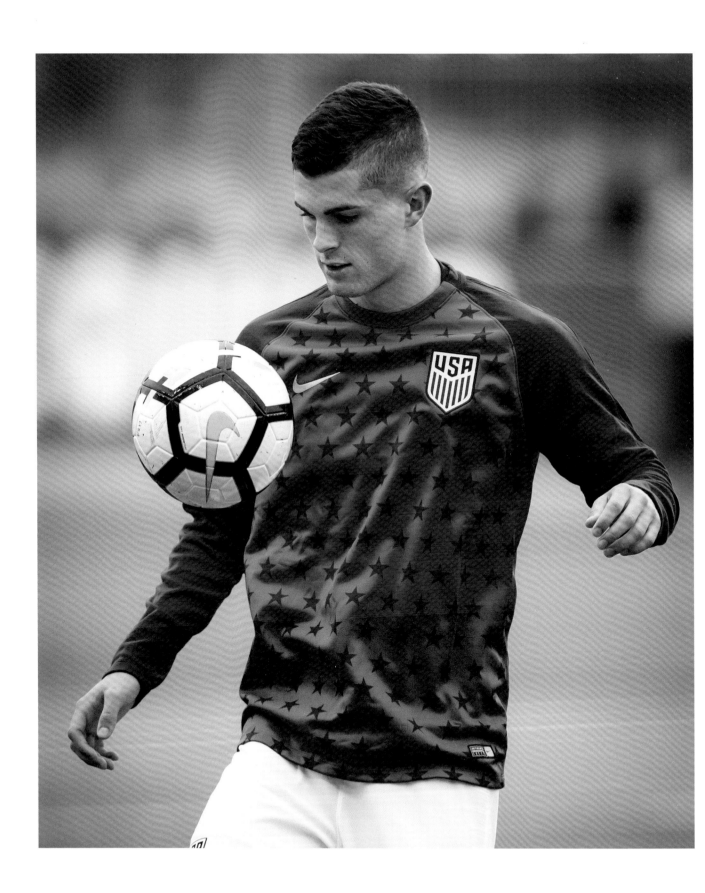

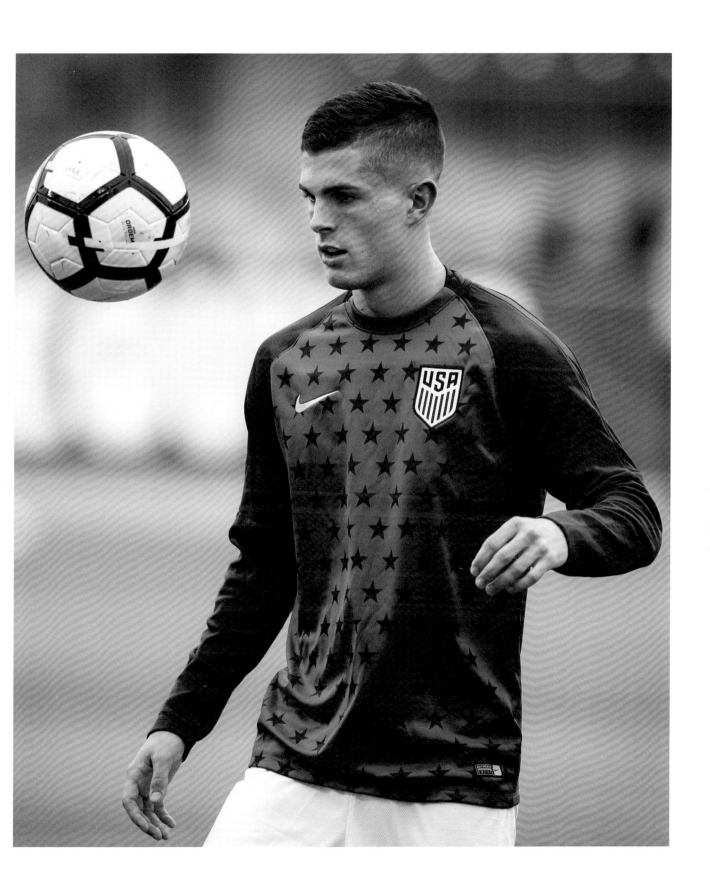

162

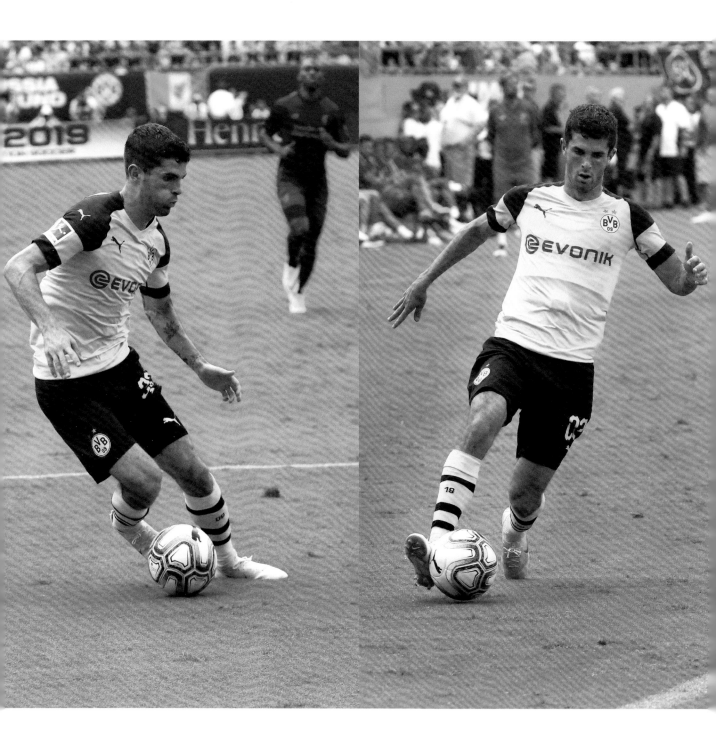

From left: Heading toward goal during the International Champions Cup match against Liverpool, Bank of America Stadium, Charlotte, North Carolina, July 22, 2018.

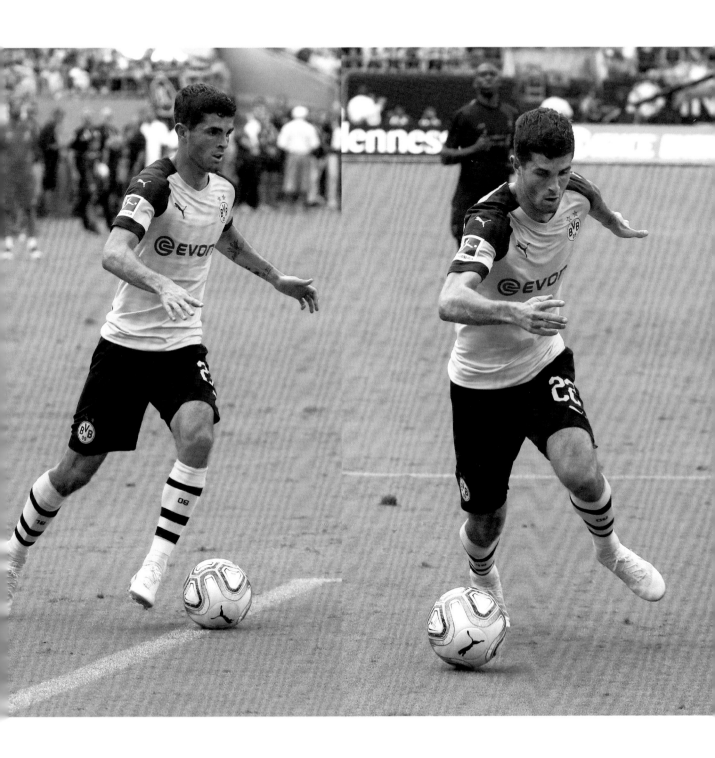

Right: Walking out of the tunnel before the friendly against Chile, BBVA Compass Stadium, Houston, Texas, March 26, 2019.

Following pages: Celebrating scoring the opening goal with Jadon Sancho in the Bundesliga match against Werder Bremen, Weserstadion, Bremen, Germany, May 4, 2019.

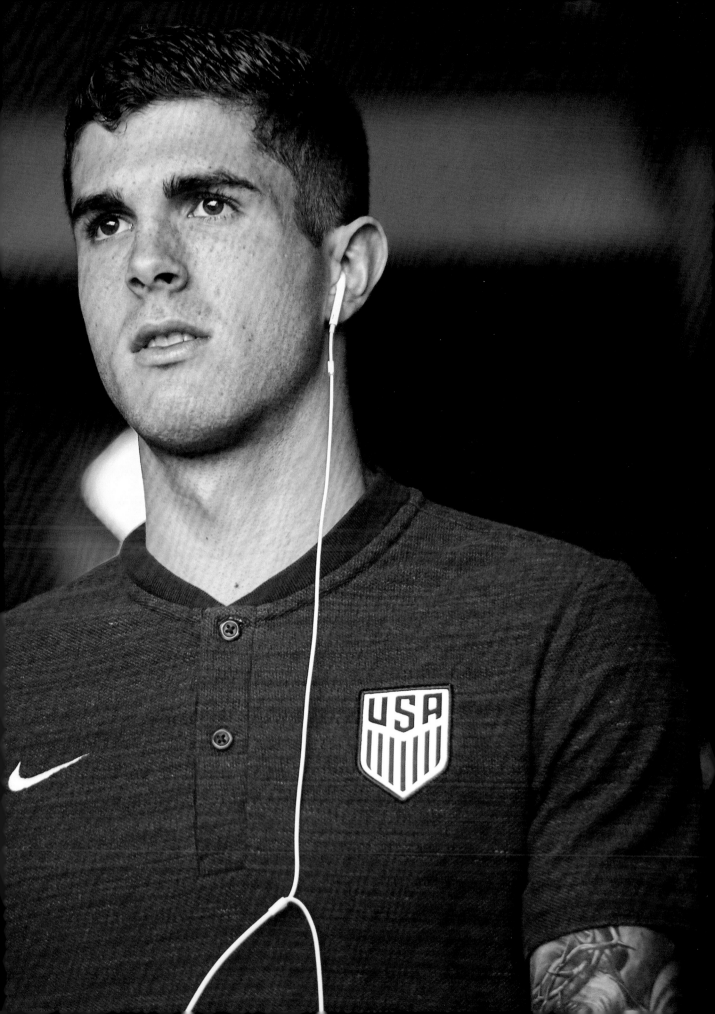

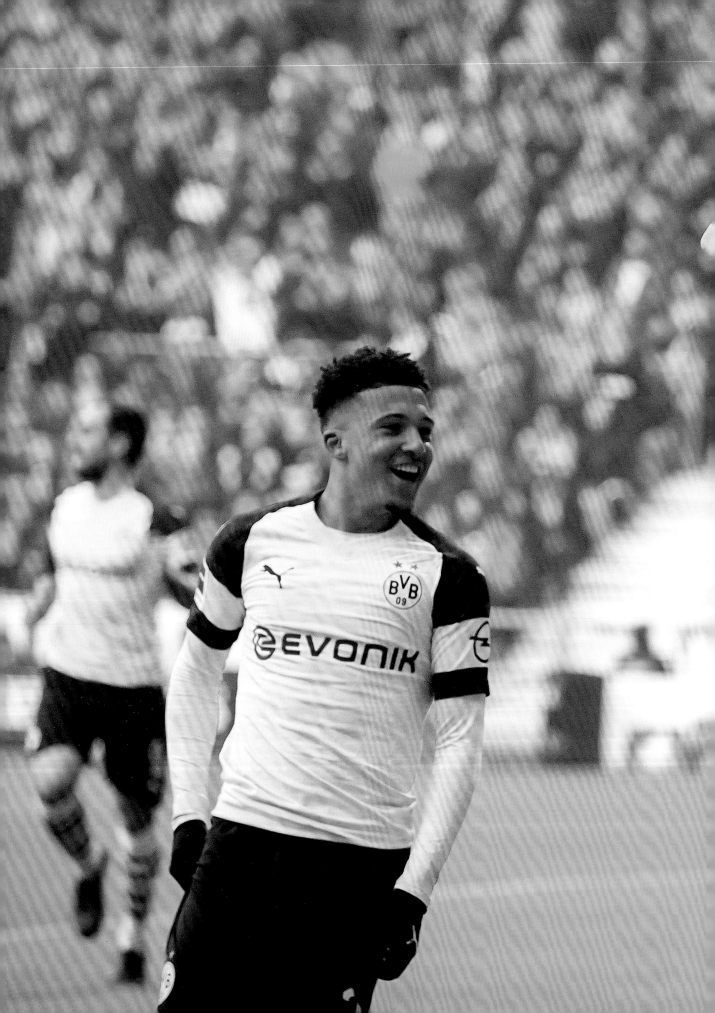

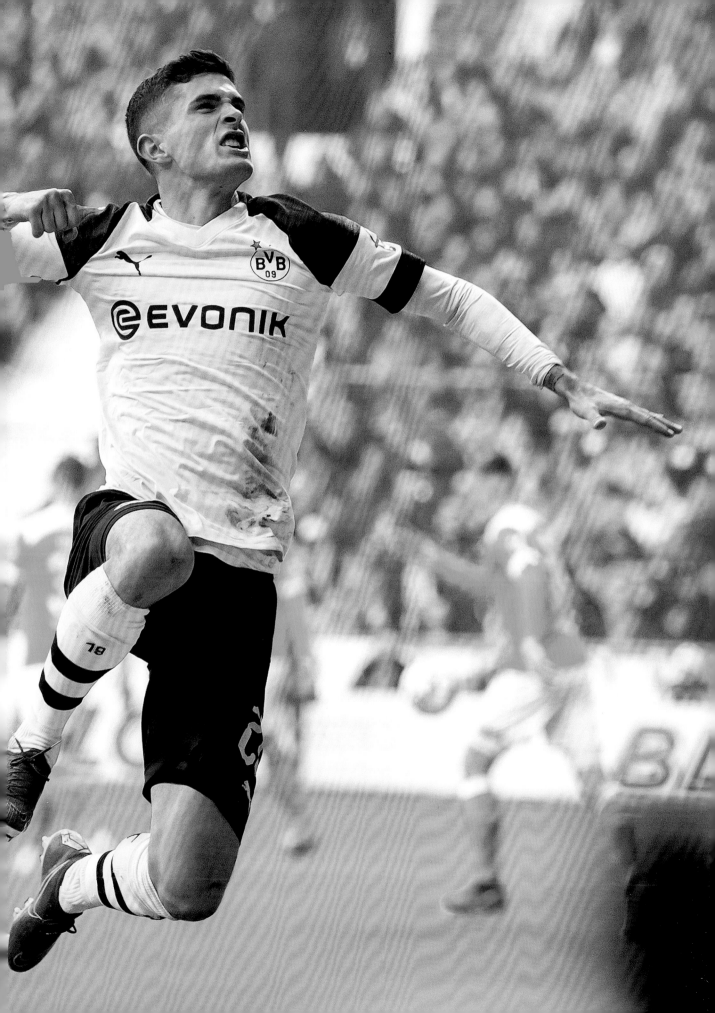

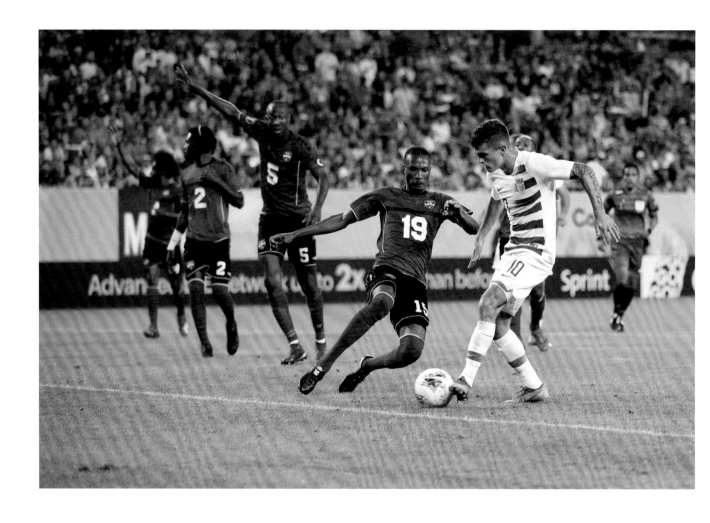

Above, from left: Scoring to make it 4–0 against Trinidad and Tobago in the group stage of the 2019 Concacaf Gold Cup at FirstEnergy Stadium, Cleveland, Ohio, June 22, 2019.

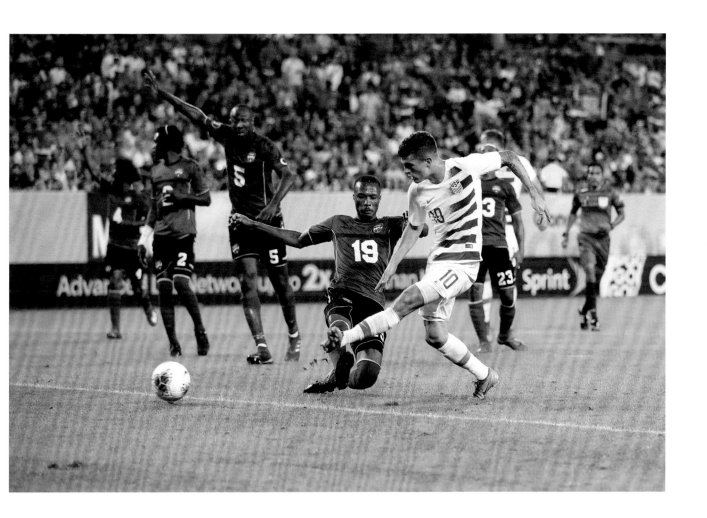

Following pages: Celebrating Weston McKennie's goal against Curaçao during the first half of the 2019 Concacaf Gold Cup quarterfinals match at Lincoln Financial Field, Philadelphia, Pennsylvania, June 30, 2019.

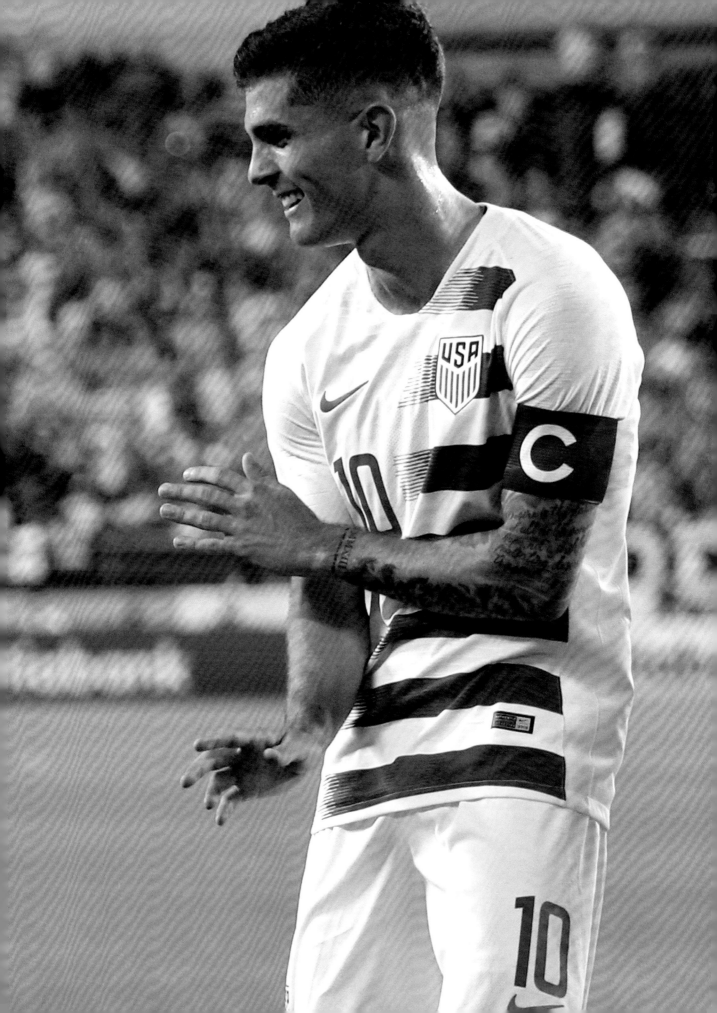

Right: During the Concacaf Gold Cup quarterfinal match against Curaçao, Lincoln Financial Field, Philadelphia, Pennsylvania, June 30, 2019.

Following pages: Kick-ups with new teammates Kasey Palmer, Tammy Abraham, Mason Mount, and Fiyako Tomori during a Chelsea training session at Mitsuzawa Football Stadium, Yokohama, Japan, July 16, 2019.

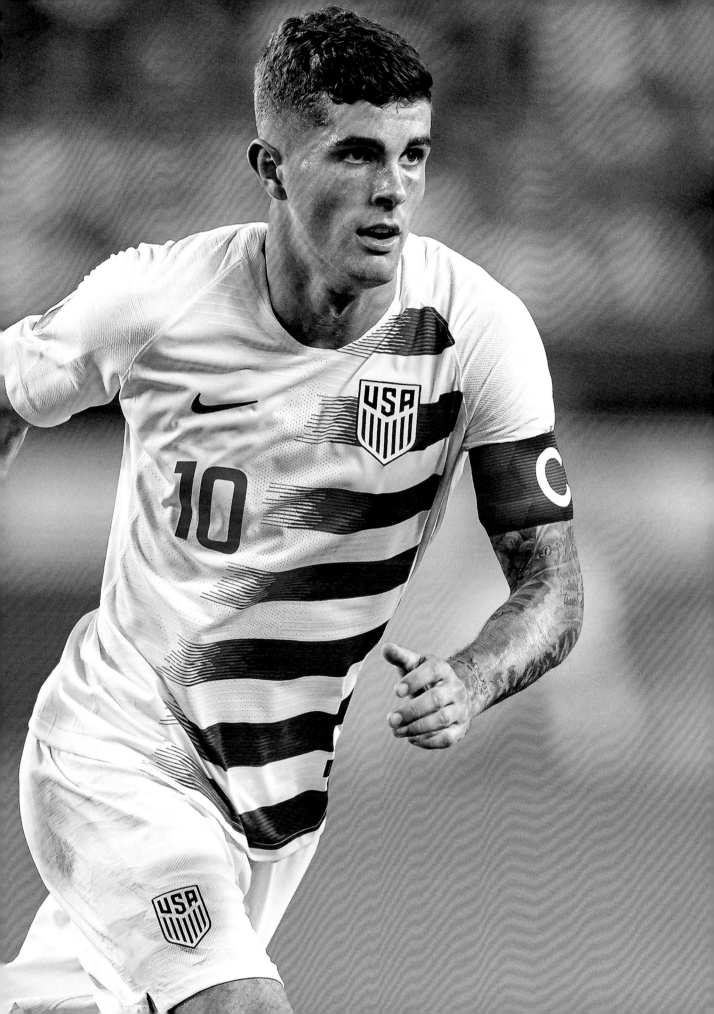

Left: Celebrating scoring in the preseason friendly against Red Bull Salzburg in Salzburg, Austria, July 31, 2019.

Following pages: Celebrating my first Premier League goal to make it 1–0 against Burnley at Turf Moor, Burnley, England, October 26, 2019.

Pages 180–81: A foul resulting in a penalty during the Champions League group match against Ajax at Stamford Bridge, London, England, November 5, 2019.

Pages 182–83: Battling with Luka Milivojević of Crystal Palace during the Premier League match at Stamford Bridge, London, England, November 9, 2019.

Pages 184–85: Celebrating after scoring Chelsea's second goal against Palace, Stamford Bridge, November 9, 2019.

Pages 186–87: Ball watching with Phil Foden during the Premier League game against Manchester City, Etihad Stadium, Manchester, England, November 23, 2019.

Pages 188–89: Celebrating with Olivier Giroud, César Azpilicueta, and Willian after scoring the second goal during the Premier League match against Crystal Palace at Selhurst Park without fans there due to Covid restrictions, London, England, July 7, 2020.

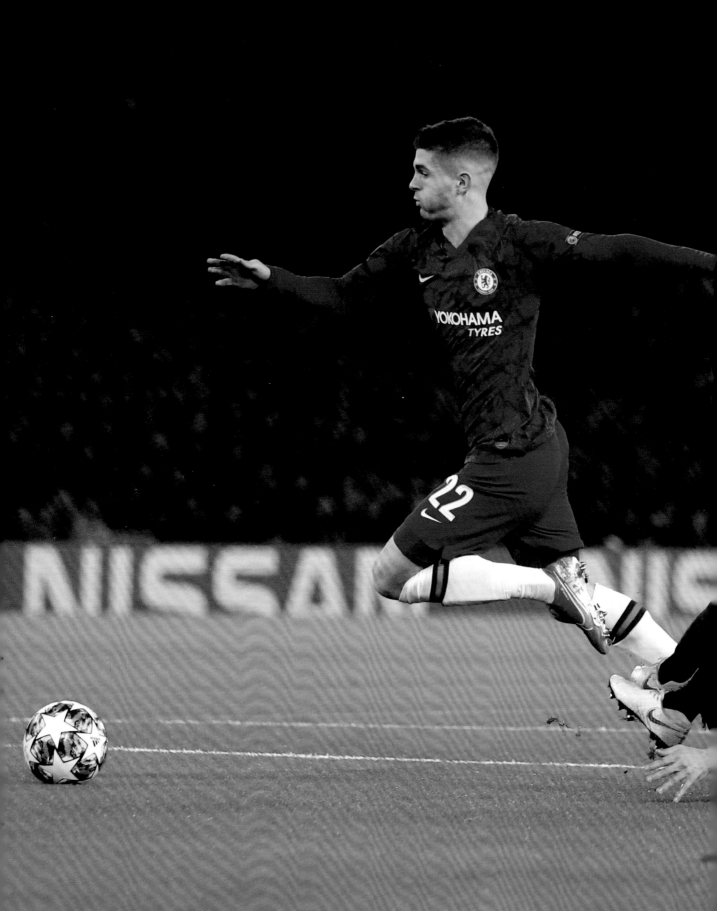

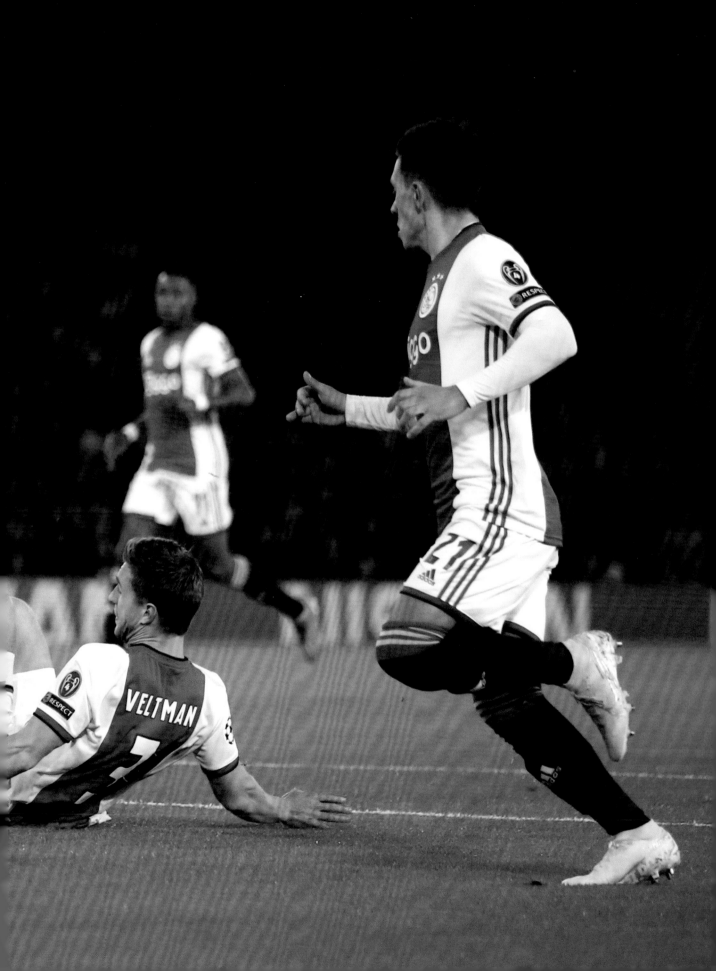

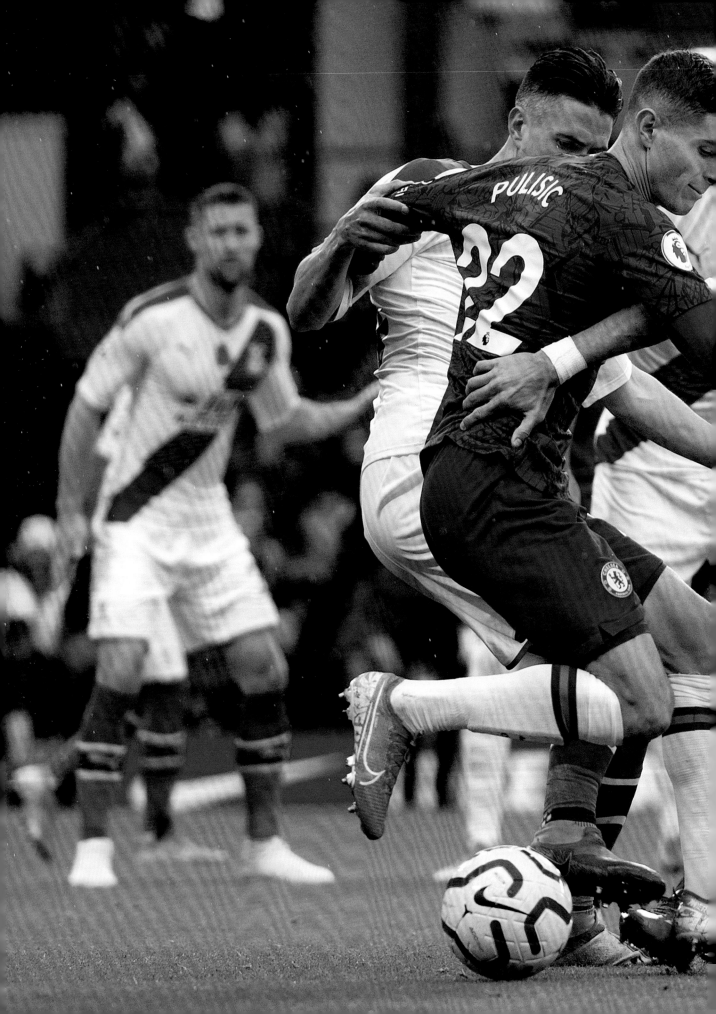

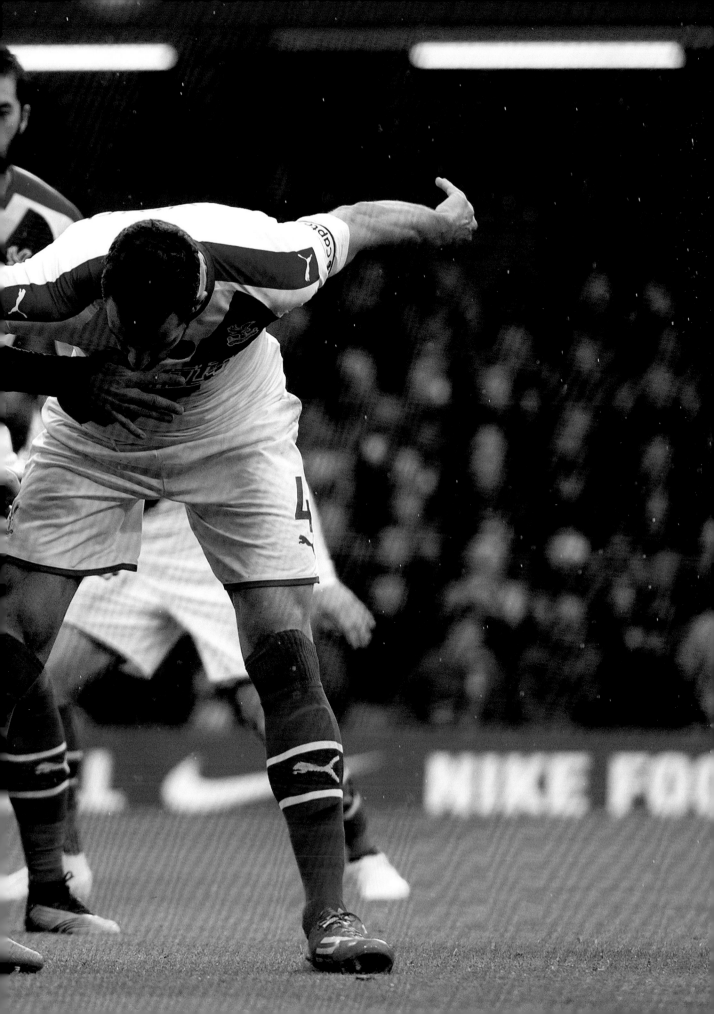

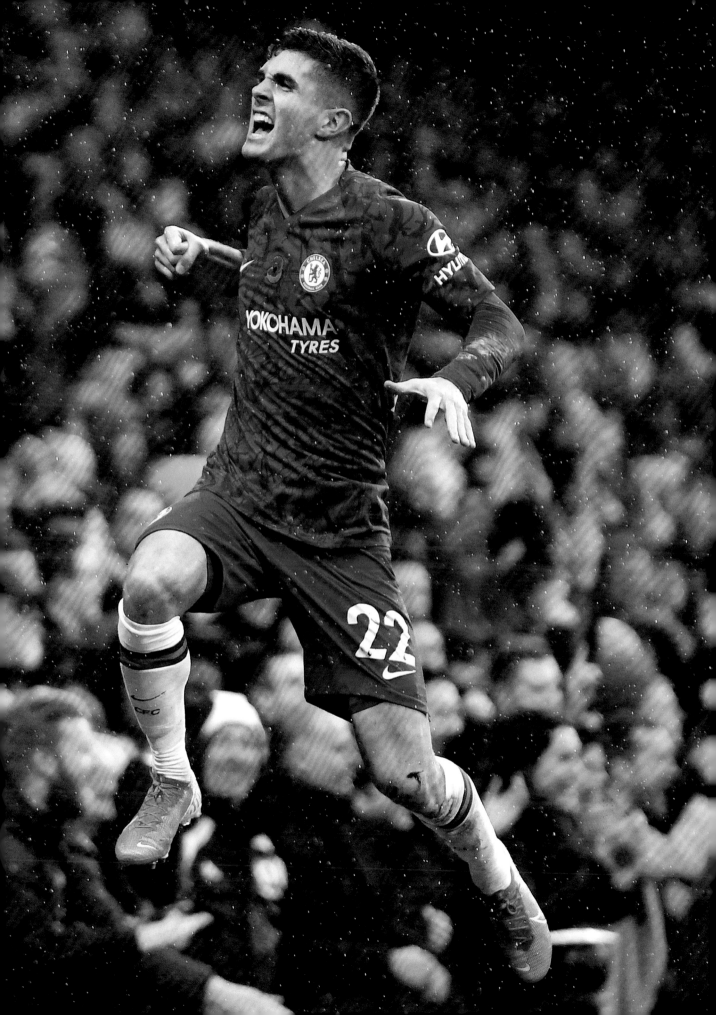

Preceding pages: Taking on Liverpool's Fabinho (on my right), Trent Alexander-Arnold (66), and Georginio Wijnaldum during the Premier League match at Anfield, Liverpool, England, July 22, 2020.

Above: With Thomas Tuchel during the Premier League match against Wolverhampton Wanderers at Stamford Bridge, London, England, January 27, 2021.

Above: With Jürgen Klopp of Liverpool before the Premier League match at Anfield, Liverpool, England, March 4, 2021.

Following pages: Taking the ball around Thibaut Courtois of Real Madrid before scoring our first goal during the first leg of the Champions League semifinal match against Real Madrid at Estadio Alfredo Di Stéfano, Madrid, Spain, April 27, 2021.

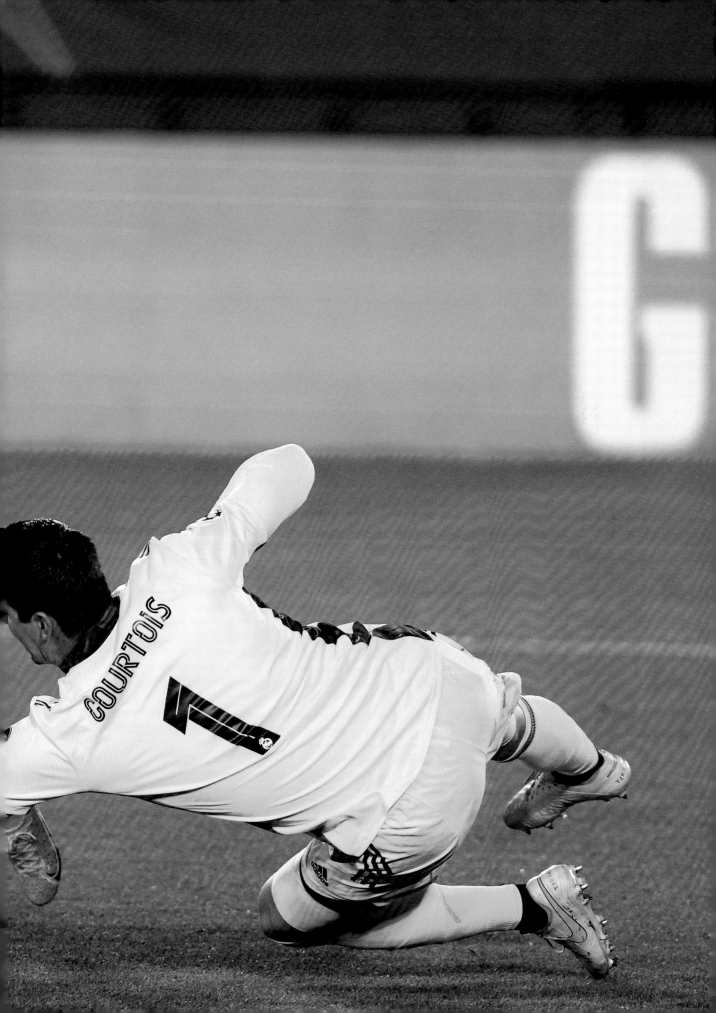

196

During a Premier League match against Aston Villa at Villa Park, Birmingham, England, May 23, 2021.

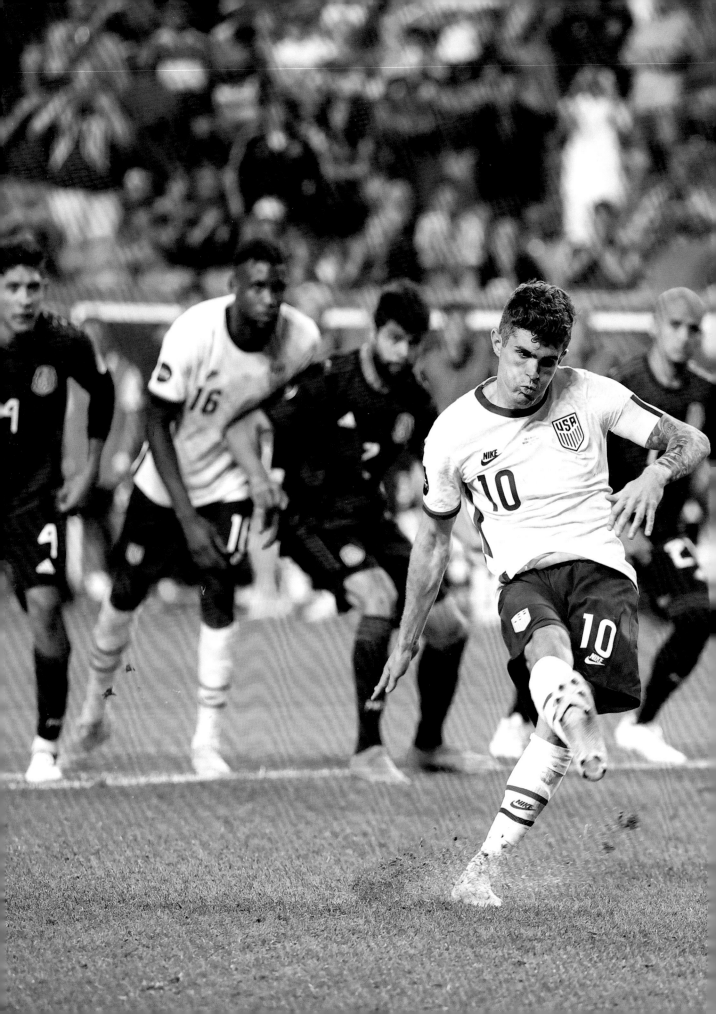

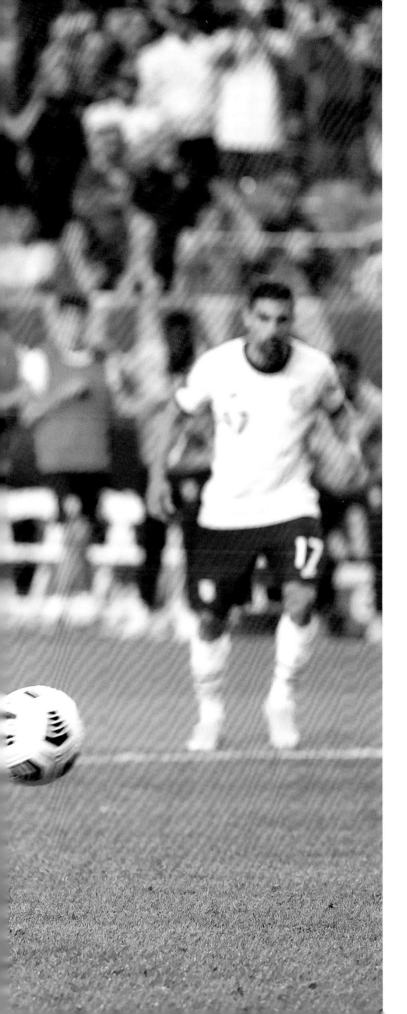

Taking the penalty in the Concacaf
Nations League Championship final
against Mexico, Empower Field at Mile
High, Denver, Colorado, June 6, 2021.

Celebrating with Ethan Horvath after the
Concacaf Nations League Championship
final win, Empower Field at Mile High,
Denver, Colorado, June 6, 2021.

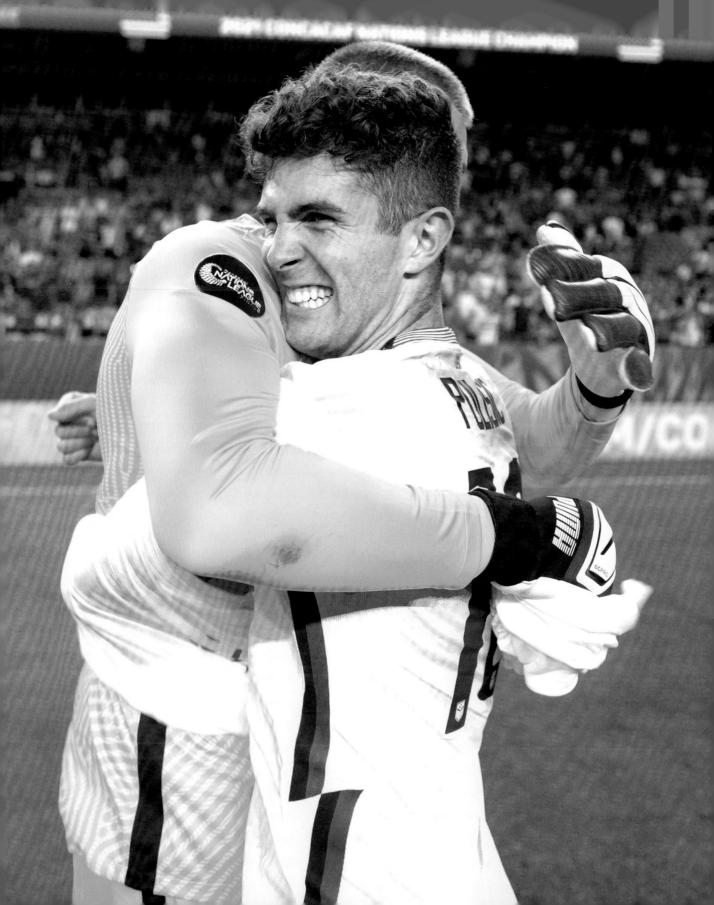

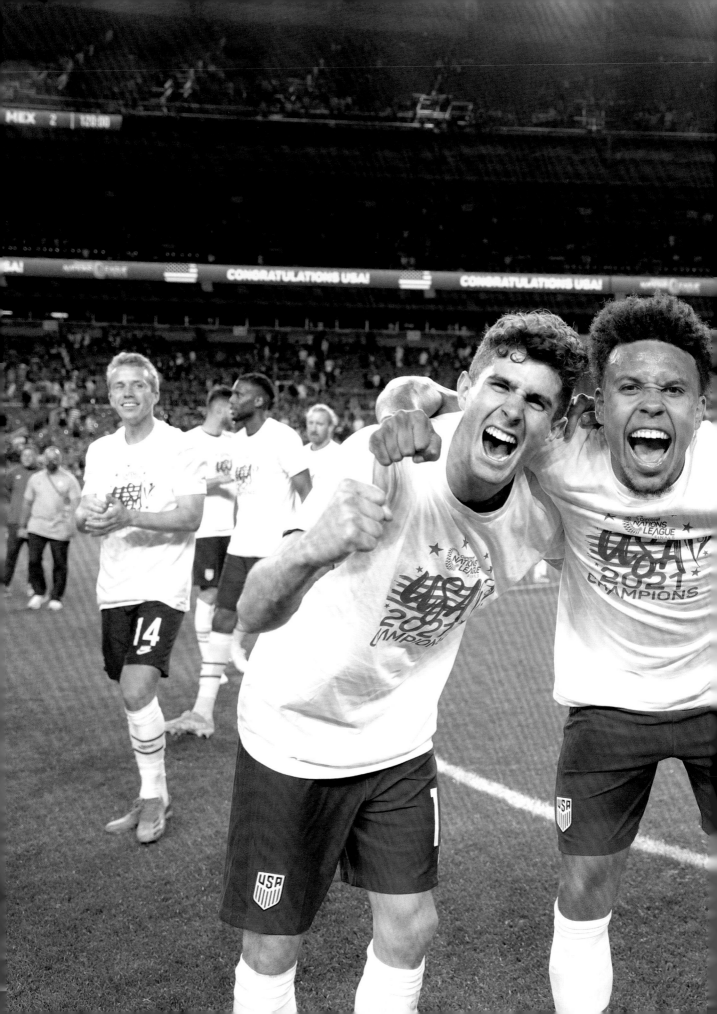

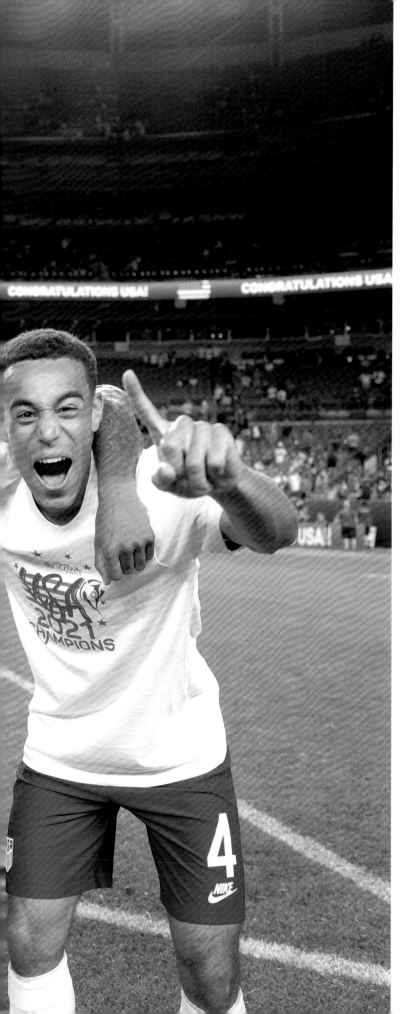

Celebrating with Weston McKennie (8) and Tyler Adams (4) after winning the Concacaf Nations League Championship final against Mexico, Empower Field at Mile High, Denver, Colorado, June 6, 2021.

After scoring in the opening game of the
2021 Premier League season against
Crystal Palace, Stamford Bridge, London,
England, August 14, 2021.

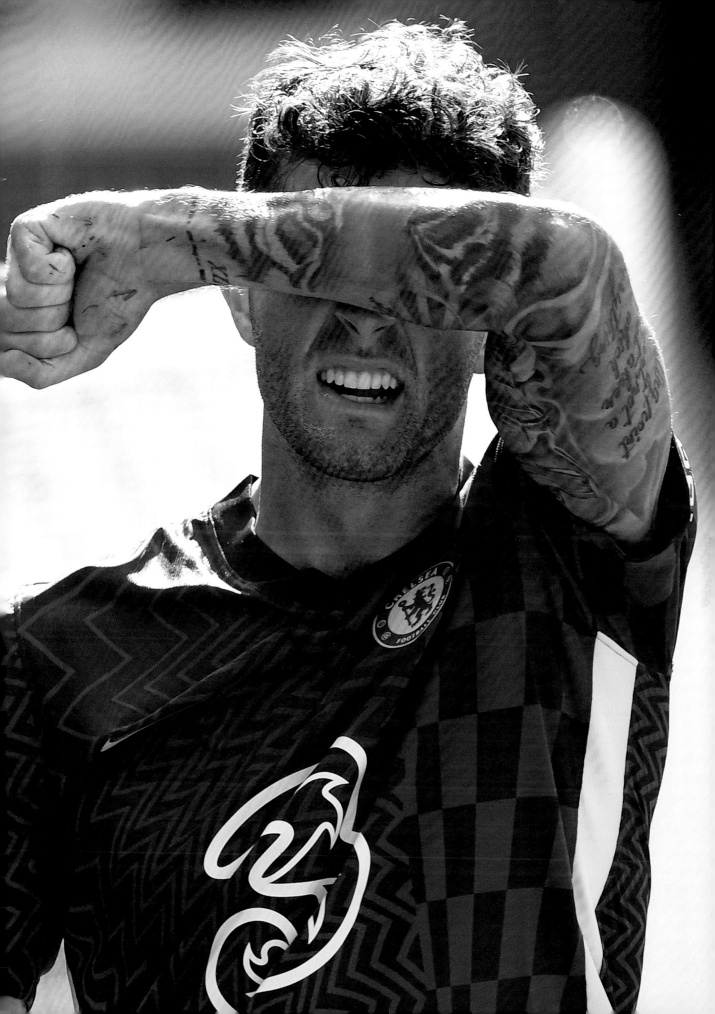

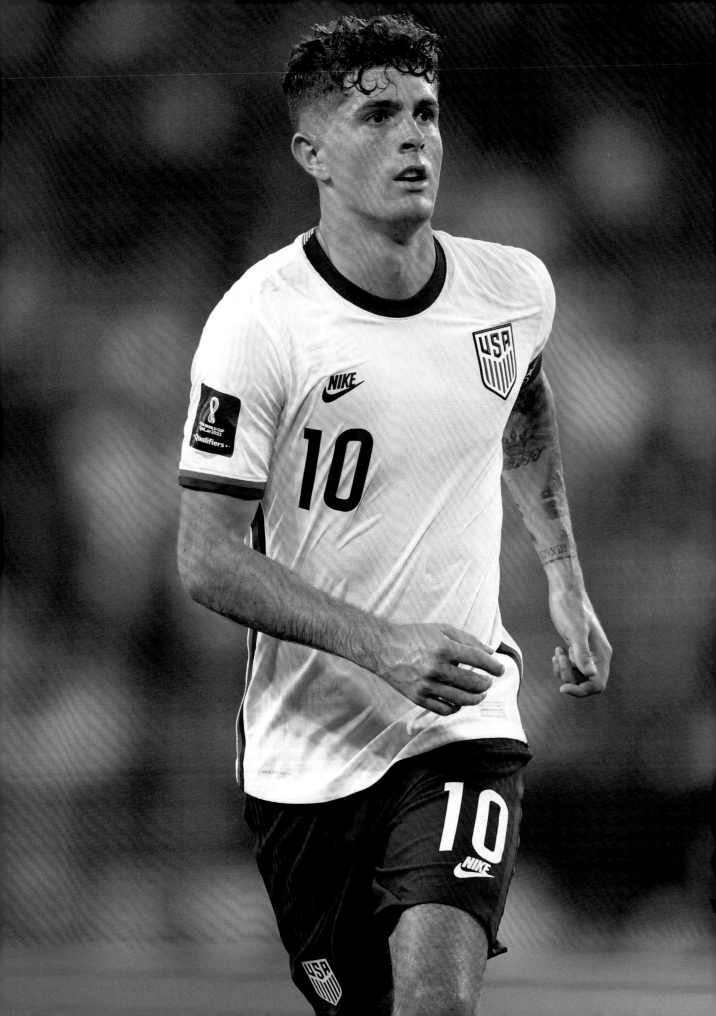

During the 2022 World Cup qualifying match against Canada at Nissan Stadium, Nashville, Tennessee, September 5, 2021.

Scoring against Mexico at TQL Stadium, Cincinnati,
Ohio, November 12, 2021.

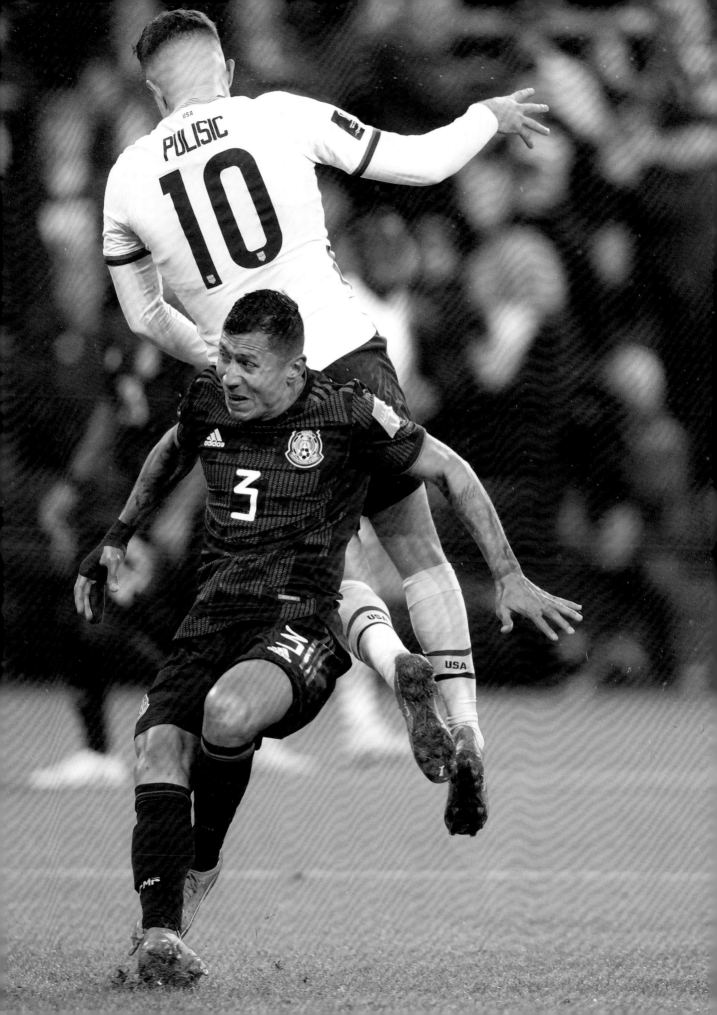

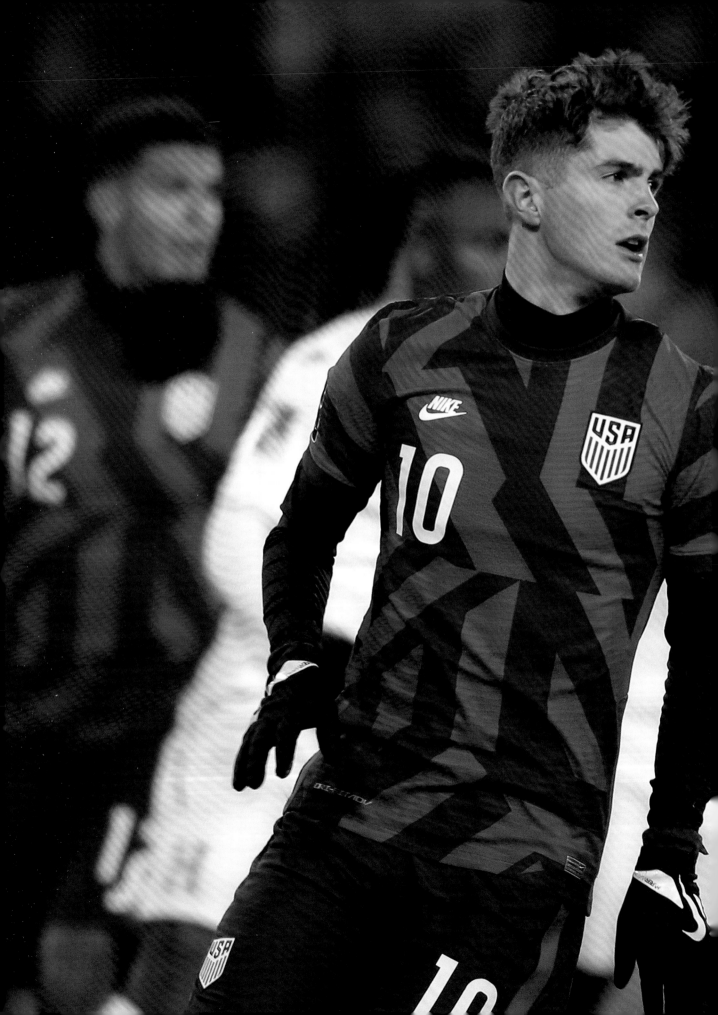

Left: During the World Cup qualifier against Honduras at Allianz Field, St. Paul, Minnesota, February 2, 2022.

Following pages: Scoring against Honduras at Allianz Field, February 2, 2022.

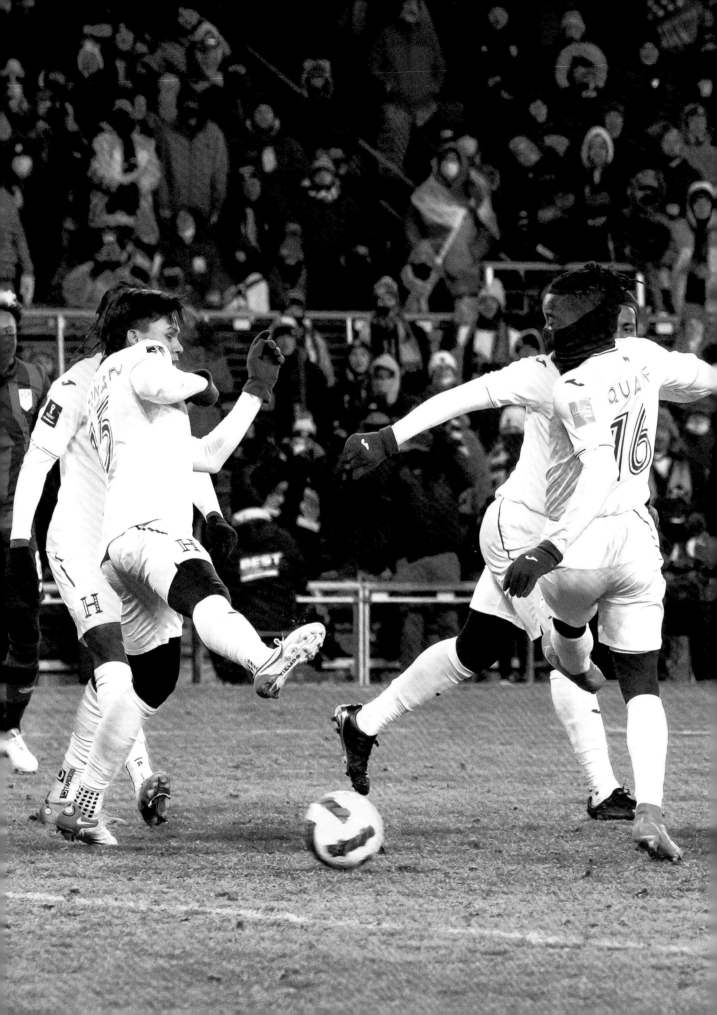

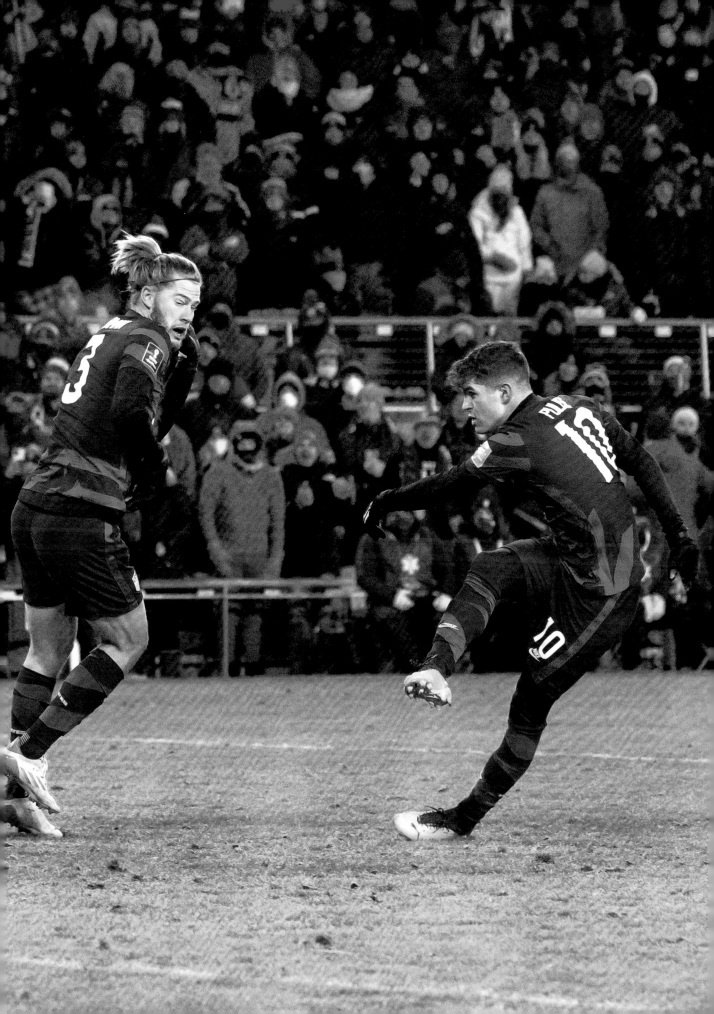

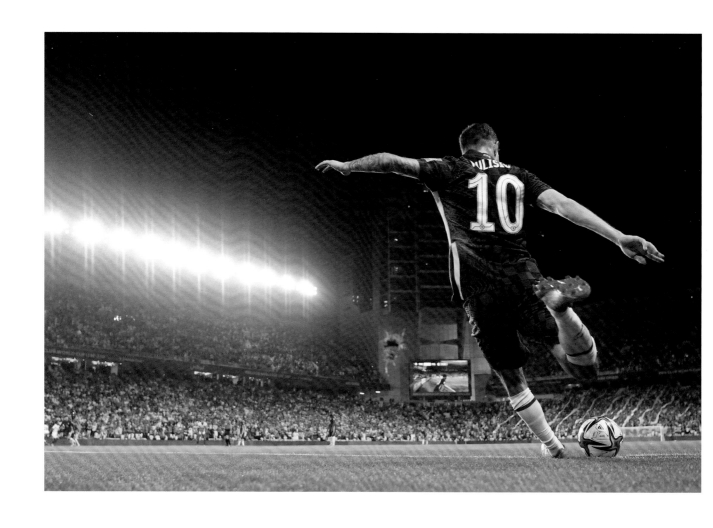

From left: Taking a corner during the FIFA Club World Cup 2021 final against Palmeiras at Mohammed bin Zayed Stadium, Abu Dhabi, United Arab Emirates, February 12, 2022.

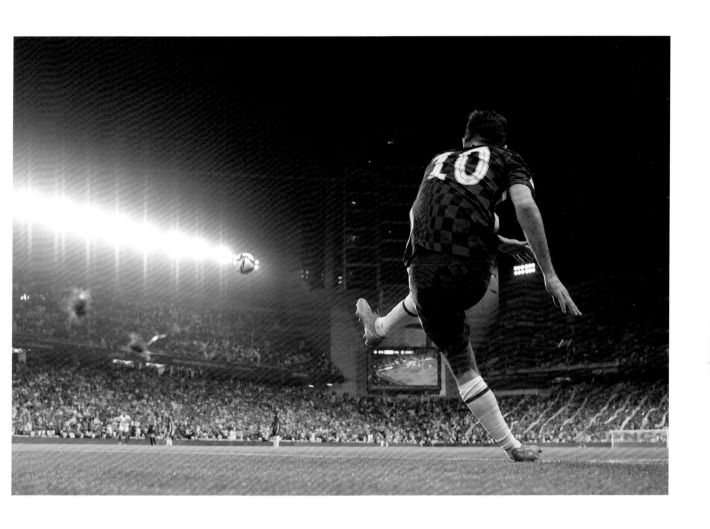

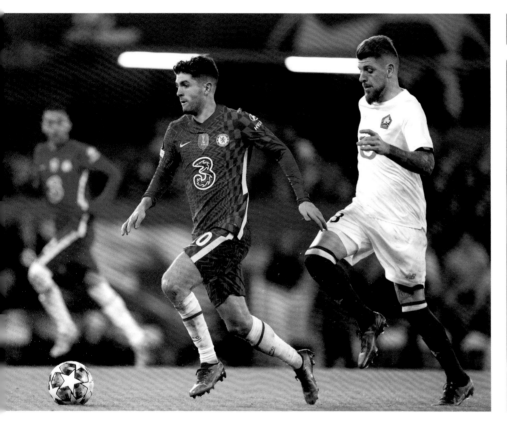

Above, from right: Battling with Xeka during the first leg of the Champions League round-of-sixteen match against Lille OSC at Stamford Bridge, London, England, February 22, 2022.

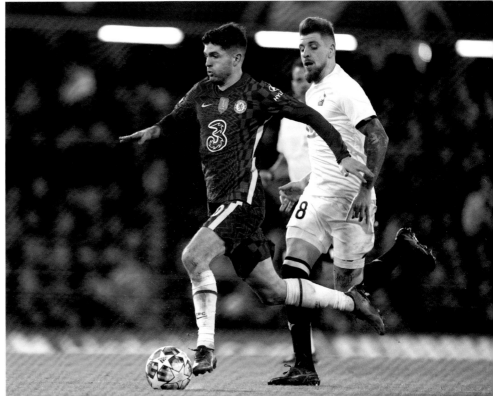

Following pages: Scoring our second goal against Lille OSC at Stamford Bridge, February 22, 2022.

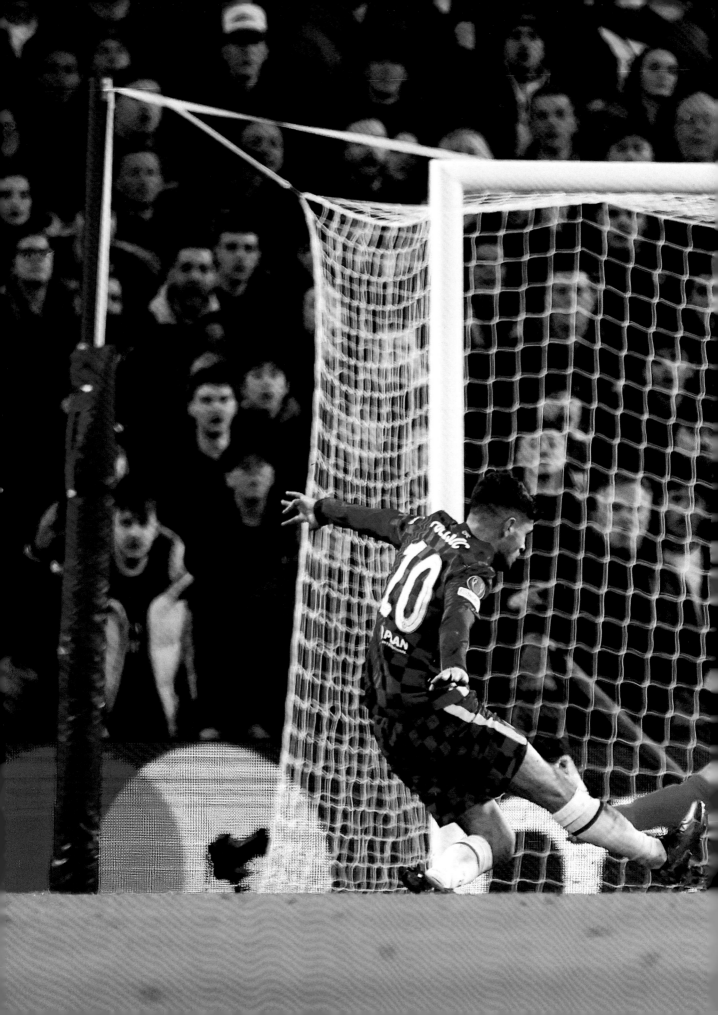

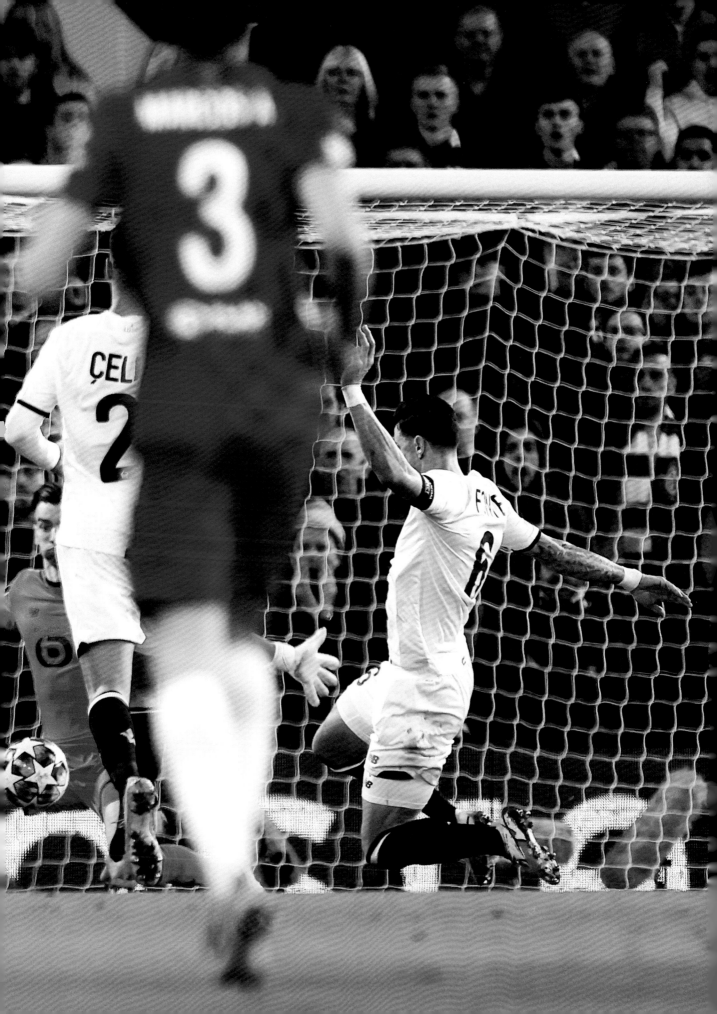

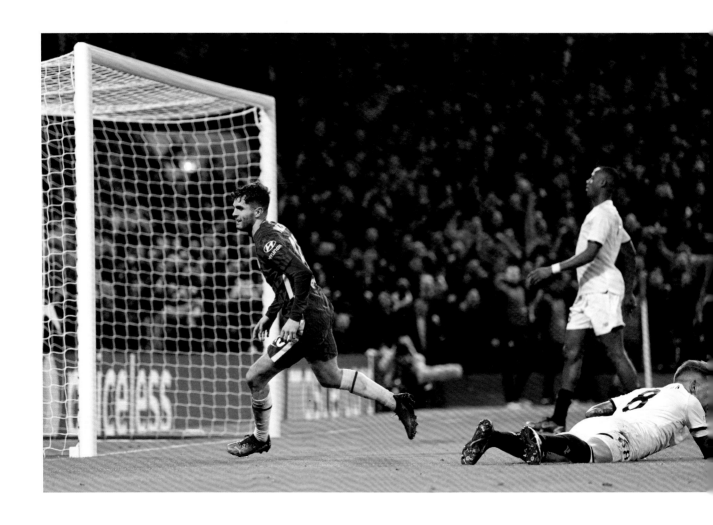

Above, from left, and following pages: Celebrating scoring Chelsea's second goal during the first leg of the Champions League round-of-sixteen match against Lille OSC at Stamford Bridge, London, England, February 22, 2022.

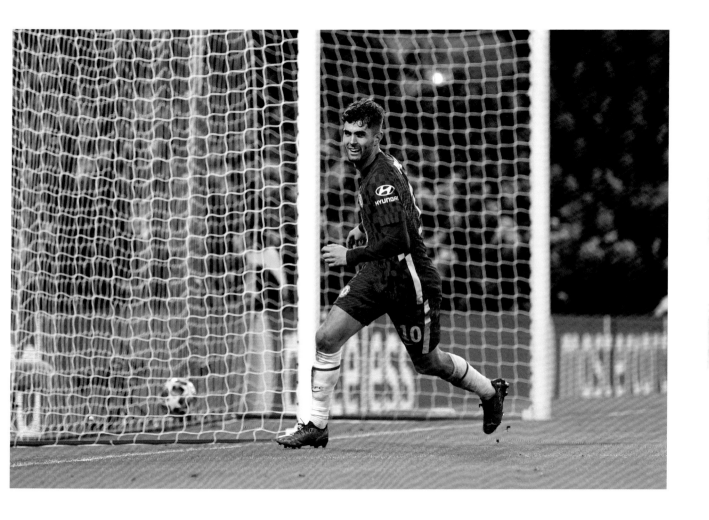

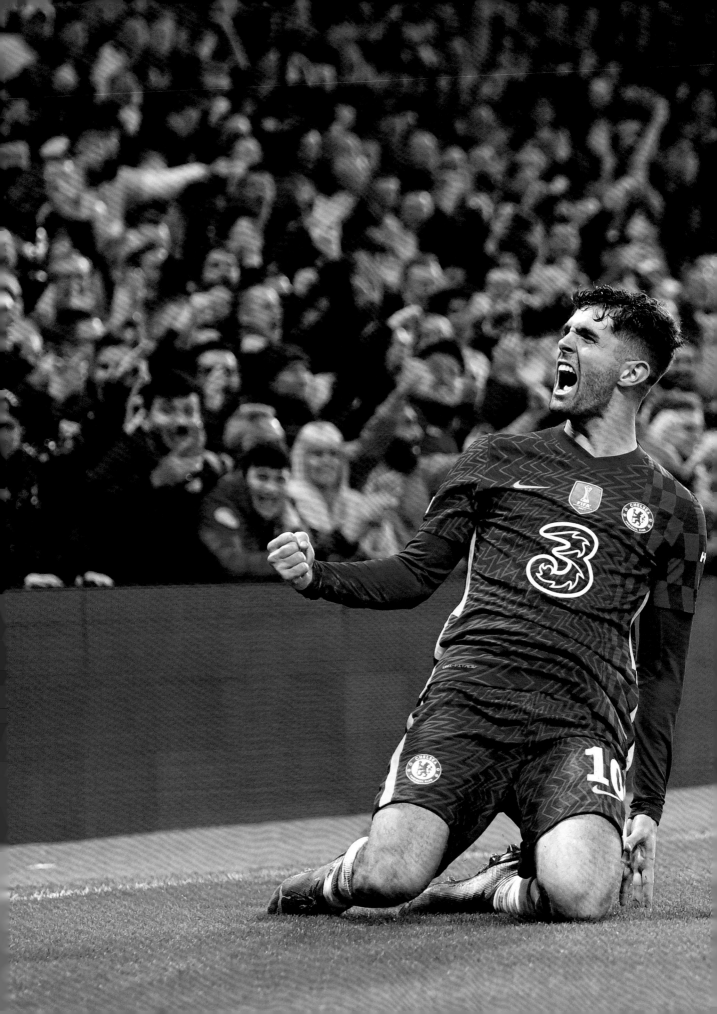

priceless

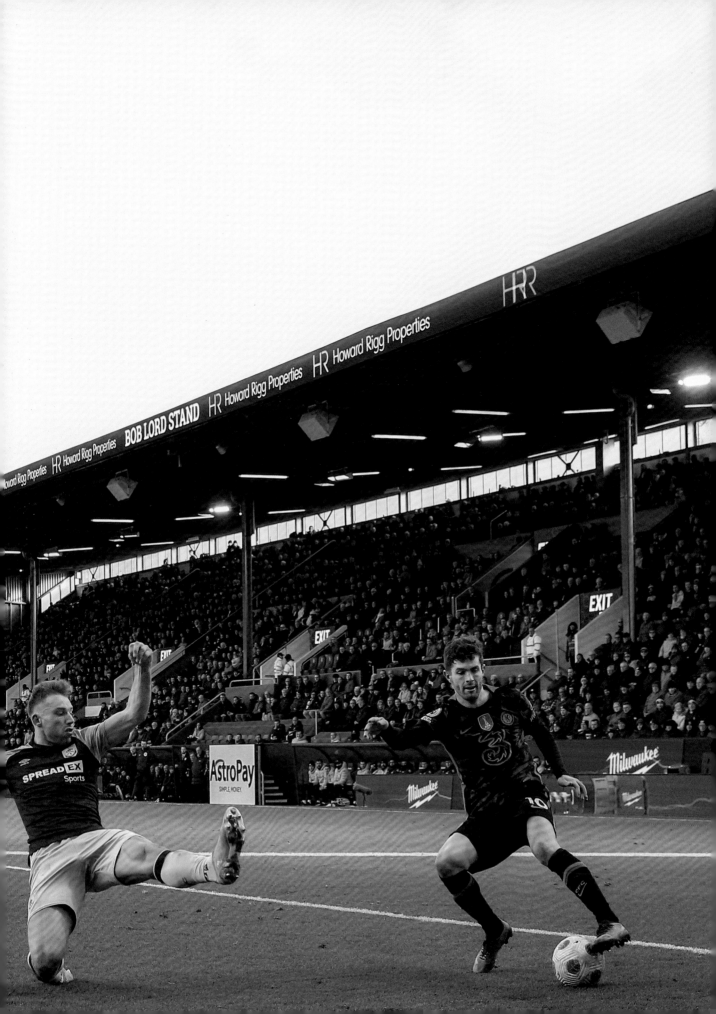

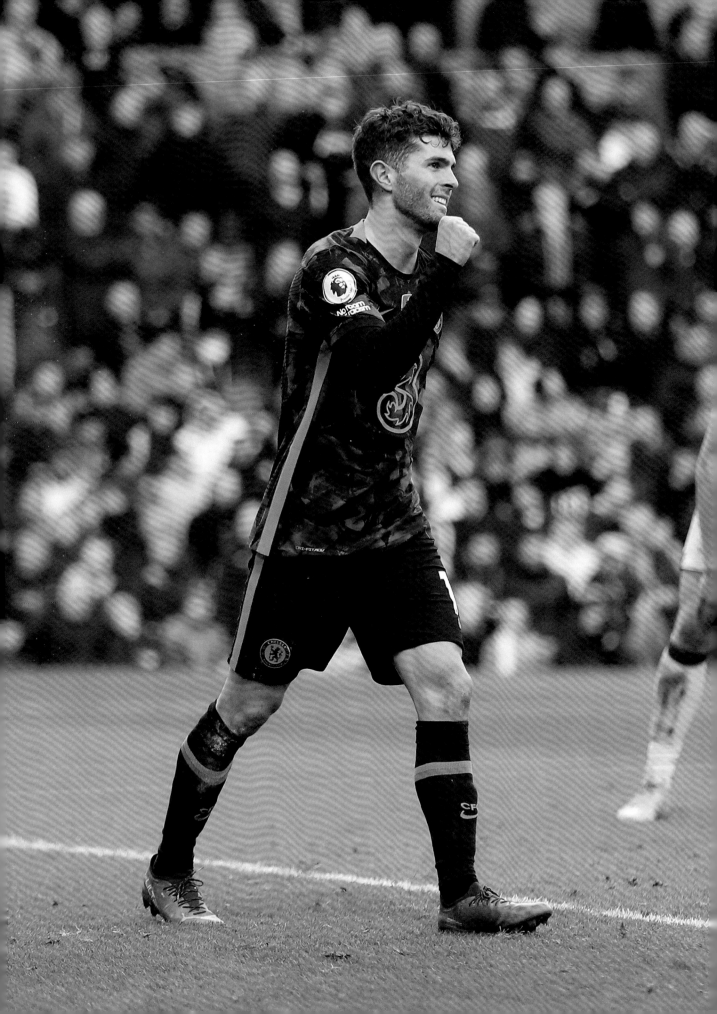

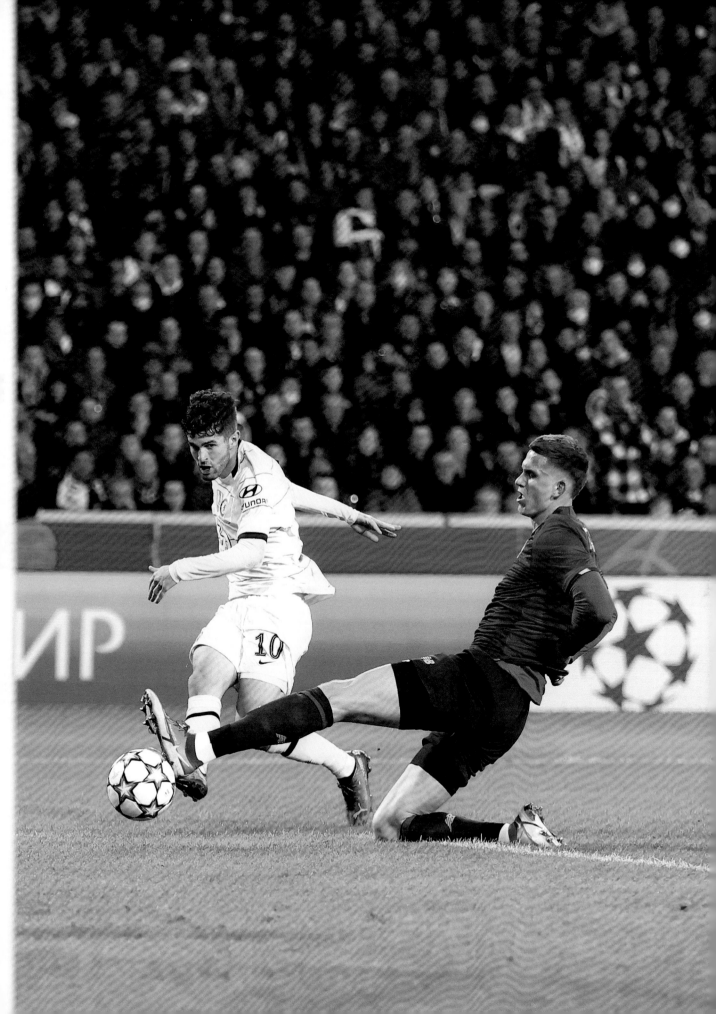

Pages 224–25: Controlling the ball during the Premier League match at Turf Moor, Burnley, England, March 5, 2022.

Pages 226–27: Celebrating scoring our fourth against Burnley, Turf Moor, March 5, 2022.

Preceding pages: Scoring Chelsea's first goal past Léo Jardim of Lille during the second leg of the Champions League round-of-sixteen match against Lille at Stade Pierre-Mauroy, Lille, France, March 16, 2022.

Right: Celebrating the goal against Lille, Stade Pierre-Mauroy, March 16, 2022.

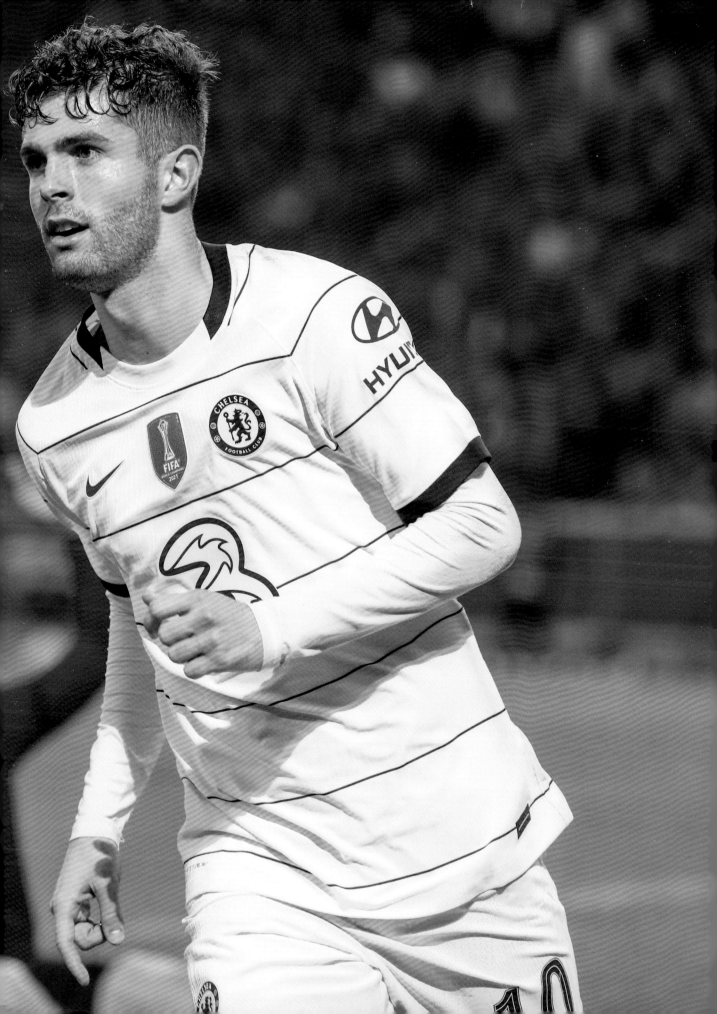

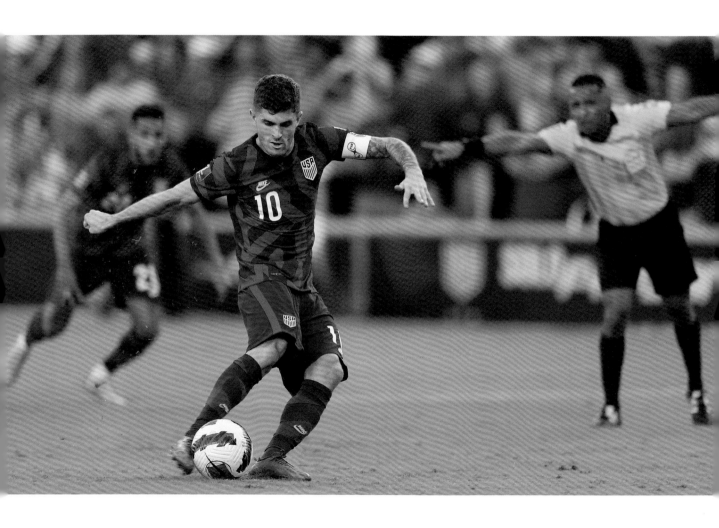

Above: Taking the first penalty kick—aiming high and to the left of the goalkeeper Luis Mejía—in the 2022 World Cup qualifier against Panama, Exploria Stadium, Orlando, Florida, March 27, 2022.

Opposite: Taking the second penalty—this time going to the right of Mejía—in the World Cup qualifier against Panama, Exploria Stadium, March 27, 2022.

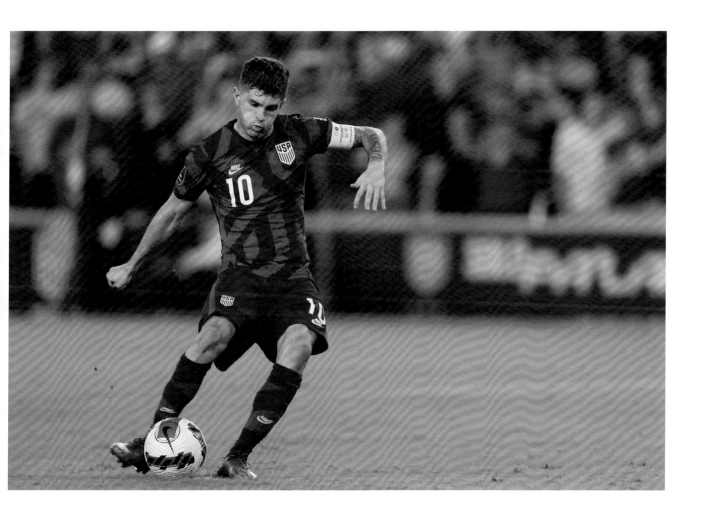

Following pages: After receiving a pass from Antonee Robinson, I took the ball around Fidel Escobar and then through Andrés Andrade's legs to have the space to shoot to Mejía's right. It was my third goal of the night and the team's fifth.

Pages 236–37: Running back to the halfway line after scoring my third goal. This was my first hat trick for the US men's team, and the scoreline meant that we were very close to qualifying for the 2022 World Cup.

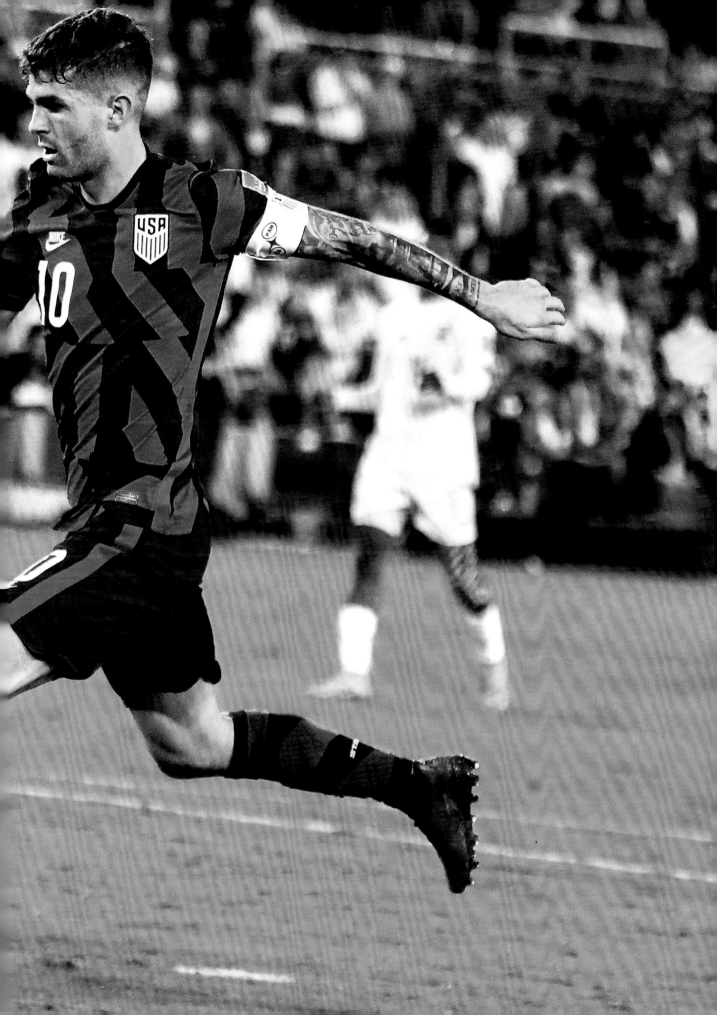

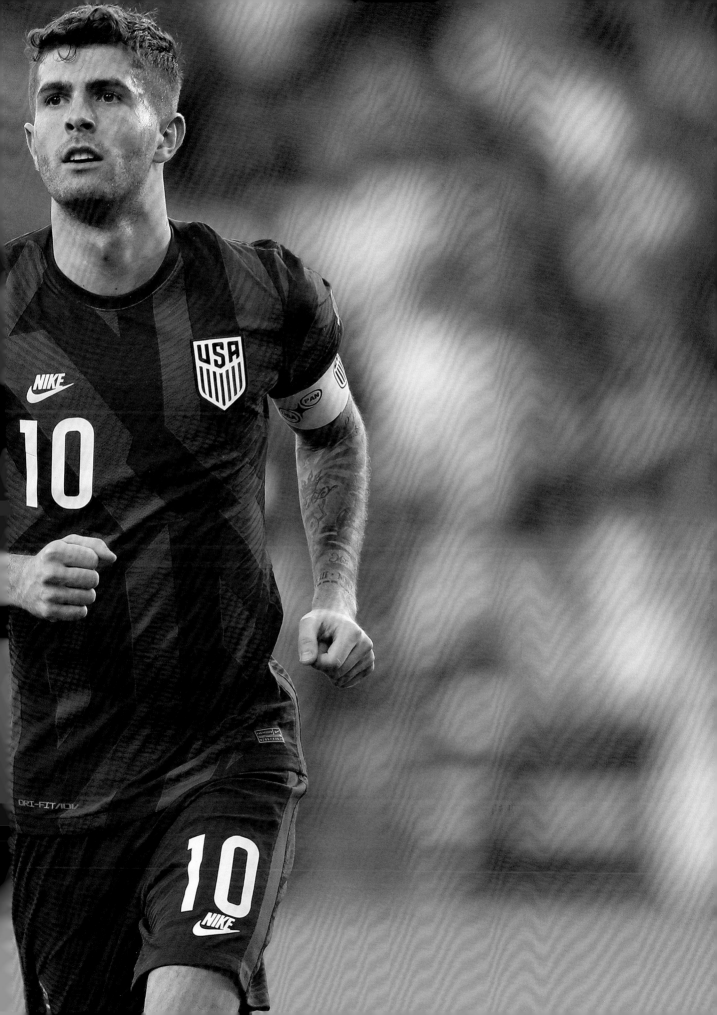

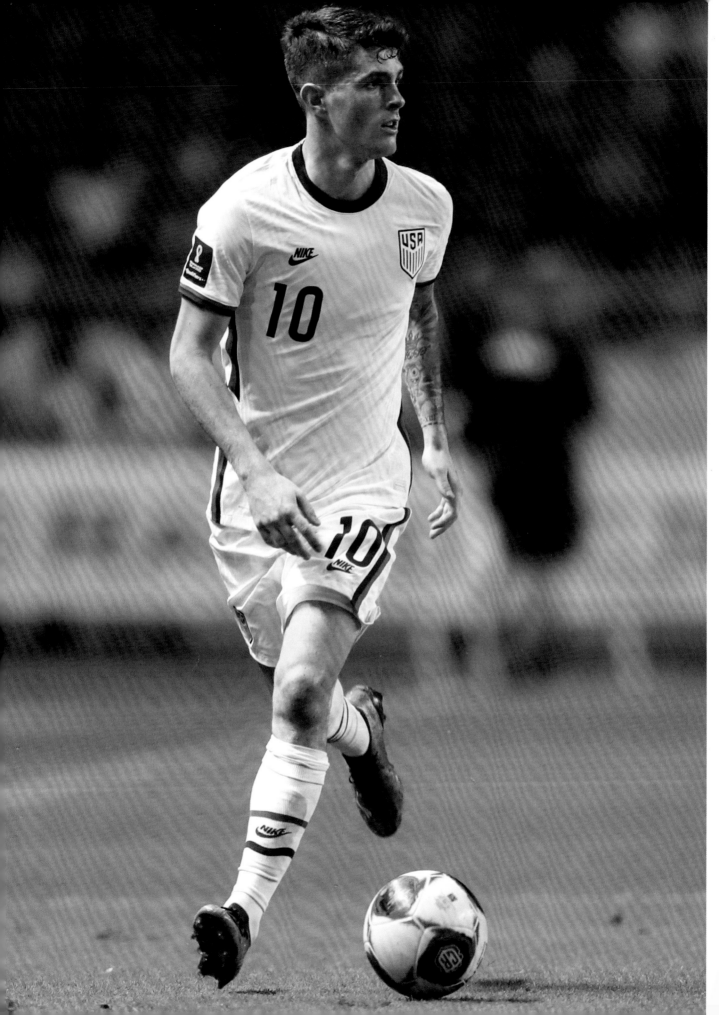

ACKNOWLEDGMENTS

Thank you, Daniel, for helping me tell my story so far. I really enjoyed our conversations, and I think we were able to produce a great book together. Thank you to Mom and Dad for spending hours going through all our photos and picking out some great ones to share. I didn't know some of these pictures existed! I appreciate your support, and I hope that this book makes you proud. Devyn and Chase, thank you for being great siblings and always being there for me. I would not be where I am without you. You are my biggest inspiration. Thank you, Arlo, for your kind words. It was wonderful to have you calling my games all these years. NBC coverage will not be the same without you. Thank you, Charles Miers, publisher of Rizzoli. This book would not have happened without you. I appreciate your support and guidance. Last but not least, I would like to thank all the fans who have supported me throughout the years. Your support gives me strength when I am feeling down, and I would not have been able to make it this far without you. Thank you for taking the time to read this book. I look forward to continuing the journey together. —Christian Pulisic

Thank you, Christian, for welcoming me into your world and for being so easy to talk to and friendly throughout our time together. I think I asked you more questions than I have asked in my entire life. You made time and were always as focused as you are on the pitch, and it is very much appreciated. Thank you, Kelley and Mark, for inviting me to your home and for sharing all your family albums and ephemera. Kelley, thank you for taking such amazing photos and for taking the time to review them all together, which was tremendous fun. Thank you, Arlo, for being a mensch and for making this book better with your words just as your commentary makes everything more enjoyable and more memorable. Rob Moore, as well as Matthew Moore and his Centre Circle agency, you are proof that a football agent can be incredibly nice and a pleasure to work with. Thank you for all of your input, support, and enthusiasm, and for contributing a number of excellent photographs too. Thank you, Charles Miers, lifelong Chelsea fan, for trusting a Gooner. Thank you, Lee Martin, for your friendship and for making this book happen, and thank you to the entire team at Getty for all the extraordinary photographs and support throughout the making of this book. Scott Prusha, thank you for the cool Panini cards. Thank you, Alyn Evans, for making sure the printing looks as good as it does. *Grazie mille*, Rino Varrasso and OGM, for taking such care and raising the bar. *Stacco!* Thank you, Jennifer Milne, for making sure Villarreal had enough *r*'s and for going above and beyond. My brother, Eytan, thank you for all your invaluable input and help as always. Dad, thank you for playing football with me as soon as I could stand, and thank you, Amanda, for playing soccer with me today. And thank you, dear reader, for giving this book a home and for taking the time to read these words. —Daniel Melamud

Looking for an open man during the World Cup qualifier against Costa Rica, Estadio Nacional de Costa Rica, San José, Costa Rica, March 30, 2022. We ended up losing the game but qualifying for the 2022 World Cup.

First published in the United States of America in 2022 by
Rizzoli International Publications, Inc.
300 Park Avenue South
New York, NY 10010
www.rizzoliusa.com

Photography except where indicated courtesy of Getty Images, Inc.
Lee Martin, SVP, Global Strategic Development

Concept, design, and edited by Daniel Melamud

Publisher: Charles Miers
Proofreader: Jennifer Milne
Production: Alyn Evans

Library of Congress Control Number: 2022936505
ISBN-13: 978-0-8478-7207-7

2022 2023 2024 2025 / 10 9 8 7 6 5 4 3 2
Printed in Italy

VIsIt Rizzoli online:
Facebook.com/RizzoliNewYork
Twitter: @Rizzoli_Books
Instagram.com/RizzoliBooks
Pinterest.com/RizzoliBooks
Youtube.com/user/RizzoliNY

Page 2: Getting on a plane to Belfast for the UEFA Super Cup
final against Villarreal, Farnborough Airport, England, August 10,
2021.

Page 4: About to take a corner kick during the international
friendly against Ecuador at Orlando City Stadium in Orlando,
Florida, March 21, 2019.

Pages 6–7: Held aloft by my Michigan Rush teammates,
Northville, Michigan, fall 2007.

Pages 8–9: Hugged by my mom during my first call-up to national
team camp, Carson, California, May 7, 2011.

Pages 10–11: Playing with my dad and sister, Annville,
Pennsylvania, summer 2001.

Back cover: Playing in the World Cup qualifier against Panama at
Exploria Stadium, Orlando, Florida, March 27, 2022.

PHOTOGRAPHY CREDITS

Robin Alam/Icon Sportswire via Getty Images: front cover, 4, 12,
64–65, 68, 71 (*top*), 72, 73, 126, 164–65, 172–73
Darren Walsh/Chelsea FC via Getty Images: 2, 97–101, 104
(*bottom*), 105, 112 (*bottom*), 116–17, 120, 124, 129, 134–37,
174–75, 204–05
Kelley Pulisic: 6–7, 10–11, 14–15, 20–21, 24–31, 33, 35–38,
40–41, 43 (*bottom*), 45, 48, 56, 61, 78 (*top row, left*), 79 (*bottom
row, right*), 81, 82, 131 (*top*)
Mark Pulisic: 8–9, 22–23, 34, 39, 50–51, 113, 131 (*bottom*)
Matthew Moore: 32, 42, 78 (*middle row, left, center, and right*), 78
(*bottom row, left*), 79 (*bottom row, center*), 79 (*middle row, center,
and right*), 125, 130
Daniel Melamud: 43 (*top*)

Adrián Macías/Mexsport: 44
John Dorton/ISI Photos/Getty Images: 46–47, 69, 200–03, 238
Pulisic archive: 52, 53, 60, 83, 121
Mike Carlson/Getty Images: 54–55
Ashley Allen/Getty Images: 57, 66
Jamie Sabau/Getty Images: 58–59
TF-Images/Getty Images: 62–63
Helen H. Richardson/MediaNews Group/The Denver Post via
Getty Images: 67
Douglas Stringer/Icon Sportswire via Getty Images: 70
Daniel Bartel/Icon Sportswire: 71 (*bottom*)
Adam Davy/Empics: 74
Adam Davy/Pool via Getty Images: 110
Alexandre Simoes/Borussia Dortmund via Getty Images: 76, 77,
78 (*top row, right*), 78 (*bottom row, center*), 79 (*top row, center*),
79 (*middle row, left*), 84, 88, 89, 92–93, 138–39, 142–43, 150–51,
166–67
Juergen Schwarz/Bongarts/Getty Images: 80
BVB: 85
Power Sport Images/Getty Images: 86–87
Lars Baron/Bongarts/Getty Images: 90, 148–49
Thomas Lovelock/Sports Illustrated/Getty Images: 94
Chris Lee/Chelsea FC via Getty Images: 96, 122–23
Alex Burstow/Getty Images: 102
David Davies/PA Wire via Getty: 103
Orlando Sierra/AFP via Getty Images: 104 (*top*)
Laurence Griffiths/Getty Images: 106, 107
James Williamson/AMA/Getty Images: 108–09, 178–79
Marc Atkins/Getty Images: 111
Devyn Pulisic: 112 (*top*)
Christian Pulisic: 114, 133
Mark Von Holden/AP Images: 115
Denis Doyle/Getty Images: 118 (*left*)
Isabel Infantes/PA Images via Getty Images: 118 (*right*),
119 (*left and right*)
Raheem Taylor-Parkes: 127
Hector Vivas/Latin Content via Getty Images: 128
The Hershey Company: 132
Ben Stansall/Pool/AFP via Getty Images: 133
Jamie Sabau/Getty Images: 140–41
Stringer/Anadolu Agency/Getty Images: 144–45
Friso Gentsch/Picture Alliance via Getty Images: 146–47
Ina Fassbender/Anadolu Agency/Getty Images: 149 (*right*)
Shaun Clark/Getty Images: 152, 153
Tobias Schwarz/AFP via Getty Images: 154–55
Zhong Zhi/Getty Images: 156–57
Odd Andersen/AFP via Getty Images: 158–59
Ira L. Black/Corbis via Getty Images: 160, 161
John Byrum/Icon Sportswire via Getty Images: 162–63
Matthew Ashton/AMA/Getty Images: 168, 169
Patrick Smith/Getty Images: 170–71
Krugfoto/AFP via Getty Images: 176–77
Marc Atkins/Getty Images: 180–81
Visionhaus: 182–83, 186–87, 196–97
Mike Hewitt/Getty Images: 184–85
Justin Tallis/Pool via Getty Images: 188–89
Phil Noble/Pool/AFP via Getty Images: 190–91
Richard Heathcote/Getty Images: 192
Alex Livesey/Danehouse/Getty Images: 193
Diego Souto/Quality Sport Images/Getty Images: 194–95
Jamie Schwaberow/ISI Photos/Getty Images: 198–99
Brad Smith/ISI Photos/Getty Images: 206–09, back cover
Omar Vega/Getty Images: 210–11, 232, 233, 236–37
Kerem Yucel/AFP via Getty Images: 212–13
Michael Regan/FIFA via Getty Images: 214, 215
Chloe Knott/Danehouse/Getty Images: 216–17
Steven Paston/Icon Sport: 218–19
Shaun Botterill/Getty Images: 220–23
Robbie Jay Barratt/AMA/Getty Images: 224–25
Lewis Storey/Getty Images: 226–27
Catherine Ivill/Getty Images: 228–29
Catherine Steenkeste/Getty Images: 230–31
Chandan Khanna/AFP via Getty Images: 234–35